THE Style MENTORS

THE Style MENTORS

WOMEN WHO DEFINE THE ART OF DRESSING TODAY

ELYSSA DIMANT

HARPER DESIGN

An Imprint of HarperCollins Publishers

THE Style Mentors

Women Who Define the Art of Dressing Today

HarperCollins books may be purchased for educational, business, or sales promotional use. For information please write: Special Markets Department, HarperCollins*Publishers*, 10 East 53rd Street, New York, NY 10022.

First published in 2012 by
Harper Design
An Imprint of HarperCollins*Publishers*
10 East 53rd Street
New York, NY 10022
Tel: (212) 207-7000
Fax: (212) 207-7654
harperdesign@harpercollins.com
www.harpercollins.com

Distributed throughout the world by
HarperCollins*Publishers*
10 East 53rd Street
New York, NY 10022
Fax: (212) 207-7654

ISBN 978-0-06-199218-6
Library of Congress Control Number: 2011927591

Book design by Christine Heslin

Printed in China
First Printing, 2012

For my grandmothers—Adelyn, Shirley, and the Esthers—
who will always be my personal style mentors.

And for my mother, Susan, who encouraged me to be my own.

contents

INTRODUCTION

Fashion is about identity, fantasy, protection, and communication. Our fashion personalities influence the way we view ourselves, the people we attract, and the roles that we play in society as a whole. We all have style mentors—individuals that serve as our fashion muses—whose way of dressing is so becoming and so impactful that we see their clothes, their accessories, and the way that they put themselves together as benchmarks from which to develop and cultivate our own looks. Sometimes our muse lives next door or works at the local boutique, but more often than not, she peers out from a magazine cover, movie screen, newspaper style section, or even fashion advertisement, where she has been primped, plucked, and perfected by a team of professionals so that her natural modishness is enhanced to epic standards.

With each emerging generation, different mentors come to the fore of popular culture as the new breed of "It" girls, their looks so fresh and novel that we can't imagine being capable of ever adapting them ourselves. And yet, even your personal style maven has her heroes. Her look is derived from women—perhaps even men—in her life, or those who have walked the red carpet or graced the silver screen before her. She adds modern tweaks to a template that has existed for decades. Looking back into the annals of fashion history, there are certain overarching styles that have endured, extracting new elements from each era and churning out icons that allow each fashion momentum and gravitas. Even in surveying contemporary fashion, these groupings are clear. *Style Mentors: Women Who Define the Art of Dressing Today*

identifies the women who have allowed each of these looks to sustain and evolve, and conveys the strategies by which you can adopt them in their current iterations.

Chapter one of this book pays homage to Icons, women whose personal styles are so influential that it seems fashion as an entity might never have existed without them. If Icons set the curve, then the Mavericks break it. Chapter two reflects upon fashion's most outlandish and daring proponents: outliers who forge new roads for sartorial expression. Sometimes fashions grow from the need to suit a particular body type. Chapter three examines the clingy concoctions of the sexy Siren, while the chapter to follow focuses on her counterpart—the coquettish Gamine. In rockier political times, the Bohemian tends to resurface, as is evident in chapter five, while more futuristic or technologically driven eras lure chapter six's Minimalists to the fore. The Rockers and their do-it-yourself stylings are examined in chapter seven, while the last chapter is dedicated to those cool Classicists, whose immaculate, tailored look perseveres as fleeting trends come and go.

By emulating your favorite mentor, you can make your own look more cohesive. *The Style Mentors* offers tips and must-have fashions that will help focus your spirit of dress, as well as words of wisdom from the style setters themselves. Each fashion personality has its own set of rules, yet within those guidelines, individual interpretation is key. The way in which you interpret each type will ultimately provide you your own fashion star. And who knows, maybe you will become someone else's muse!

"Fashion fades.
Only STYLE
remains the same."
—Coco Chanel

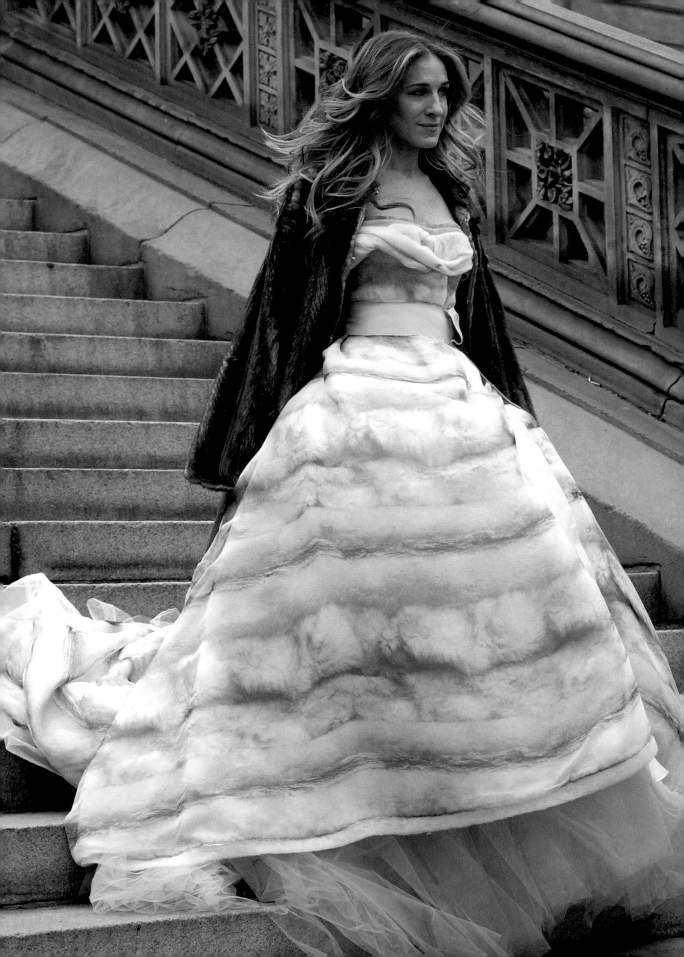

Some would say you're a fashion addict. Hopeless. You've been flipping through magazines since before you could read, and you know the signatures of every designer, dead or alive. The perfect day is one in which your ensemble suits every situation you encounter. Almost always, you feel like the best-dressed woman in the room. Your friends look to you for guidance not only on what to wear, but also on where and how to wear it, and you are happy to offer your keen sensibility and impeccable eye. You are the sun in your fashion solar system, but you have long been eyeing those pillars of style who have come to define fashionable dress and cutting-edge aesthetics over the last half century. These women are Icons. They, like you, inspire fashion enthusiasts to be more imaginative, to draw from vintage and runway equally, and to adapt any number of looks with ease and confidence.

An Icon is both creator and muse, able to successfully realize a designer's vision yet have the capability to mix and match styles herself to discover the perfect balance between exploration and reserve. Though her clothes always reflect good taste, they also magnify her natural beauty and grace.

As a pop culture phenomenon that premiered in 1998 and veritably pulled women—stilettos first—into the new millennium, the HBO Original Series *Sex and the City* celebrated fashion as an expression of unrestrained glamour. The show's protagonist, sex columnist Carrie Bradshaw, was far more beloved by *SATC* fans for her obsession with high fashion than for her musings on sexual anthropology. Played endearingly by Sarah Jessica Parker, Carrie nearly singularly popularized Manolo Blahnik pumps among a mass audience and made it plausible for women everywhere to embrace decadent, over-the-top designs such as tutu skirts, taxidermy hats, and slinky dresses. As Carrie, Parker wasn't the first to play the role of the hedonist's enabler; the divine Marie Antoinette, wife of Louis XVI, was the first identifiable fashion icon to champion such unbridled consumption. (For more on Marie Antoinette, see "Fashion's First Icon" on page 16.)

Over the last decade, both Carrie Bradshaw and Sarah Jessica Parker have emerged as proponents of Marie Antoinette's dress-up-or get out

Opposite: Sarah Jessica Parker as Carrie Bradshaw on the set of the *Sex and the City* movie, 2008.

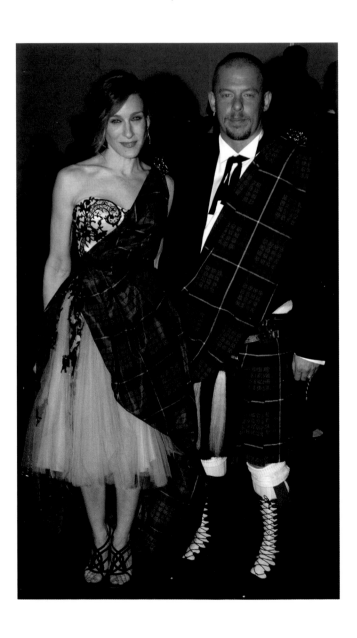

approach to fashion. After each new breakup, Carrie took solace in the consumerist haven of the shoe boutique. She consistently purchased footwear she couldn't afford, contributing to an ongoing addiction (and an extraordinary collection!) that became a running joke throughout the show. The copious selection of coordinated Christian Dior ensembles in which stylist Patricia Fields dressed Carrie for a jaunt in Paris neither shocked nor unnerved doting fans. And since she did a stint as a writer for *Vogue* on the show, Carrie's lavish Vivienne Westwood wedding gown in the first *Sex and the City* film was par for the course. The clothes fit the girl: Carrie's success, both in the "City" and with her viewers, had everything to do with her access to and display of high fashion.

Sarah Jessica Parker, whose reputation in fashion has been fairly stellar since the turn of the millennium, hosted the MTV Movie Awards in no fewer than fourteen different gowns, has appeared as the spokesperson for Garnier and The Gap, and even served as a judge on *Project Runway* in 2007. In 2010, Parker was tapped as a creative consultant for the brand Halston Heritage, and the actor continues to launch her own brands as well, which now include five different fragrances. Though Carrie was a friend to all designers (Chanel, Cavalli, and Alaïa were just of few of those mentioned during the series' run), Sarah Jessica Parker has been consistently affiliated with wunderkind Alexander McQueen. McQueen seemed every bit Parker's own "minister of fashion" when the actress wore his black taffeta gown with an extravagant black lace headpiece by longtime McQueen collaborator Philip Treacy to the London premiere of

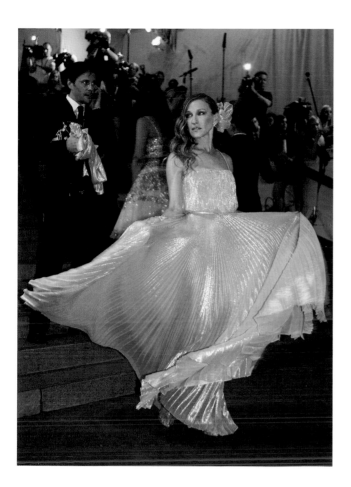

Sex and the City 2. She also arrived in a full kilt tartan gown with the designer (who wore a matching kilt ensemble) to the 2006 opening of the exhibition "AngloMania: Tradition and Transgression in British Fashion" at the Metropolitan Museum of Art's Costume Institute. After the couturier tragically ended his own life in 2010, Parker wore a purple and pink printed gown handpicked by McQueen's successor, Sarah Burton, to eulogize the designer at the 2010 Council of Fashion Designers of America Awards.

Sarah has also been known to step out in Oscar de la Renta, Chanel, and Christian Dior. Regardless of the couturier, Sarah favors open backs, revealing necklines, and ball gown skirts: the most consistent factor in SJP style is to make an impact.

"I like my money right where I can see it . . . hanging in my closet."

—Sarah Jessica Parker as Carrie Bradshaw, *Sex and the City*

Fashion's First ICON

Though Marie Antoinette, the queen of France from 1774 until her death by guillotine in 1793, was vastly criticized by the French people for her unchecked spending, she managed to accrue the most enviable and extraordinary wardrobe in all of Europe. The queen's personal mission at Versailles was to beautify: to teach her court subjects to embrace a more refined and luxurious lifestyle. When her husband, King Louis XVI, gave her the Petit Trianon, a small château and surrounding park on the grounds of Versailles, she set about straightaway to landscape the property in the refined style of British horticulture. Her tastes were so extravagant that she is reputed to have encrusted an entire interior wall in the Petit Trianon in gold and diamonds.

Marie Antoinette's most notable impact on French aesthetics was made via her sartorial choices, however. When she took the throne, formal court dress was very traditional, mainly robes with wide panniers, extrarigid corsetry, and textiles embellished with exaggerated silver and gold brocades. The queen rejected the old-fashioned style of dressing, with its thick rouge and heavily powdered hair, and imposed a more relaxed if no less lavish court dress that reflected a modern eye. With the assistance of her "ministers of fashion," dressmaker Rose Bertin and hairdresser Léonard, Marie Antoinette popularized the bosomy polonaise gown,

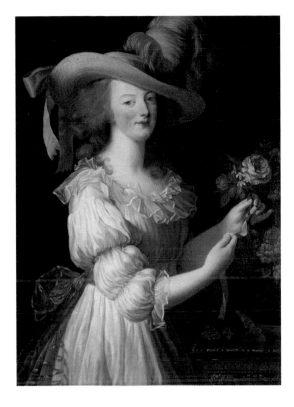

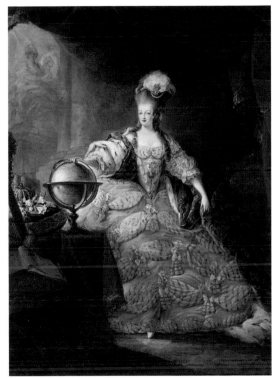

which fell ankle-length, and the "pouf" hairstyle, a towering mass of lightly powdered curls that Léonard decorated with combs and ornaments of all shapes and sizes.

Marie Antoinette also brought the chemise dress of translucent fine linen into high fashion and brightened it with a waist sash of silk satin, typically in blue or pink. Though the dress still required a corset, it appeared more effortless and artistic than some of the stiffer and more ostentatious silk robes. In Élisabeth Vigée-Lebrun's 1783 portrait of her, *Marie Antoinette en chemise* (above, left), she is dressed whimsically in her chemise dress, and her hair is arranged in the "hedgehog" style and topped with a wide-brimmed hat covered with her signature white ostrich plumes. With the exception of the gaulle dress, many of Marie Antoinette's fashions were far too exaggerated or elaborate to be heavily copied, but her attention to detail, unwieldy expenditures, and unconstrained adoration for fashion secured her dichotomous legacy: as a shamed hedonist killed in the name of revolution, and as a style icon, whose passion for fashion will forever resonate with contemporary consumers. Marie Antoinette's voice is the one we hear in the dressing room, when we're not sure whether to splurge, or in front of the mirror, when we're worried that this coat or that hat may be a drop too opulent; the queen encourages us to show off, to embrace extremities, and to delight in the accoutrements of fashion.

Above, left:
A portrait of
Marie Antoinette
attributed to
Elizabeth Louise
Vigée Le Brun, 1783.
Above, right: *Queen
Marie Antoinette*
by Jacques-Fabien
Gautier d'Agoty, 1754.

A resident of New York City, Sarah is seen around town in daytime clothing that's more practical than her red carpet attire, though no less put together. Oversize knit berets, dark sunglasses, and sculptural winter scarves glamorize her winter looks, while she often pairs cotton beach dresses with an ornate belt, a large pendant, or sky-high platforms during the summer months.

Parker, both on-screen and off, has helped infuse fashion with a sense of drama and glamour that in turn inspires us to be a little fashion crazy: to take chances, to be fearless, and to splurge, splurge, splurge. The look is high-high, so even if you throw on something that didn't come with a serious price tag attached, you better strut your stuff like it's worth a million bucks.

In 1954's *Rear Window,* Grace Kelly's character, Lisa Carol Fremont, sent a similar message when she stated proudly "I never wear the same thing twice." Fremont's velvet-bodice dresses, white halter-neck blouses, and veiled hats were truly the stuff of dreams and were rivaled perhaps only by Grace's wardrobe for *To Catch a Thief* the following year, in which she wore strapless gowns, chic Capri pants, and chunky costume jewelry. In real life, Grace was considered just as much of a fashion arbiter, but her tastes were subtler and more graceful than those of her on-screen roles. Her 1956 wedding to Prince Rainier of Monaco was viewed worldwide, as her gorgeous gown, designed by Hollywood costume designer Helen Rose of MGM, was configured from three hundred yards of antique Brussels rose-point lace, twenty-five yards of stiffened taffeta, and one hundred yards of silk net, all studded with pearls. The dress continues to set the bar for glamour at the altar. When Grace used the Hermès *sac à dépêches* to conceal a pregnant belly later that year, the French luxury firm renamed their famed handbag model "Kelly" in her honor.

Grace was decidedly loyal to the same designers for most of her life. Balenciaga, Madame Grès, and Yves Saint Laurent were among her favorites, and she was famously frugal about her selections, storing garments once they became unfashionable, as she appreciated each and every one for its longevity and impact as a work of art. Rather than follow a trend, Kelly determined the cuts that worked best for her figure and adopted silhouettes in which she felt most comfortable. The actress-turned-princess was so elegant that her signature accessories easily became instant icons of fashionable dress.

Grace Kelly's reverence for fashion and her signature poise are embodied by actress Cate Blanchett, who has been praised for her dramatic skill and envied for her red carpet wardrobe. Blanchett's accomplished film work has included the title role

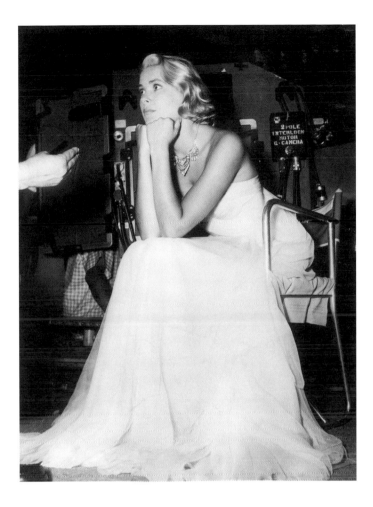

of *Elizabeth* (1998), an Irish journalist in *Veronica Guerin* (2003), and Katharine Hepburn in *The Aviator* (2004), all of which afforded her seminal red carpet appearances. She once remarked to *Elle* Deputy Editor Maggie Bullock, "I'm a great lover of sculpture, which is why I love Galliano, Ghesquière, Gaultier. . . . The silhouettes are so unusual. And with fewer and fewer houses able to afford to produce couture, if someone's willing to let you borrow these things—er, squeeze yourself into them—you really have to."

Blanchett embraced her ability to flaunt fashion effectively in the Donna Karan New York advertising campaigns from 2003 to 2005. When asked why she chose Cate, Karan explained, "You don't look at the photographs and think, 'That's Cate Blanchett wearing Donna Karan.' She inspires a more personal connection. Instead, you think, 'That's a beautiful woman. That's how I want to look.'"

The fashion cognoscenti first noticed Cate's charming style and impeccable eye when she wore a purple knit Galliano gown embroidered at back with a bright hummingbird to the 1999 Academy Awards. The actress, who has been alternately described as "intriguing," "animated," "chameleonlike," and "drop-dead divine in a wrinkled sweater that's lost its elastic," is widely admired for her subtle yet glamorous style. Like Grace Kelly, Cate exudes a quiet, regal quality. She clearly respects the detail bestowed by the

designer and embraces the creations that are developed for her, fully and without alteration. Though her gowns sometimes push the envelope with their bareness, girth, or outright lavishness, they are never brazen. The lesson to be learned from the classic screen goddess—whether of Grace's era or Cate's—is to retain a ladylike restraint. Your hair can be pulled back in loose waves and secured with a chignon or bun. Your eyes should be made up, but not heavily, and don't forget your lipstick—even if you're just going to the grocery store. Don't dress too sexy; your clothes need not shout from the mountaintops. There is an ensemble for every occasion, and your personal style can only enhance it. If you're attending a formal event, perhaps try something beautifully tailored rather than sweeping or draped. If you do go with a Grecian gown, make sure it grazes the floor, so you appear every bit the divine statue you're emulating. If you're walking your dog, a silk jersey day dress with belted waist demonstrates your attentiveness to your image. Even a jaunt to the country should provide the opportunity for a series of walking trousers and fitted sweaters; just because you're out of the city doesn't mean you're out of sight.

While movie stars like Blanchett and Kelly promote elegance and encourage a thoughtful wardrobe, some fashionistas seem to uncannily project iconic style. Both in her capsule design collections and with a seemingly endless store of quirky vintage pieces, actor, designer, and all-around fashion VIP Chloë Sevigny does just that. Her designs combine ethnic or floral 1980s-tinged dresses with youthful slim-tailored separates and chunky footwear such as wide-heeled boots or saddle shoes.

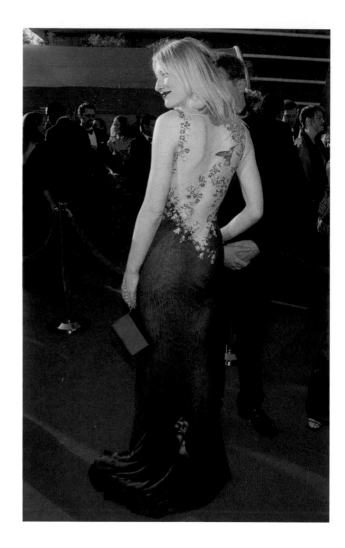

"I'm one of those strange beasts who really likes a corset."

—Cate Blanchett

20

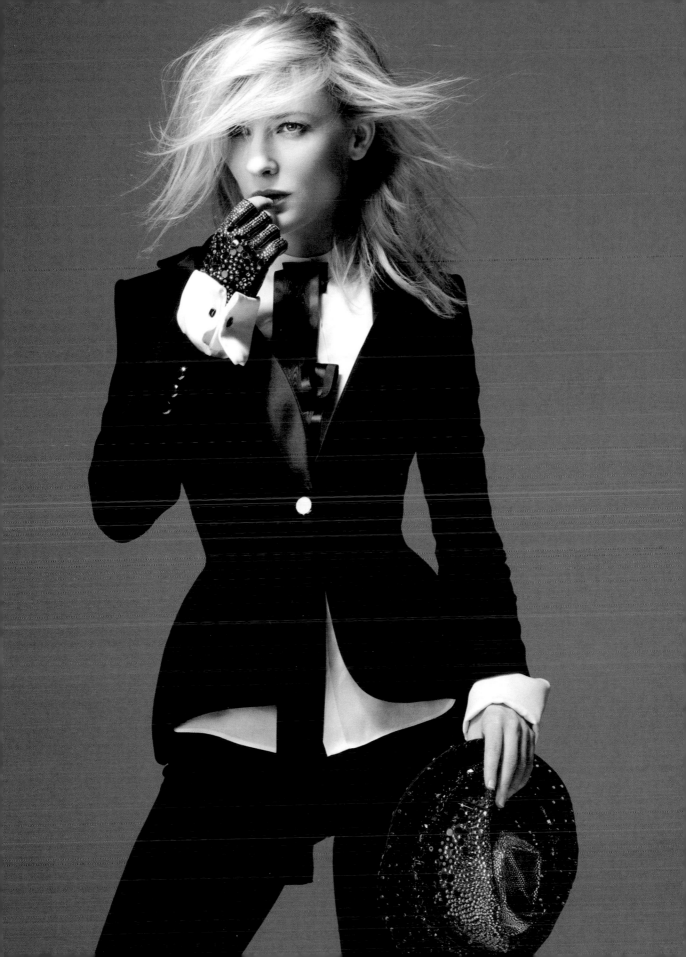

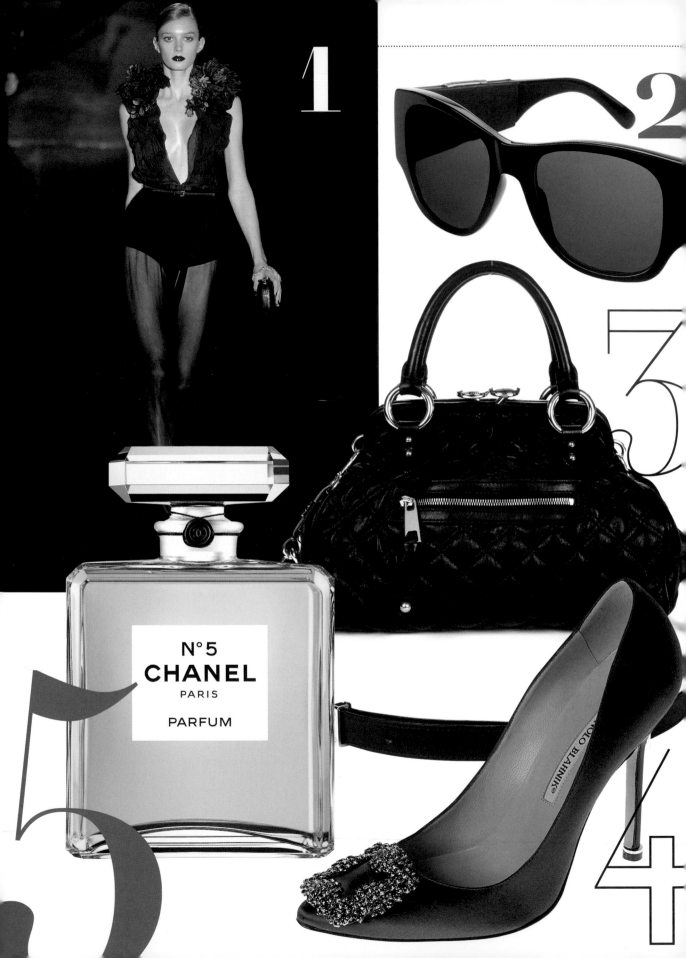

1

2

3

N°5
CHANEL
PARIS

PARFUM

4

5

AN ICON'S
Must-Haves

1. A Killer Dress
There are very few women who have the opportunity or the bank account to accrue a limitless collection of red carpet gowns. But if you want to emulate an Icon, consider procuring at least one statement dress for special occasions that allows your sartorial light to shine bright. Though the cost of an elaborate haute couture gown by John Galliano for Christian Dior, Oscar de la Renta, or Carolina Herrera might be too much to invest, the designers' vintage pieces, found in discerning secondhand shops the world over, might offer worthy and more affordable alternatives. Another option when trying to envision this special frock is to consider a slightly less exaggerated dress—with a shorter hemline or less surface embellishment—that can be dressed up with glamorous accessories—and confident posturing.

2. Oversize Sunglasses
Jackie, Anna, and a host of contemporary fashion personalities use big sunglasses, whether in black or a range of subtle, fashion-forward colors, as a way to elevate their look with minimum effort. The oversize frames can contribute mystique and sophistication to any ensemble, but make sure the shape suits your face: if you invest in the wrong pair, you might appear goofy rather than glamorous. Eyewear designs from Chanel, Costume National, Prada, and Lanvin boast a wide variety of contours and transparencies, so be sure to try on the glasses before you buy.

3. The "It" Bag
Though each fashion season isolates a new must-have handbag, sometimes the timeless choice trumps the trendy. The Hermès Kelly or Birkin models, the Bottega Veneta plaited leather shoulder bag, or the Chanel or Marc Jacobs quilted box bags, all classics that are reissued periodically, provide wonderful accents to any outfit. In black or brown, they can serve as everyday bags, while an exotic orange or red hue can offer a more restrained ensemble a flash of color.

4. The Status Shoe
Whether Christian Louboutin, Roger Vivier, Jimmy Choo, or Manolo Blahnik, the designer pump is a must for any serious fashion follower. Though it's certainly acceptable to maintain a footwear collection that fulfills your basic fashion needs and doesn't totally deplete your bank account, an acquisition from one of the aforementioned cobblers communicates that you are willing to invest in your look, and that you choose your brands wisely. A true fashion insider will recognize Louboutin's red sole or Jimmy Choo's signature stiletto anywhere; so don't be afraid to flash that footwear!

5. Signature Perfume
Wearing the same perfume year after year—perhaps switching it up for the rare event or affair—will establish your stylistic confidence. Created in 1921, Chanel No. 5, though not the first designer perfume, is by far the most iconic. Of the scent, the Chanel website boasts, "every woman adds something of herself to it."

Opposite: 1) Gucci runway dress, Fall/Winter 2011–12; 2) Chanel sunglasses; 3) Marc Jacobs Mini-Stam handbag; 4) Manolo Blahnik pump; 5) Chanel No. 5 perfume bottle

"**i** always like something that is a little unusual."

—Chloë Sevigny

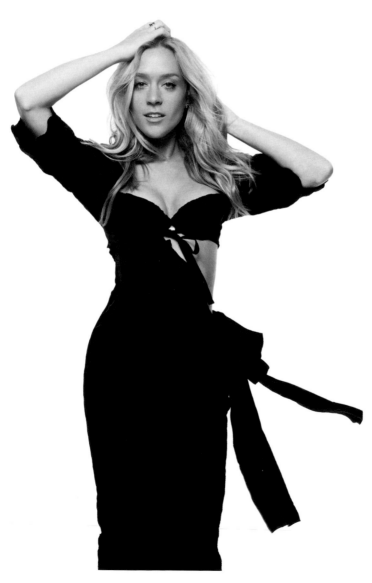

If these looks sound strange, it's only because Sevigny herself is an offbeat Icon. She moved from her hometown in Connecticut to Brooklyn, New York, at eighteen and appeared in music videos for Sonic Youth and the Lemonheads. Though her breakthrough role as Jennie in the 1995 movie *Kids* first garnered her attention, Chloë's subsequent turns in *Boys Don't Cry* (1999) alongside Hilary Swank, *American Psycho* (2000) with Christian Bale, and as a principal character in the HBO Original Series *Big Love* have ensured her reputation as a premiere actor. Sevigny's sartorial inspirations run the gamut from David Bowie to *Little House on the Prairie*, and her style frequently interweaves girlish femininity with a sort of tomboy sloppiness. This indie eclecticism is evident in her work with Opening Ceremony, about which she has mused, "It wasn't a huge thing to think about. I think we have similar aesthetics, similar references. There's always a little something quirky, something different."

Though Chloë has been a recognizable fixture in fashion since her creative collaboration with Tara Subkoff on the controversial brand Imitation of Christ (2000–7), her more recent appearances in Valentino, Prada, Lanvin, and Chloé have provided her with fashion establishment credibility. Rather than always christen the newest collection garments from these big fashion houses, however, Chloë frequently draws on vintage pieces from her own closet. Her look screams "mix it up" and dares to take a misstep, for in her style realm, patterns intermingle and cocktail dresses meet sneakers. Chloë is often inspired by another era or a bygone trend, however she never revisits these fashion moments with nostalgia or irony, but instead with the earnestness of sincere appreciation.

> "a good fashion is a daring fashion, not a polite one."
>
> —Daisy Fellowes

Interesting then, that Chloë's adventurousness as well as her unique positing between quirky fashion independent and style insider seem to channel a style Icon from the past: the inimitable Mrs. Reginald (Daisy) Fellowes, who Karl Lagerfeld once deemed "the chicest woman I ever laid eyes on." Like Chloë, Daisy had a range of interests and professions that included novelist and poet as well as editor in chief of French *Harper's Bazaar* in the 1930s. One might say that Fellowes was born into fashion, as she was the heiress to the Singer sewing machine fortune. She was a great patron of Elsa Schiaparelli's work, as its surreal elements and tongue-in-cheek embellishments provided her a much-needed break from the seriousness of French couture. She was a regular fixture of the international café society and recognized as both a trendsetter and a pioneer by her peers.

Barbara "Babe" Mortimer Paley enjoyed a similar reputation in New York City, where she was the fashion editor at *Vogue* in the early 1940s. If Fellowes and ultimately Sevigny can be considered quirky or indie Icons despite their insider status, then Babe was a highbrow cultural powerhouse: she was voted on to *Vanity Fair*'s "International Best-Dressed List" fourteen times before being inducted into their "Fashion Hall of Fame" in 1958, and reputedly bought entire couture collections when she shopped from the seasonal presentations. Paley, whose husband, William S. Paley, founded the CBS network, was named by *New York* magazine as "the most famous of [Truman] Capote's swans," which also

Opposite: Chloë Sevigny in Prada's Spring/Summer 2009 collection for C magazine. Above: Daisy Fellowes, photographed by Cecil Beaton, 1941. Page 26: Babe Paley in a John-Frederics hat featuring a stuffed marten, circa 1939.

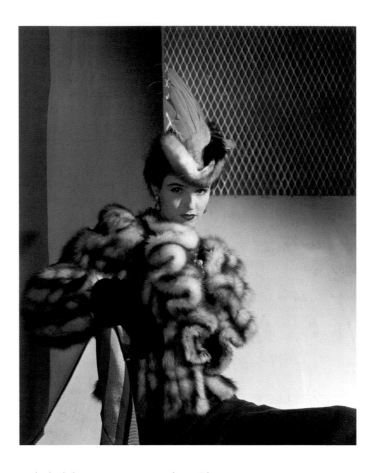

"I never saw her not grab anyone's attention, the hair, the makeup, the crispness. You were never conscious of what she was wearing; you noticed Babe and nothing else."

—Bill Blass, on Babe Paley

included the prominent socialites Gloria Guinness and C. Z. Guest. Capote was a longtime friend of Babe's, and drolly remarked after her death, "Babe Paley had only one fault: she was perfect. Otherwise, she was perfect." Paley's perfection manifested itself in the details: from pristinely brushed furs and pressed Dior suits to layered strings of Chanel pearls over sporty Mainbocher jumpsuits. Babe's look always touched on the most prevalent seasonal trends, but it did so in an inventive and exuberant way that conveyed her natural gift for styling. Her influence was unquestionable: when Babe tied her scarf around her handbag as a matter of convenience, women all over the world copied the trend.

Today Kate Moss wields the same power as Babe Paley did in her day. In 2003,

ICONS

Never, EVER...

>>

Wear something from last season. If you aren't dressed in new clothes, put on something from three years back and show off your new "vintage" piece.

>>

Abandon their signature hair or makeup to embrace seasonal beauty trends. An Icon changes clothes but always retains her identity.

>>

Look to others to set the curve. As an Icon, you're the one who sets the stylistic benchmark.

>>

Fall out of touch with monthly (even weekly) fashion magazines. As a fashion stylist in your own right, you'll need constant inspiration.

>>

Forget to add their own touch to an outfit. It's okay to wear a minimalist ensemble one day and a jewel-encrusted one the next, but make sure you add something of your own creation (that is, you always belt your tops or wear four-inch heels or high-waisted pants) to each ensemble to retain the thread of your own unique style.

W magazine declared Kate its unofficial muse, while British *Glamour* deemed her the "World's Best Dressed Woman" in 2007. Just under a year after upsetting her credibility in the fashion industry with a drug scandal in 2005, the model bagged a Fashion Influence award from the Council of Fashion Designers of America and was back on top with eighteen different advertising contracts for Fall/Winter 2006, among them Chanel, Dior, Versace, Bulgari, Cavalli, Louis Vuitton, and Burberry. The late designer Alexander McQueen honored her the same year by taking a bow in an I LOVE YOU KATE T-shirt after his Spring 2007 runway show.

Kate rose to fame after appearing at fifteen in Corinne Day's black-and-white images for *The Face*'s "Summer of Love" editorial in 1990, and was soon recognized worldwide as the unassuming waif posed next to then-rapper Mark Wahlberg in a Calvin Klein Jeans advertising campaign photographed by Herb Ritts (1993). In the early 1990s, the five-foot-seven Kate became the face of the heroin chic movement and the unexpected spokesmodel of a generation. She has since appeared on thirty British *Vogue* covers, served as the subject of a forty-page portrait series for *W* magazine, and appeared as a hologram at the Fall/Winter 2006 McQueen presentation. Moss has additionally been the muse for various contemporary artists, including Lucian Freud, Chuck Close, and Marc Quinn, who cast her in a solid 18-karat gold sculpture as the modern-day Aphrodite for the British Museum, London.

There's no question that Moss has a pretty face, but her reputation owes as much to her sartorial intuition as to her enchanting looks. Though People for the Ethical Treatment of Animals (PETA) included Moss on their "Worst-Dressed" list in 2008 because she frequently wears fur, the rest of us are keen to learn from her innate ability to pair a sundress and sling backs, skinny jeans and mukluk boots, or ballet flats and a leopard coat, all with the same matter-of-fact nonchalance. In 2007, the British retail chain Topshop launched Moss's line of clothing and accessories at all 225 (now they have nearly 300) of their UK stores, and the collection was made available to customers in the United States at Barneys New York soon thereafter. Her final line for the retailer was in winter 2011.

Nonetheless, the Topshop designs represent the most important component of Moss's style ethos: whatever you're wearing—designer duds, vintage, or affordable knockoffs—make sure to add a bit of rock and roll. While Moss doesn't ever adhere to one look for long, she consistently reminds us that she's a wild child—both in life and in fashion. If her

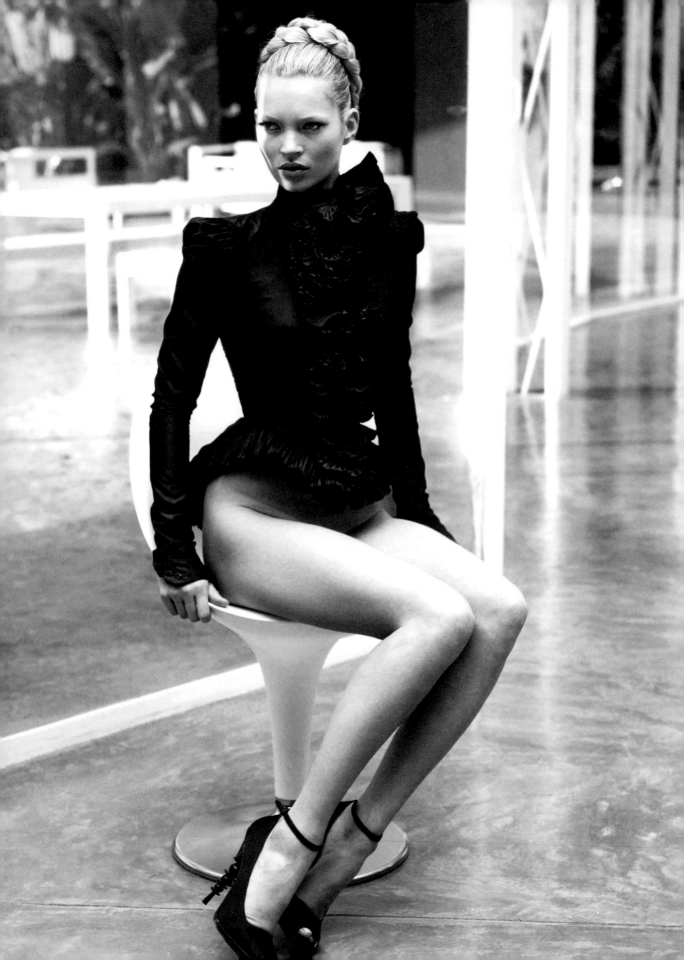

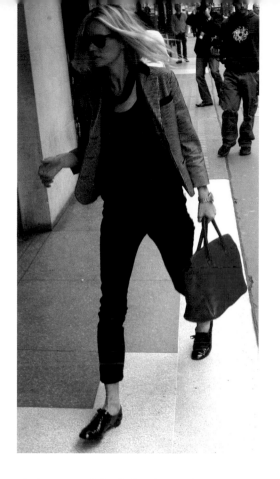

"**i** have a dress-up chest at home. I love to create this fantasy kind of thing."

—Kate Moss

clothes are polished, then her makeup is messy. If she's dressing minimalist, then her accessories are flashy. If her dress is frayed and fettered, then her hair is pulled smartly into a neat chignon. Kate's look offers the opportunity to avoid definition. When you get dressed, you can choose "retro-chic," with a midcentury vintage jacket and stilettos, or "hipster basic," with a worn band T-shirt, jeans, and a Burberry trench coat.

If you're not entirely comfortable switching fashion personas every day and prefer to emulate an Icon with a more consistent aesthetic, you'll find no better model than the late Gabrielle "Coco" Chanel. This couturiere, who established her first boutique in Deauville, France, in 1913, and popularized the vogue for tanned skin, the intermingling of costume and precious jewelry pieces, and used men's jersey as a women's suiting fabric,

has had an immeasurable impact on modern dress. Though the coordinated boxy tweed jackets and straight skirts still associated with the atelier today didn't enter Chanel's collections until the mid-1950s, Coco's straighter, more modest nubby tweed and jersey cardigan ensembles had already become the rage of Paris by 1920. The designer worked very carefully within a restrained palette during these early years, providing ivory, black, and navy tiered lace and chiffon evening gowns with picot-finished hems to complement day dresses of beige and black crepes of either wool or silk, depending on the season. Chanel premiered her little black dress in 1926, which was quickly dubbed the "Ford" by *Vogue* for its versatile applications and easy-to-copy construction. Chanel produced a sort of luxe sportswear: separates intended for pairing with

Opposite: Kate Moss, photographed by Mert Alas and Marcus Piggott for *W*, 2005. Above: Moss in cigarette pants, a striped blazer, and patent leather walking shoes in London, 2007.

30

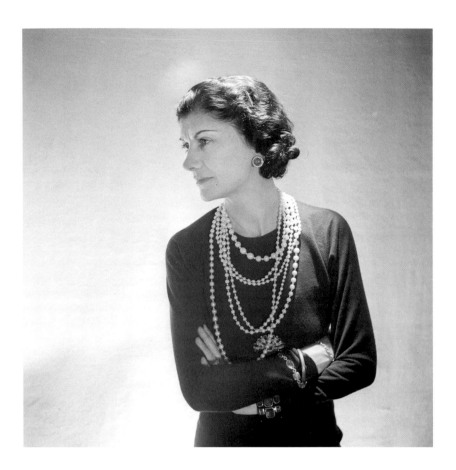

Right: Coco Chanel in a simple black shift adorned with strings of pearls and costume jewelry. Pages 32–33: Carine Roitfeld, photographed by Hedi Slimane, 2008.

Verdura cuffs and fake pearls, quilted handbags, and two-tone pumps. Her look was extraordinarily cohesive, but only because she admittedly modeled all of her designs in her own image.

Despite the fact that the details of Chanel's youth and career are a constant source of interest for films such as *Chanel Solitaire* (1981) or *Coco Avant Chanel* (2009), or for an extensive list of books, which includes Axel Madsen's *Chanel: A Woman of Her Own* (1990), Chris Greenhalgh's *Coco & Igor* (2003), or most recently, Justine Picardie's *Coco Chanel: The Legend and the Life* (2010), her story has always been somewhat obscured by the multitude of falsehoods that she perpetuated during her lifetime. Chanel literally reconstructed her upbringing and early career; this self-mythologizing contributed to the very style and

COCO CHANEL says

On Cut:

"A woman must never show her knees. They are the ugliest part of the body."

On Perfume:

"One should use perfume "wherever one wants to be kissed."

On Luxury:

"Luxury must be comfortable, otherwise it is not luxury."

On Aging:

"Nature gives you the face you have at twenty; it is up to you to merit the face you have at fifty."

On Elegance:

"Simplicity is the keynote of all true elegance."

On Palette:

"Women think of all colors except the absence of color. I have said that black has it all. White, too. Their beauty is absolute. It is the perfect harmony."

substance of her fashion. As an orphan, a fact she romanticized, Chanel found it easier to impose her *pauvre chic*—a label created by rival Paul Poiret to describe her high-low aesthetic of easy separates. Chanel viewed her sartorial fame as an opportunity to reenvision her past, to recount the story of her life as she wanted it to be told.

If the career of Carine Roitfeld, the former editor in chief of French *Vogue*, is not as glazed in artifice and carefully cultivated as was Coco Chanel's, her signature style of sky-high stiletto heels, heavily outlined kohl eyes, and sultry dress or suit ensembles certainly is. During her six-year reign as the stylist for Tom Ford at Gucci and Yves Saint Laurent, Roitfeld's overt sexiness and eye for contemporary luxury bolstered Ford's own vision exponentially and veritably defined his now iconic genre in postmodern fashion. Roitfeld has acknowledged Ford's influence on her as well: "It wasn't until I started to work for Gucci in the 1990s that [my style] started to become clear to me. And that's because Tom Ford was pushing me to do the dark eye makeup, to wear high heels, and to keep things very simple and lean."

Quintessentially French in its embrace of staple luxury items such as "the perfect velvet pencil skirt," the oversize fur coat, or the classic black Burberry trench, not to mention lavish fabrics such as suede, bobbin lace, and cashmere, Roitfeld's angular, fashion-forward wardrobe has influenced countless contemporary collections, including those of Riccardo Tisci at Givenchy and Christophe Decarnin at Balmain, most notably. Roitfeld's clothing is impeccably tailored by someone she has labeled her "retoucher," who makes sure that every hem hits the right length on her svelte frame and that every seam lies flatly and neatly. Though *New York* magazine's Amy Larocca correctly identified Roitfeld's image as "svelte, tough, luxurious, and wholeheartedly in love with dangling-cigarette, bare-chested fashion," Carine is able to convey this aggressively expressive style through the accrual of classic pieces dressed up by luxury accessories and outerwear.

While Chanel created and produced her own wardrobe, Roitfeld's connections and her status as a key figure in global fashion have built hers: she has access to the work of a great many designers and rarely foots the bill for the lavish fashions she wears. Like Coco, Roitfeld keeps a laundry list of instructional quips on hand, such as advice on how to maintain beauty with age, but she rarely adheres to the dos and don'ts of dressing that Chanel once championed; Carine's style relies more on the changing looks of each season, even if her potent sartorial severity never wanes.

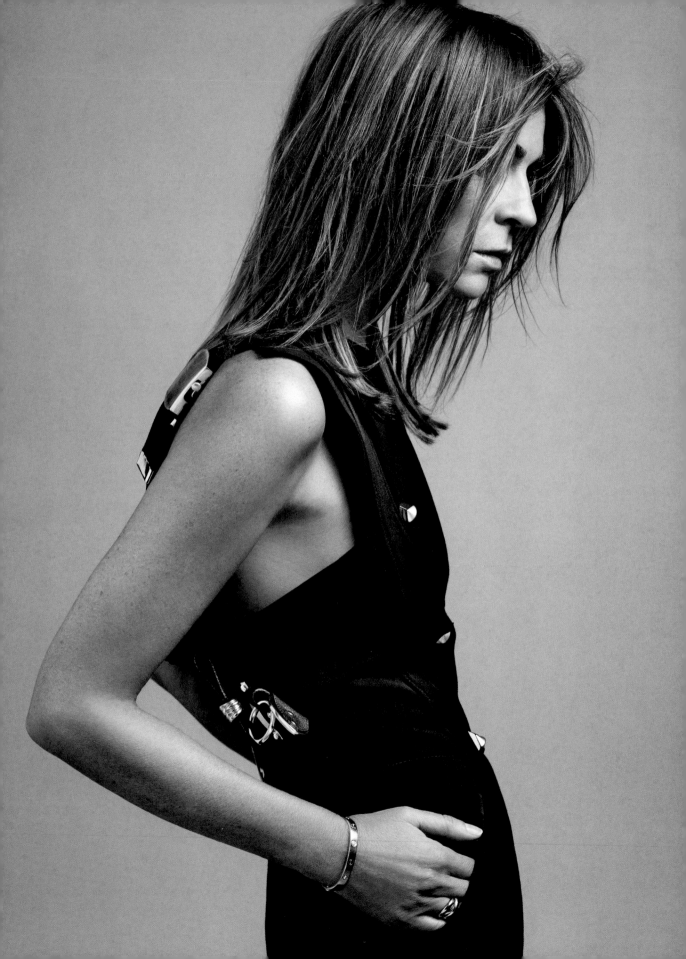

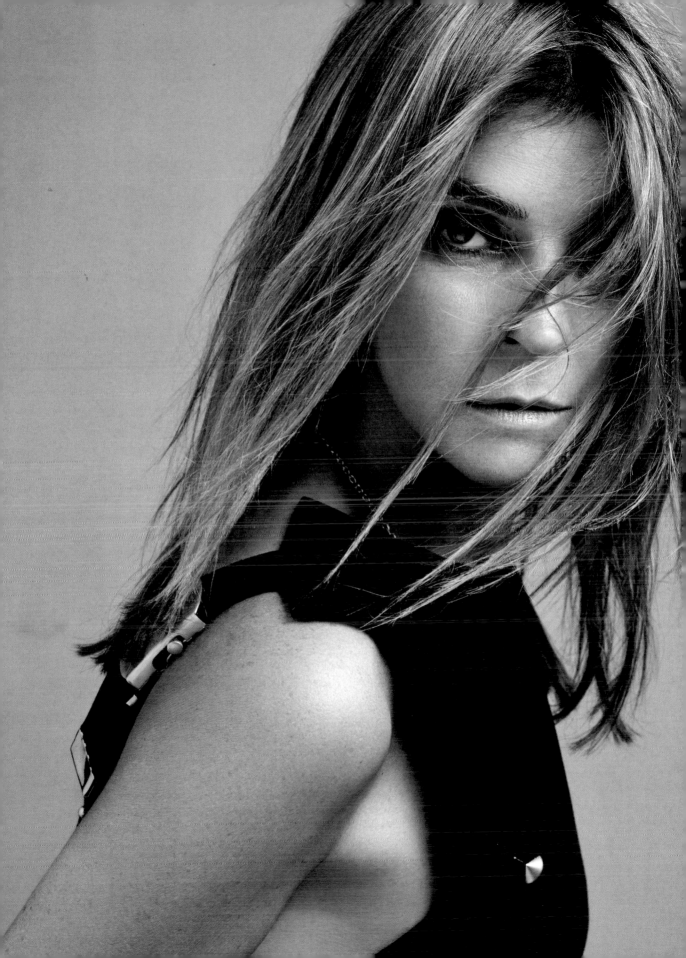

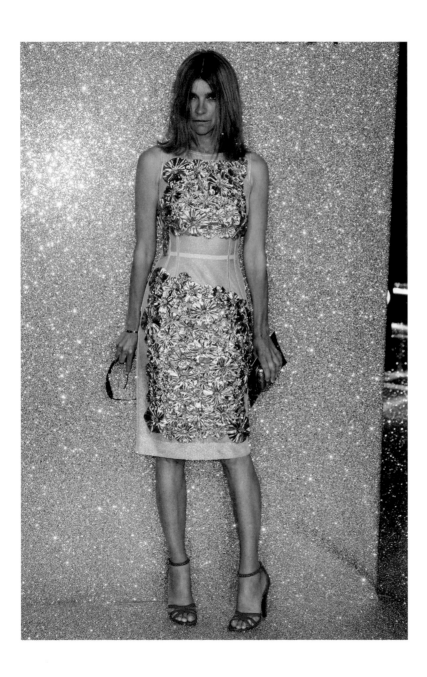

CARINE ROITFELD SAYS

On Makeup:
"I'm a black-eyes girl," but add a bit of white to the inner lid; it "lifts and opens [the eyes]."

On Handbags:
"You can wear a completely transparent shirt and show all the breasts—I don't care. But I prefer to have my hands in my pocket than to have a nice little bag. So I am not good for all these fashions. They have to sell bags, bags, bags, bags, bags, bags. I hate handbags."

On Underwear:
"Before, I loved strings. Now I hate strings."

On Jewelry:
"I hate watches. I never wear these things."

On Disposition:
"Never, ever frown."

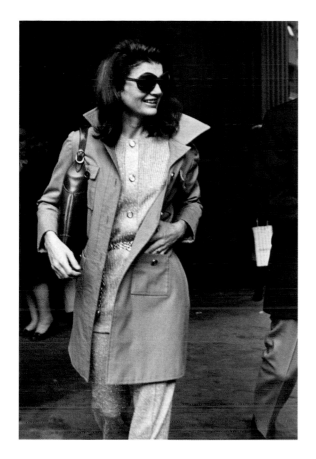

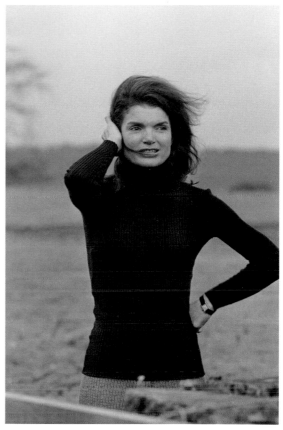

While Coco Chanel and Carine Roitfeld pioneered extraordinarily disparate looks—the former, buttoned-up, restrained, and modest, the latter, aggressive and sexually charged—the lesson to learn from these two is the same: whether you spend a lifetime cultivating your own mythology and reinforcing it with a distinct sartorial look, or you champion your own look and delight as it's adapted by others, it's important to be consistent: your style must make a cohesive, definitive statement about who you are. You might rein in your look by picking a specific palette, limiting your variation from one dress or suit silhouette, or even by wearing one or two designers exclusively. A signature perfume, accessory, or hair color also helps define an enduring style.

One of the world's most famous women of style, Jacqueline Kennedy Onassis, exerted this control by reinforcing specific separates and accessories throughout her lifetime in the public eye. She rose in popularity as a style Icon during her time in the White House, where her pastel Oleg Cassini columnar gowns, clean A-line dresses, suit ensembles, and pillbox hats reflected the neatly tailored look pioneered by couturier Hubert de Givenchy. But as her personal style evolved in the years after John F. Kennedy's assassination, she began to appear more relaxed and casual, and her signatures emerged in the forms of black turtlenecks, white jeans, beige trench coats, peacoats, wide-leg trousers, Hermès silk scarves, and large, round sunglasses—a shape

Opposite: Carine Roitfeld at the Cannes Film Festival, 2007. Above, left: Jacqueline Kennedy Onassis in a classic trench coat in New York City, 1970. Above, right: Onassis in an essential wardrobe staple: the black knit turtleneck, 1969.

that to this day is referred to as a "Jackie" frame. Anna Wintour, the formidable editor in chief of *Vogue* since 1988, swears by a pair of oversize sunglasses that differ only slightly from those the first lady once wore. The shades have long been a curiosity for fashion enthusiasts, and Wintour once explained that they are a sort of armor to obscure her reactions and allow her to move seamlessly through her high-profile appointment schedule without revealing anything to those with whom she is conferring.

Like Jackie and Coco, Wintour abides by very distinct style rules and, like Roitfeld, insists that a few luxury pieces each season is enough to convey one's dedication to fashion. As her position commands such authority and therefore requires an expertly controlled appearance, Anna relies on certain signature items that have defined her look for decades. Her clothing, at least for daytime, is somewhat conservative: she gravitates toward simple fitted sleeveless dresses or skirts with coordinating jackets, always inset with a designer label, and always current to the season. The garments generally cling to her diminutive frame, but unlike Roitfeld's clothes, never boast a high hem or a décolleté neckline. Wintour's look is all-business, and she effectively emulates the sartorial aspirations she has for the American woman as well. Wintour once said, "There's a new kind of woman out there. . . . She's interested in business and money. She doesn't have time to shop anymore. She wants to know what and why and where and how."

This "new woman" has learned as much from Anna's own wardrobe as from the magazines with which she's established her influence, including then-titled *Harpers & Queen,* British *Vogue, Savvy, New York, Harper's Bazaar* and, of course, *Vogue.* Wintour's style, including the signature blond bob that she's been wearing since age fourteen, have been revealed and codified for a broader audience in recent years, both in ex-assistant Lauren Weisberger's 2003 roman à clef, *The Devil Wears Prada* (whose antagonist is reputedly based on Wintour), and during the R. J. Cutler–directed documentary, *The September Issue* (2009), which traces the development of the September 2007 issue of *Vogue*— the largest in the publication's history. Though Wintour has been famously credited with urging celebrities onto the covers of fashion magazines, her real strength as an editor has always been in conveying timeless good taste and fashion know-how to a mass audience. If we can learn from Wintour's rigorously homogenous personal style and exacting editorial eye, the lesson is to educate oneself on the changing mores of high fashion so as to more finely tune one's own aesthetic sensibilities. Journalist Amanda Fortini at *Slate* observed, "Most of us read *Vogue* not with the intention

> "A newspaper reported that I spent $30,000 a year buying Paris clothes and that women hate me for it. I couldn't spend that much unless I wore sable underwear."
>
> —Jacqueline Kennedy Onassis

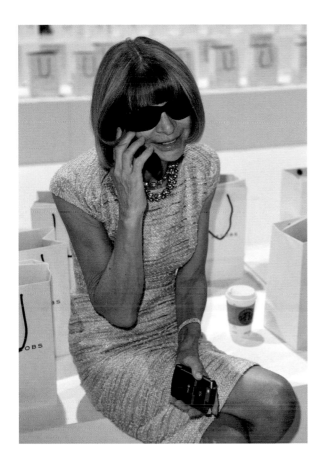

"You either know fashion or you don't."

—Anna Wintour

of buying the wildly expensive clothes, but because doing so educates our eye and hones our taste, similar to the way eating gourmet food refines the palate."

Anna and Jackie have, in different eras, occupied the same cultural role as the Icon's icon: their reputations are untouchable, their looks highly imitable, and their impact on the fashion world unarguable. The fashionable silhouette of each is so deeply ingrained in pop culture that both have had dolls created in their image. Anna's was a limited-edition configuration by artist Andrew Yang for Barneys New York's Fashion Night Out event to benefit the New York City AIDS Fund, and caricatured the editor in a neatly coordinated Chanel suit and bauble necklace, not a hair on her cloth head out of place. Jackie's doll was less exclusive; her

porcelain frame, manufactured by the Franklin Mint Company, was dressed in the first lady's iconic 1961 white sleeveless inauguration gown.

Whether alive or gone, endearing or intimidating, true fashion Icons impact generation after generation of fashion enthusiasts, imparting sartorial lessons: to embrace and celebrate fashion, no matter what the cost; to adapt a style that suits one's figure and one's reputation; and to establish the boundaries of one's own look so as to create a tangible aesthetic persona rather than an arbitrary assemblage of fashion acquisitions. An Icon strikes us all with the same awe: though her status and reputation might be unattainable, her look is singularly identifiable. The Icon is a legend in her own time and informs all of fashion as it moves around her.

Anna Wintour at the Spring/Summer 2010 Marc Jacobs runway show.

Move

RiCKS

"Don't look back.
Just go ahead.
Give ideas away.
Under every
idea there's a
NEW IDEA
waiting to be born."
—Diana Vreeland

dmit it, you're a little different. Everyone else may go for a classic black quilted leather clutch, but you head straight for the fluorescent pink crocodile briefcase. Your lipstick, toes, and fingernails aren't strictly matching in a "Putty" hue; they're painted "Salsa Red," "Luxury Lime Crème," and "Pistol Packin' Pink," respectively. While your friend might borrow your Chanel blazer to wear over a demure camisole and jeans, you usually use the jacket as a foil for a shimmering bias-cut gown. You delight in shocking those around you, whether with your outlandishly large costume jewelry or your itty-bitty minidresses. High school might have been a bit rough for you, but without your trailblazing style, Maverick, fashion wouldn't be nearly as much fun. As the writer Kurt Vonnegut Jr. quipped, "We are what we imagine ourselves to be." In other words, keep dreaming: before long, you'll be leading the pack!

When getting dressed, it might feel natural to pursue any and every aesthetic whim with the same aplomb, but it's important to apply a method to your madness. The trick is to rein in your exuberant instincts so that your look still makes a splash, but one in which dynamism and vision outweigh quirkiness. You'll most likely need a signature accessory or two, and sticking with one hairstyle—no matter how extreme—will certainly help ground your silhouette by giving it a central focus that all other magnificent elements can orbit around.

But how does one find her signature? Don't fret: you come from a long line of adventurous, inventive women who were nothing if not attentive to their stylistic legacies. Whereas the Mavericks of a bygone era may have embraced the gowns of Mariano Fortuny or Paul Poiret, today's pioneers-of-the-peculiar gravitate toward the work of Dutch duo Viktor Horsting and Rolf Snoeren (Viktor & Rolf), Karl Lagerfeld for Chanel, John Galliano, Philip Treacy, Stephen Jones, and the late Alexander McQueen. The Maverick has an eye for spotting talent and cultivating it, so be on the lookout for that obscure label that might just become the next big thing. The typical Maverick identifies herself readily with a wide breadth of artists and tastemakers, as she needs constant inspirational fodder.

Marchesa Luisa Casati, a veritable eccentric, icon, legend, and historical

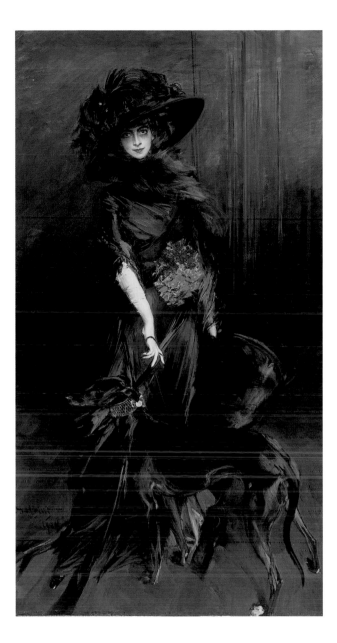

*Marchesa Luisa
Casati with
a Greyhound,*
Giovanni Boldini,
1908.

figure, was the quintessential Maverick and star of early twentieth-century European society. Nicknamed Coré, or the "Queen of Hell," by one of her lovers, the marchesa's look fit the part: a crop of red curls hung unevenly around her heavily powdered face and ignited her gaunt, pallid frame. Her lips were colored with vermillion, and she used poisonous belladonna, or "deadly nightshade," drops in her large, kohl-outlined eyes in order to dilate her pupils to achieve the desired blackened effect. Though the marchesa had a home in Paris—Le Palais Rose, so named for its extraordinary red marble—she most famously strolled the Venetian Grand Canal near her Italian mansion Palazzo dei Leoni in the nude, protected only by oversize furs and the pet cheetahs that she kept on diamond-studded leashes. Her tastes in jewelry were both refined (she was a star client at Lalique and is said to have inspired the Panther design at Cartier) and extreme: she wore lives snakes as ornaments on more than one occasion. Fortuny, Léon Bakst, and the costumer Erté were her couturiers, the latter of whom called her "the most extravagantly odd woman I have ever met." Above and beyond any preference for color (though she did tend to wear black, deep purple, and emerald green quite frequently) or pattern, Luisa insisted that her clothes emote drama: a full gown of peacock feathers or an evocative detail such as dress panels that sway—even high-cut neckties wrapped around her neck several times—looked quite natural on the marchesa's petite frame.

Although it's hard to forget someone so bizarre, the marchesa ensured that we never would: over the years, she commissioned over 130 works in her image from painters, sculptors, and photographers such as Augustus John, Giacomo Balla, Catherine Barjansky, Man Ray, Cecil Beaton,

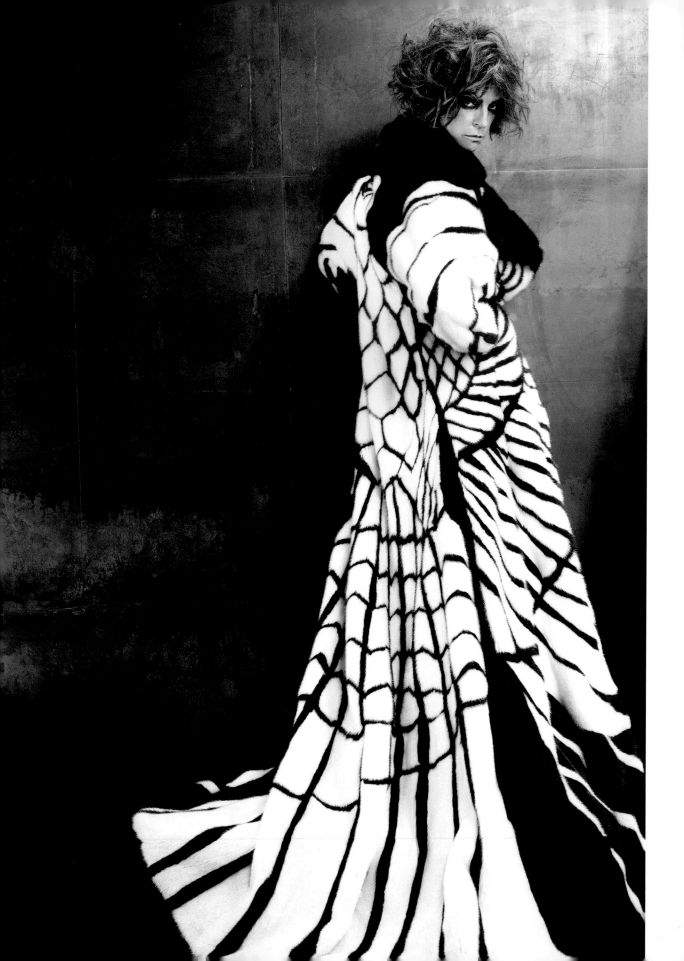

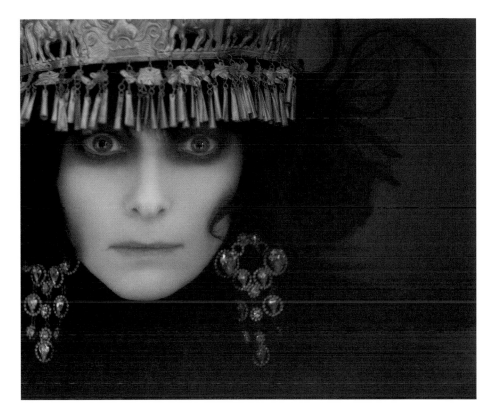

Opposite: Carine Roitfeld as Marchesa Casati, photographed by Karl Lagerfeld for *The New Yorker*, September 22, 2003. Right: Tilda Swinton as Marchesa Casati, photographed by Paolo Roversi for *Acne Paper* magazine, Fall/Winter 2009.

"I want to be a living work of art."

—Marchesa Luisa Casati

Umberto Brunelleschi, and Prince Paul Troubetzkoy, among many others. The marchesa's tombstone is engraved with Shakespeare's words "Age cannot wither her, nor custom stale her infinite variety"—a statement that rings true in the seemingly endless images of the marchesa that are created with each new generation of artists. A 1908 portrait of the marchesa by Giovanni Boldini served as the inspiration for John Galliano's eponymous 2008 fragrance. The bottle champions the same bewitching aesthetic as the marchesa's black satin Poiret gown, sable muff, large plumed hat, and violet waist sash, as rendered by Boldini. Tom Ford, Alexander McQueen, and Karl Lagerfeld have paid tribute to her in their collections; Lagerfeld's Resort 2010 presentation for Chanel revived this Maverick's wavy bobbed hair and kohl-rimmed eyes on models who walked coyly along the Venice Lido in dramatic black capes over skimpy maillots and oversize tricorn hats.

This wasn't the first time that the marchesa played Lagerfeld's muse. Seven years earlier he had created a portfolio of sketches and photographs for the September 22, 2003, issue of *The New Yorker*, one of which featured Carine Roitfeld outfitted as the marchesa (opposite), complete with a Poiret-esque trailing fur coat. Photographer Paolo Roversi's homage to the marchesa for *Acne Paper* in 2009 was even more haunting. Tilda Swinton was Roversi's channel: her wild hair and vacant stare are eerily reminiscent of the marchesa's own,

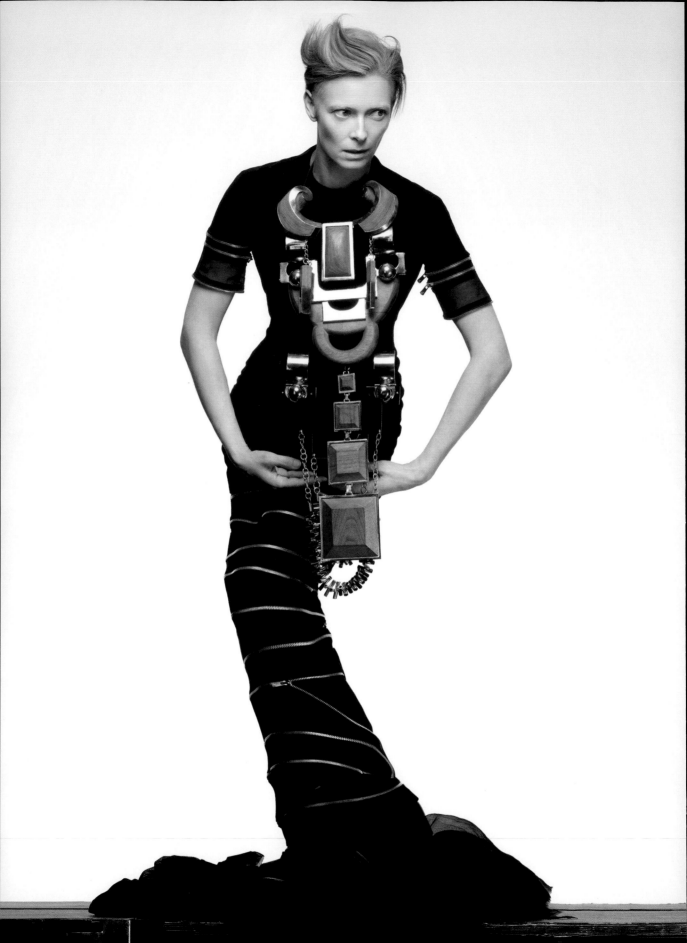

enhanced effectively with layered tulle robes and padded coats that certainly would have suited the marchesa's dramatic sensibilities. Swinton is perhaps the most poetic choice for emulating Luisa Casati: her vibrant red hair and penchant for embracing extremes, both personally and sartorially, suit her to take over the marchesa's long-standing reign over Maverick fashion.

Tilda Swinton similarly hails from a lofty lineage; her Anglo-Scot family can trace its heritage back nine generations to the High Middle Ages. A Cambridge graduate and member of the Communist party, Swinton has had an impressive career that began at the Royal Shakespeare Company but has evolved to include more than fifty films such as *The Chronicles of Narnia* (2005–10); *Michael Clayton* (2007), for which she won an Academy Award; *The Curious Case of Benjamin Button* (2008); and *I Am Love* (*Lo Sono l'Amore*) (2010). In keeping with her unusual looks, her roles have been that of eccentrics, experimenters, and champions of a life less ordinary. She has reflected upon her many characters as vehicles for their wardrobes: "As in life, the details of how any one individual expresses their relationship to the world around them are easily plantable in their clothes and the decisions, conscious and otherwise, they make when presenting themselves physically."

Swinton prescribes the use of clothing as communicator of one's artistry and individuality. She prizes creativity and exaggeration above restraint. Designers Viktor & Rolf honored Tilda's untethered expressiveness in their Fall/Winter 2003–4 collection, entitled "One Woman Show." As the models, each dressed to mirror Swinton herself, walked down the runway, the actress read a poem she had written that assured the show's attendees: "There is only one you. Only one." Though Viktor & Rolf are her most frequent costumers,

Swinton has also patronized the ateliers of Martin Margiela, Jean Paul Gaultier for Hermès, and Miuccia Prada for her dramatic couture wardrobe. She usually wears her hair short in a sort of slicked bouffant style, and her androgynous, angular features provide her a beautiful mannishness that is arresting. Unlike the marchesa, Tilda rarely wears makeup, enhancing her intense pallor, which stylist Jerry Stafford kindly dubbed "the skin of the Scottish highlands."

No matter how outlandish Swinton's outfit may be, her jewelry and accessories usually play a supporting role, never competing with the ensemble. This is an important distinction when exploring a more theatrical look: there has to be a balance between expressiveness and restraint. If your jacket is an unusual fabric and your earrings are huge, or your shoes are unwieldy and your hair is feathered within an inch of its life, your look becomes scattered rather than successfully impactful. Swinton allows the garment to be sculpture, so in effect, her body must be the withdrawn, vacant foundation from which to exhibit it. Hilton Als, the theater critic and writer at *The New Yorker* described Swinton as "one of the great thinkers, because she exists always in the realm of possibility."

As a Maverick, the "realm of possiblity" is key: if you're willing to experiment and be open to recognizing new talent and vision, your style will champion this freedom. When Isabella "Issy" Blow first started as Anna Wintour's assistant at *Vogue* in 1981, she brought her inventiveness and keen observational skills to the job. Wintour remembered, "Isabella wasn't too good at getting to the office before 11 A.M. . . . but then she would arrive dressed as a maharajah or an Edith Sitwell figure. I don't think she ever did my expenses, but she made life much more interesting." *Vogue* European editor at large Hamish Bowles

Opposite: Tilda Swinton, photographed by Craig McDean for *AnOther Magazine*, Spring/ Summer 2009.

recalled Blow's daring and wit when she wore a necklace that read BLOWJOB to a party at the Princess Michael of Kent's house. Blow was one of the first to embrace David LaChapelle's pornography-influenced snapshots of drag queens and Amazonian supermodels. She once immersed model Sophie Dahl in a bath of baked beans for an editorial shoot. She even paid a visit to Karl Lagerfeld's home in Paris wearing a Joan of Arc ensemble, complete with loose chains that trailed behind her.

Though Blow's style was certainly unpredictable, her signatures were unmistakable: a saturated application of a rich, dark lipstick and a dramatic, custom-designed hat. The editor once told her staff, "If you don't wear lipstick, I can't talk to you. You need to have lips. They are very important for getting men." The cosmetic company MAC didn't waste any time in exploiting Issy's attachment to lip color: they created a shade entitled Isabella and even partnered with the editor to launch her own line, Blow, in 2005.

The over-the-top signature is a must for any true style Maverick, as it's a definitive mark of originality. Between the hats, the sky-high heels, the bright red lipstick, the dark (or sometimes fire-engine red) bob, and the austerely tailored suits and dresses, Blow championed multiple signatures. She credited her obsession with millinery to her earliest memory: trying on her mother's pink hat at a young age. Blow's headdresses, usually designed by Alexander McQueen cohort Philip Treacy, would become her most beloved fashion accoutrements. Whether she was wearing a hat inspired by Dalí's 1935 masterwork "New York Dream—Man Finds Lobster in Place of Phone," a hat that literally talked back to her, or a hat of one hundred veils, Blow was instantly recognizable in fashion crowds. At a lunch, Nicholas Coleridge, the Condé

"**m**y style icon is anyone who makes a bloody effort."

—Isabella Blow

Nast International executive, once asked Isabella, "How are you going to eat?" Blow promptly replied, "That is of no concern to me whatsoever." Nonetheless Blow insisted that the purpose of her hats was a much more practical one: in a 2002 interview with Tamsin Blanchard of *The Observer*, Blow said that she wore hats to "keep everyone away from me. They say, 'Oh, can I kiss you?' I say, 'No, thank you very much. That's why I've worn the hat. Good-bye.' I don't want to be kissed by all and sundry. I want to be kissed by the people I love."

Those that knew Blow well concurred that the hats served as a sort of barrier between her and everything else. Tilda Swinton, too, has recognized the unique capability of fashion to serve as a dress-up uniform, not only to walk the walk and talk the talk, but also to provide a useful disguise when cultivating one's public persona. Blow once said, "If I feel really low, I go to see Philip [Treacy], cover my face [with his hats] and feel fantastic.... Wearing a hat is like cosmetic surgery." Blow's hats were intrinsic to her personal style, allowing her a sort of false anonymity; though it was often difficult to see her face, her extraordinary hats always championed her presence. The accessories announced her status as a fashion insider; she was the unofficial house model for both McQueen and Treacy and became known for her prophetic ability to discern talent in even a very novice designer.

After Blow's death in 2007, Anna Wintour told *New York* magazine, "No one had an eye like Issy . . . so whenever I got that phone call that Issy said I should see something, I would go." Having taken to heart her family's motto of *haud muto factum*, "nothing happens by being mute,"

Opposite: Isabella Blow in a Philip Treacy headpiece, photographed by Donald McPherson for *Vanity Fair*, May 2003. Above: Blow dressed as Joan of Arc, photographed by Tim Walker for *Vanity Fair*, 2007.

"I think you do have a more fun life if you wear beautiful clothes. There is a certain joy in it; dressing well is an art and it shows respect to be neatly turned out."

—Daphne Guinness

Blow was a tireless advocate of young talent and is responsible for discovering and championing some of the most significant tastemakers of contemporary fashion. She was the first to spot the brilliance of Alexander McQueen, purchasing his entire graduation collection from Central Saint Martins College of Art and Design in installments. Treacy has acknowledged the part Blow played in catapulting his own career: "She often saw herself as a piglet looking for truffles—we were all truffles to her. Me, Alexander McQueen, Stella Tennant, Sophie Dahl, all of us."

Like Marchesa Casati, Blow needed to seek out the vanguard in order to ignite her own passion and creativity. But if Blow rarely reaped the benefits of her advocacy financially, she was instead supplied with a vast and extraordinary collection of Alexander McQueen apparel and Philip Treacy millinery. Extreme fashion doesn't come cheap, so unless you have a very healthy bank account, you must be resourceful in order to achieve the stylish Maverick wardrobe. You might do like Blow and mine talent from local fashion or art schools; befriend a designer who will later provide you with appropriately inventive components to your wardrobe. Seek out sample and fire sales to locate those items that were too extreme for the average customer.

Oscar Wilde insisted that "anyone who lives within their means suffers from a lack of imagination." This adage seems to be doubly true for the Maverick, many of whom have amassed great debt (Marchesa Casati was in the hole for $25 million by 1930 and

died a pauper), but you don't have to break the bank to appear unique; you just have to be creative! The trick is never to abandon your signature style, whether attending an event or going for a walk around the block. As a fashion Maverick, you must always dress the part—you are both a stylist and a muse.

Isabella Blow's dear friend Daphne Guinness, heiress to the brewery fortune and ex-wife of Spyros Niarchos, son of shipping magnate Stavros Niarchos, once said, "You can tell the state of civilization by the way people dress. If the people who fought two world wars came back to 2010 and saw all of us running around in tracksuits, what would they think? It is just about being sloppy. And it is not about the money—it is a mind-set." Guinness purchased Blow's clothing collection in full to avoid its division and sale at Christie's. She called the collection "a diary, a journey of a life, and a living embodiment of the dearest, most extraordinary friend."

If Isabella's wardrobe configured an armor—a public disguise—then Daphne's personal style is honest, straightforward, and fearless. A Maverick in her own right, Daphne's signatures include heel-less platform shoes and an inverted Bride of Frankenstein hairstyle coiffed by Yves Durif. Of the shoes, she has said, "I found it inconvenient to have heels at one point. . . . These just made more sense." As for her offbeat locks? "When I think my hair needs a bit of help, I just glue another bit onto my head." The socialite and editor claims to have uncovered her true aesthetic persona after taking a clowning class in London, which proved an exercise in freeing her inner stylist.

Though Daphne, the mother of three, has never remarried, she has been romantically linked to the French writer Bernard-Henri Lévy, who once told the heiress, "you are no longer a person; you are a concept!"

Guinness's "concept" involves interminably short skirts and impossibly high heels, Chanel costume jewelry and capes, jackets and collars of feathers. The designer Valentino once told American *Vogue*, "We joke that we can find [Daphne] in London by just following the plumes scattered on the ground." If Daphne isn't befeathered, she's certainly wearing one of the jewel-encrusted corsets or large ruffled collars that Karl Lagerfeld produces each season at Chanel, or a head-to-toe leather gear ensemble from Gareth Pugh. Daphne is also quite close with the Mulleavy sisters of Rodarte, jeweler Shaun Leane, and Calvin Klein's Francisco Costa. When she attended the AIDS Community Research Initiative of America (ACRIA) benefit at photographer (and friend) Steven Klein's Bridgehampton estate in 2010, she wore Costa's silver metallic gown with a matching crinkled mantilla. The absurdity of Daphne's sartorial eccentricities aren't lost on her though: she told *New York* magazine at the event, "I'm dressed really weird. I do it for the old people who laugh at me in airports. You can only dress like this if you get the humor of it."

Opposite: Daphne Guinness at the Dorchester Hotel, London, 2010. Above: Guinness at the funeral of Isabella Blow, 2007

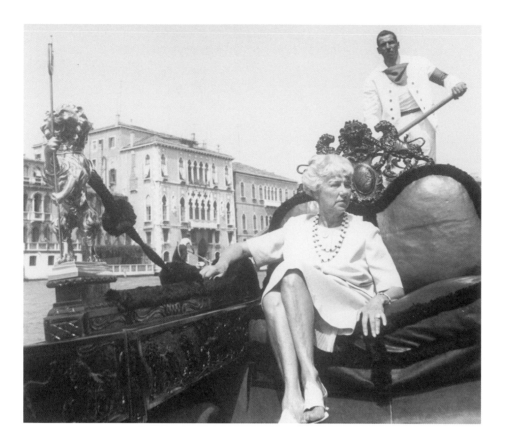

In fact, being a fashion Maverick does require a certain lightheartedness. Daphne doesn't take herself too seriously and doesn't expect others to either. When David LaChapelle photographed her wearing eerie white contacts, Guinness was heavily criticized for wearing them off the editorial set. In response, she stated, "When did some people become so boring? They don't have to look. I'm not selling anything! You would think … that I was a criminal."

Daphne is not the first heiress to be mocked for her creativity and slightly askew sense of personal style. Marguerite "Peggy" Guggenheim was well known for two things: her outrageous eyeglass frames and her massive collection of American art. Guggenheim and Daphne's mother, the Frenchwoman Suzanne Lisney, ran in the same social circles in the 1930s and 1940s. Both were friends with Marcel Duchamp, who advised Guggenheim on her first fine

art purchase in 1937. By 1938, Guggenheim had opened her own gallery in London, only to see it close the following year. With an impressive collection of art to offer, Peggy migrated back to New York and tried to accrue the funding to open her own museum in the early 1940s, but her efforts were foiled by the recession of the war. With each new endeavor, Peggy surrounded herself with new communities of artists and tastemakers. While she never believed in buying a lot of clothing, she was a loyal patron of Paul Poiret in the 1920s and would purchase a few key looks each year. As she built her reputation in the fine art community, her wardrobe became constructively simpler and more conservative to allow for lively prints by textile designer Ken Scott, gaudy statement jewelry by Alexander Calder, and the custom-designed bat-wing frames by painter Edward Melcarth that have secured her legacy.

Peggy Guggenheim in her private gondola on the Grand Canal, Venice, 1964.

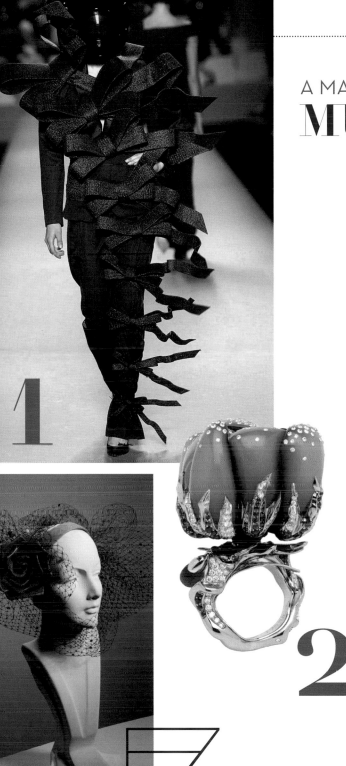

A MAVERICK'S
Must-Haves

1. Art as Dress

Whether you emulate the surrealist sculptural brooches of Schiaparelli's collections, stick your tongue firmly in your cheek with a vintage Moschino dress—perhaps one made entirely of bra cups?—or go all out with a gift-wrap or Russian doll ensemble by Viktor & Rolf, an assertive piece of wearable art demonstrates the Maverick's confidence and is sure to have onlookers gawking.

2. Elaborate Jewelry

Though some trendsetters prefer to go without when it comes to jewelry, an oversize cuff or intricate necklace can provide the ultimate Maverick fashion statement. A style Maverick in her own right, Victoire de Castellane launched Dior's Haute Joaillerie department in 1998 and has since produced oversize bejeweled cocktail rings, diamond-encrusted skull pins, and ornate floral brooches that, when paired with even the simplest dress, will identify you as a true fashion Maverick. If you're looking for something more reasonable than the Dior price tag, 1960s costume jewelry, with its baubles and shimmering stones, often packs the same aesthetic punch.

3. The Statement Hat

Before Isabella Blow held her hat high, Marie Antoinette glided about in her court robes with carved ships, exquisite combs, and exaggerated plumes decorating her powdered hair. Though there are a host of up-and-coming milliners in Paris, London, and New York, the fashion Maverick in the know tips her hat to the ateliers of Stephen Jones and Philip Treacy, respectively. Jones has created accompanying headwear for the collections of Christian Dior, Alexander McQueen, Vivienne Westwood, and Jean Paul Gaultier, among countless others. Though his toppers poetically complete even the most complex haute couture ensembles, the fashion Maverick might wear them with a T-shirt or tailored suit for maximum effect.

1) Viktor & Rolf ensemble, Spring/Summer 2005; 2) Victoire de Castellane ring; 3) Stephen Jones headpiece.

Like Guggenheim, Guinness is constantly trying to reinvent herself and look for new ways to channel her creativity. While Peggy tended to focus her attention more on fine art than fashion, Daphne has adapted her own highbrow aesthetic into various mainstream fashion and cultural enterprises. She created a clothing line for Dover Street Market and a signature scent for Comme des Garçons in recent years (both called Daphne), starred in advertising campaigns for NARS cosmetics and Akris apparel, and even produced the film *The Phenomenology of Body* with a soundtrack by LCD Soundsystem. She explained, "What I love doing most of all is collaborating with people and being the midwife, if you like, to their brilliance."

Though Daphne is strictly against "must-haves"—the antithesis of the Maverick's anomalistic wardrobe—her obsession with surrealism provided her with a yearning for Nicolas Ghesquière's robotic metal leggings, which were trendy during the Spring/Summer 2007 season. Many offbeat style makers are in essence surrealists, as the movement's fusion of cultural commentary and overt artistry lends to the Maverick's embrace of peculiarity and avant-gardism. Two of the most important fashion Mavericks are the surrealist-inspired designers Elsa Schiaparelli and Isabel Toledo.

Schiaparelli's first perfume was launched in 1937 and appropriately called Shocking. Though her first collection, "Pour Le Sport" was featured in *Vogue* in 1927 for its clever use of trompe l'oeil bow and scarf appliqués, the designer went on to create surreal broochlike buttons of fake insects, rams' heads, tambourines, and peanuts, which she affixed onto finely tailored crepe and twill opera jackets. In addition to her surface embellishments, Elsa's creations offered certain constructive innovations, such as a skirt that could be worn as a cape. As she was never the most beautiful girl in the room, Schiaparelli's clothing had to take center stage. She employed the venerable French House of Lesage to create her embroideries, and experimented with cellophanes, jerseys, and metallic threads to make her clothing more unique. She even created a "glass" cape in 1934 from the transparent plastic Rhodophane.

Elsa always viewed clothing as a sculpture—an artistic assertion—never simply as something to be worn and ignored. She worked with surrealists such as Salvador Dalí and Jean Cocteau, and famously created her 1937 "Lobster" dress as a tribute to Dalí's *Lobster Telephone*. Dalí and Schiaparelli collaborated on the "Tears" dress, which featured an ivory silk crepe textile painted with rips and tears and a matching veil onto which the two had affixed real torn panels. They also created the "Skeleton" dress, which was a simple long black crepe gown inset with quilting in the shape of ribs and a spine. Both "Tears" and "Skeleton" were part of Elsa's 1938 "Circus Collection."

MAVERICKS NEVER, EVER...

Wear a coordinated "total look" ensemble. Leave the sweater sets to those classic girls.

Turn down a designer gift: rely on the kindness of strangers!

Wear sweats out of the house. Your look should always be thoughtfully put together; the Maverick dresses for impact.

Abandon their signature: your token hat, shoe, bag, or color define your fashion legacy.

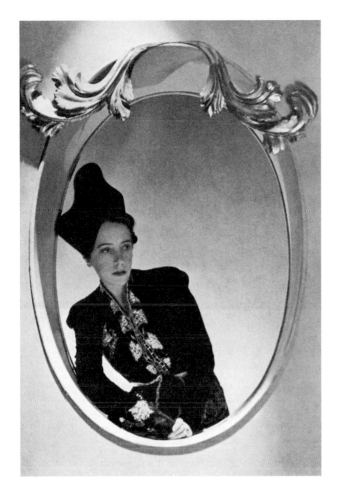

"never fit a dress to the body but train the body to fit the dress."

—Elsa Schiaparelli

Elsa Schiaparelli, photographed by Horst, 1934.

Chanel referred to Schiaparelli as "that Italian artist who makes clothes," belittling her ability to create wearable, well-tailored clothing. Though Elsa's collections were finely constructed, they offered something more: each piece was a work of wearable art that imposed the dictate of playfulness and novelty in fashion, even for the most formal affairs. Schiaparelli's work, as well as her personal style, set the precedent of showmanship for designers such as Alexander McQueen and John Galliano. As a style guru, Elsa inspires us to see our body as a base for elaborate, imaginative clothing. After all, a true Maverick always makes a statement.

Though Schiaparelli distinguished herself with overt artistic messaging, Isabel Toledo offers sartorial fodder for a more subtle

or thoughtful fashion trendsetter. In Tilda Swinton's recent film *I Am Love*, designer Raf Simons of Jil Sander configured a full wardrobe for her in which each garment's colors were coded by the character's emotions. Swinton explained: "[Raf] gave her a red dress to fall in love in, the extraordinary tangerine orange dress when she first encounters the Eden of the garden, and, at a particular, unmentionable moment of tragedy, a dress the color of marble, which subtly changes its shade— lighter to darker—from scene to scene, before and after the crucial event, as if becoming, in an instant, flooded with grief."

Toledo operates with the same covert messaging. She has said, "Colors are emotion." She works out of a pristine white studio that overlooks the contrasting

54

A portrait of
Isabel and Ruben
Toledo for *Paper*
magazine, 2009.

madness of Times Square in New York
City. Perhaps the city's frenetic nature
and eclecticism inspire her. Isabel's
designs utilize rich, complicated hues and
surprising textures that can't be worn by
the timid. "When a woman walks into a
place in my clothes, she's definitely going
to be noticed, which means she has to be
secure, because she takes up a lot of room.
I love to take up a lot of room. And look at
how small I am." Isabel is tiny, with graceful
features and soulful eyes that her husband
and creative partner, Ruben, describes as
"a poem that you can't quite understand."
As Isabel envisions the work, Ruben
illustrates it, and they inspire each other
in each new collection, without exception.
While Isabel's designs are architectural,
strong, and present, they are also pretty:
perhaps her most famous construction,
the chartreuse and gold brocaded suit
that First Lady Michelle Obama wore to
her husband's inauguration, conveys a

sense of splendor and newness. Like the
political force of the Obamas themselves,
the ensemble was an unexpected victory;
it was refined yet unarguably unique,
glamorous, and flashy, but not ostentatious.
 Isabel's long, straight black hair is often
pulled back into a tight bun or arranged
to fall precisely down her shoulders. She
wears little to no eye makeup, allowing her
black eyes even more visual resonance,
but her lips are, by contrast, almost always
a carefully applied cherry red. These strict
beauty rules provide a consistent template
upon which to build her unique clothing.
Isabel claims Hula-Hooping is her favorite
form of exercise. As a true eccentric, she
is her own muse and has compared her
creative process to being "an alchemist in
a lab." She believes that experimentation is
the path to creation. She once told *Paper*
magazine editor Kim Hastreiter that as
a child, her only clothes were hand-me-
downs from older sisters. As such, she

would cut and reconfigure the clothing so that the garments would be her own. Her clothes are often evolving works of art: one dress she contributed to the Fashion Institute of Technology's museum exhibit on Latin American fashion was covered in a gold foil that was crinkled and crumbling, ultimately to reveal a different textile beneath it. Toledo encourages us to be our own "alchemists": a Maverick must have her own vision as well as the willingness to embrace someone else's. If you want to "take up space," you must be conscious of your use of color, texture, and silhouette, as these components will work together to strike your pose.

If Schiaparelli and Toledo have respectively served as the Maverick's designer, Diana Vreeland and Diane Pernet are two visionaries whose critical eye has offered a unique perspective on fashion itself in recent years, informing our ability to hit the Maverick mark. Diana Vreeland, who lovers of fashion always refer back to with wonderment and delight, lent her exquisite editorial perspective to two fashion magazines (*Harper's Bazaar*, 1937 to 1962, and *Vogue*, 1963 to 1971) and the exhibitions at the Costume Institute at the Metropolitan Museum of Art (1971 to 1984). In fact, Toledo's dramatic flair for styling and skill as a colorist may have been sublimated by her tenure as an intern under Vreeland at the museum. Like Luisa Casati before her and Daphne Guinness since, Diana came into fashion from high society; she was the eldest daughter of an American socialite, a descendent of George Washington's family, a distant cousin of Pauline de Rothschild, and the wife of New York banker Thomas Reed Vreeland. Though she was a loyal patron at Chanel from 1926 on, Vreeland distinguished herself from other members of the international elite by establishing her own boutique, which offered lingerie selected by Vreeland herself. Diana was famously plucked from exclusivity by *Harper's Bazaar* editor Carmel Snow in 1936, after Snow saw her at the St. Regis Hotel in a Chanel gown with roses set into her hair. She offered Diana a job that led to the now-famous column "Why Don't You . . . ?"

"Why Don't You . . . ?" became the genesis for Vreeland's popularity and underscored the root of her fashion philosophy. The column made fanciful suggestions to the *Harper's Bazaar* reader such as "Why Don't You . . .": "wash your blond child's hair in dead champagne, as they do in France?" or "turn your old ermine coat into a bathrobe?" or "buy a geranium chiffon toque?" Though some of Vreeland's musings were more practical than others, they were meant to convey a grand theatricality. The significance of Diana's perspective was her belief that anyone and everyone could adorn themselves creatively, fancifully, and elaborately with the mere momentum of their own enthusiasm.

"I remember playing under a tall, heavy, black, magical sculpture that I pretended was a castle. . . . I later recognized it was a Victorian Singer sewing machine."

—Isabel Toledo

A champion of the word *pizzazz* in the fashion editorial, Diana reinforced the grandiosity and exhibitionism of fashion. For the Yves Saint Laurent exhibit at the Costume Institute at the Metropolitan Museum of Art in 1983, she reputedly soaked the galleries with the spray of Saint Laurent's Opium fragrance, so that viewers would have an olfactory as well as visual experience. Even as an older woman, she clarified the role of the style Maverick as a visionary and trendsetter. She understood how to adapt to fashion and embraced newness. She once declared, "Blue jeans are the most beautiful things since the gondola." Diana's jet-black hair and red lacquered nails were legendary, as was her tendency to inhabit every space to the fullest. Her style was maximalist and exotic—littered with fashionable trinkets and treasures from around the world. Yet Diana's sartorial style was more conservative than one would have expected; a former *Harper's Bazaar* accessories editor described "her usual head-to-foot black cashmere sweater, black wrap skirt, the pointed shoes, now famous, that were polished on the bottoms. The hands were beautifully manicured, the hair just so. It was a helmet."

A more contemporary critic and style icon has recently appropriated this monochromatic black uniform, though with more panache. Premier blogger Diane Pernet is religiously devoted to black turtlenecks, blouses, skirts, and dresses. Her onyx hair is sculpted into a bouffant at front and pinned down only by an extraordinary black lace mantilla, secured in place with a silver beetle hairpin. Though she does have designer favorites such as the British duo Boudicca, Diane's clothing never boasts explicit branding. She is usually quite pale and wears only red lipstick. It's rumored that the only pieces she allows in her closet that are not black are her bathrobe (white) and various undergarments (blue, red). A pair of opaque cat's-eye Ray Ban–style sunglasses complete Pernet's innovative if slightly vampiric aesthetic, and they also inform the name of her highly regarded blog: A Shaded View on Fashion.

Diane's fixation on black began when she was a clothing designer, from the late 1970s until 1990. She explained, "I wanted to fade into my designs, and black became my only palette." Though Vreeland once fancifully pronounced (to Jackie Onassis, nonetheless) that "pink is the navy blue of India," Pernet panned the tradition of such color anecdotes in fashion commentary and simultaneously reinforced the potency of her own signature; she insisted, "Every year, someone writes, 'Navy is the new black,' or, 'Pink is the new black.' But there is no new black. There is only black."

A Shaded View on Fashion launched in 2005 after Diane's stints as a personality on CBC's *Fashion File,* an editor at *Joyce* magazine, and as "Dr. Diane" at *Elle.* Pernet now consults for Milan's White

"*t*he only real elegance is in the mind; if you've got that, the rest really comes from it."

—Diana Vreeland

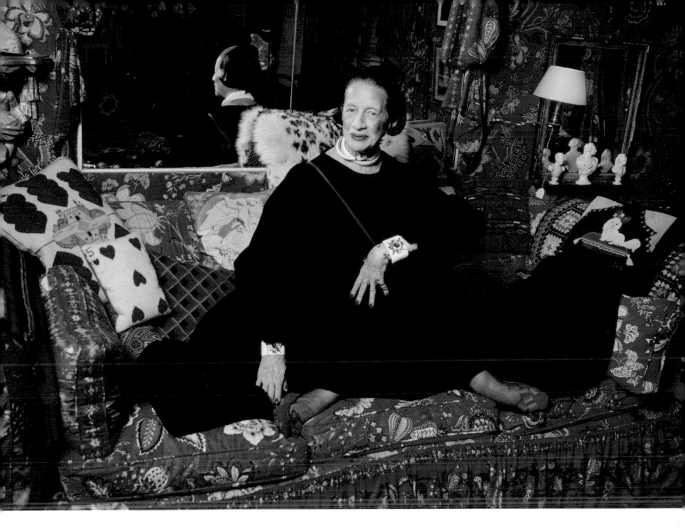

Club and is the coeditor in chief of *ZOO* magazine. Her voice has contributed to the runway criticism at all major fashion weeks, as well as gallery openings, brand launches, and other international fashion events. She is a requisite guide for the Maverick dresser, as she is comfortable identifying some of fashion's more offbeat designers as the next generation of visionaries. Diane has pointedly championed Bruno Pieters as well as CassettePlaya, the latter of who she dubbed "the de Castelbajac of her generation." In 2010, Pernet told Full Frontal Fashion television that she feels that "the secret to dressing well is finding your own style. Fashion is something that you buy, and style is a natural attribute—it has nothing to do with the seasons and everything to do with personal taste. . . . It's all about creating your own signature,

and I believe that is the same whether you are an architect, filmmaker, or fashion designer."

If you're a fashion Maverick still in search of your signature, you might consider dressing strictly monochromatically, like Pernet, or adapting a personalized accessory, not unlike Guinness's heelless shoes or Blow's statement hat. However, if you require a bit more guidance, look no further; Lady Amanda Harlech will show you the way. Harlech is a living fashion industry legend. She lives in an old farmhouse in the British countryside but stores her couture collection at her grace-and-favor suite at the Ritz in Paris. She studied at Oxford and considered doing a Ph.D. thesis on Henry James, but traded it for a career in fashion. Her title is somewhat under

Diana Vreeland, photographed by Jonathan Becker, in her Garden in Hell sitting room, 1979.

58

Above: Diane Pernet
in her signature man-
tilla, 2010. Opposite:
Amanda Harlech in
a Maison Michel hat,
photographed by
Karl Lagerfeld, 2010.

dispute, as she has been called "adviser,"
"consultant," and even "muse" in her
roles at the atelier of John Galliano
(from his graduation from Central Saint
Martins until his move to Christian Dior
in 1996) and now with Karl Lagerfeld, for
whom she is expected to be on hand for
the eight Chanel, four Fendi, and four
eponymous collections that the designer
creates each year.

It's no wonder that some of the most
visionary couturiers of our time keep
her around. Amanda Harlech could
make a trip to the grocery store sound
romantic, brooding, and delicious. She

has said, "If I do have a gift, it is as a map-
reader, a pathfinder." Though tempering
Lagerfeld's brand of futurist modernism
with her own romanticism is a full-time
job, Harlech has lent her aesthetics as well
to some of the most impactful fashion
editorials of our time, including very
recently a *Harper's Bazaar* spread entitled
"Peggy Guggenheim's Venice," in which
she acknowledges the impact of the late,
great collector and philanthropist.

In a certain light, Harlech seems a perfect
fusion of all fashion Mavericks who have
come before her and have arrived since: like
Guinness, Casati, Blow, and Swinton, she

exudes a palpable isolation and admittedly enjoys her independence, though amid throngs of fashionable admirers; she has no signature garment, per se, but she wears Chanel and Manolo Blahnik pumps religiously; she adores the exquisite vintage piece; she believes haute couture should be worn day and night; she is known for a tremendous collection of vintage garments that she—like Toledo as a child—tailors to make her own. Though she has always been well supplied with looks from the latest season, she wisely insists to those less fortunate, "If you love something, you should keep wearing it. It doesn't matter how old it is." As an example, she cherishes a Fortuny dress that belonged to her Great-aunt Helen for its "beautiful pewter pleats and hem frayed by her dancing shoes."

Dramatic and passionate, Amanda is in front of the camera when she is not behind the lens (most recently as a kimono-clad Kabuki performer on SHOWSTUDIO.com [2009] and as Wallis Simpson in Lagerfeld's short film *Remember Now* [2010], which he directed for the Paris-Shanghai collection). A true Maverick, she is driven and compelled by her judgment alone. Her advice: "Instead of buying the thing because everybody else has got it, maybe you should think as to what you really, really want. And why."

Though these Maverick mavens can inform you as you discover your own signatures and style guidelines, Harlech's words are crucial: the Maverick never follows the crowd. Mine your aesthetics from fine art, high fashion, vintage shops, and street style. Consort with artists, musicians, and designers. Find inspiration wherever you can and, in turn, be willing to inspire and incite the creativity of those around you. Above all, remember that the style Maverick is always on display, so make sure you dress the part!

"Never leave home without a pair of heels and a little black dress. Everything else you can invent. Or borrow."

—Lady Amanda Harlech

Rens

"SEX APPEAL is
50 percent what
you've got and
50 percent what
people think you've got."
—Sophia Loren

reek myth warns us of the Siren: her beautiful voice and exquisite physicality lure mariners under false pretense. She is a charmer, an enchantress, and in some cases even a femme fatale. As a modern-day Siren, you intuitively understand the art of seduction. You're no stranger to catcalls, whistles, or long, adoring stares. Your curves, which follow the hourglass mold, are perhaps best described as dangerous. Your body emulates that of Betty Grable, Jane Russell, or any number of 1950s Amazonian pinups, but your proportions can sometimes be challenging to dress and even trickier to flatter. Sack and drop-waist dresses are no-nos; they don't properly celebrate that tiny waist of yours! You can certainly do décolletage, but how low is too low? Your voluptuous lines can be irresistible, but they require a very specific style: suggestive and clingy, but tailored, cohesive, and sophisticated as well.

The Siren's wardrobe traces its roots all the way back to Eve and her strategically placed leaves, but the sartorial archetype found its footing in the nineteenth century, with formal black dresses, cinched-waist corsets,

pouter pigeon busts, and waterfall bustles. The belle epoque's gowns were meant to emphasize an erotic body, but there is hardly an image from this period that incited more controversy and outrage than John Singer Sargent's 1884 painting *Madame X*. The model, American Virginie Amelie Avegno Gautreau, was, like Sargent, an expatriate. She hoped to gain further footing in Paris's elite society by sitting for a respected painter. Though married, Gautreau was regarded by many as a "professional beauty" and used her charms to accrue invitations and gifts from the Parisian upper crust. The painter Edward Simmons claimed that she was so enticing that he "could not stop stalking her as one does a deer."

In *Madame X*, Gautreau presents herself as a prototypical style Siren: her voluptuous curves are mirrored by the table upon which she rests her hand; a vampish black gown clarifies her hourglass shape; and her gaze is averted, conveying both aloofness and mystery. A draped sweetheart bodice of black velvet shows off her ample bosom, thrust out to convey her sexuality. Her bare shoulders, covered only by thin gilded straps, incited public controversy upon the painting's exhibition at the Paris Salon of 1884, for Sargent had depicted

> ## "All women do have a different sense of sexuality, or sense of fun, or sense of like what's sexy or cool or tough."
>
> —Angelina Jolie

Virginie without implying the typical nineteenth-century underpinnings, thereby disregarding modest convention. The Siren, with her enticing body and palpable sexuality, is often the subject of scandal, which only adds to her allure.

The most chameleonlike modern-day Siren, Angelina Jolie, has often given fodder to the gossip rags, having worn black rubber pants and a white T-shirt with first husband Jonny Lee Miller's name scrawled in blood on it to their wedding ceremony; kissed her brother passionately in front of the world at the 2000 Academy Awards; and wore a vial of second husband Billy Bob Thornton's blood suspended on a necklace in place of a wedding ring.

Though Jolie first garnered attention for her roles in *Hackers* (1995) and *Gia* (1998)—in which she portrayed the movie's namesake, a bisexual model who died of AIDS in 1986—the actress catapulted into Hollywood limelight as a sociopath in the 1999 film *Girl, Interrupted*. To accept her Academy Award for the part, Jolie wore a vampiric, black silk mermaid gown; her hair long, straight, and jet-black; and her skin pale as the powdered face of Madame X.

Though Jolie's lithe frame, sizable bust, and pouty lips are hard to miss anyway, she has always emphasized her curves with clingy cotton T-shirts, camisole necklines, slip dresses, and tight leather pants. As Lara Croft in the *Tomb Raider* series, Jolie admitted to having worn a padded bra underneath her Lycra tank tops to mimic the exaggerated proportions of the legendary video game heroine. If the rocker must-haves of Jolie's twenties depicted her as a stereotypical bad-girl sex symbol, her wardrobe has recently become more conservative. A goodwill ambassador for the United Nations High Commissioner for Refugees (UNHCR), Jolie wears fitted sweater sets, lush cashmere wraps, and clingy

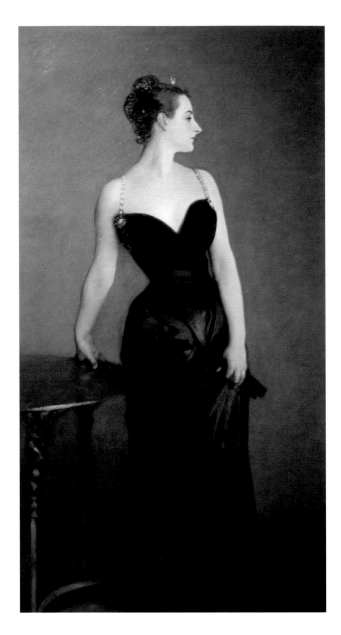

Above: *Madame X*, by John Singer Sargent (1884). Opposite: Angelina Jolie in an Elie Saab gown at the 81st Annual Academy Awards, 2009.

silk formal gowns. Though Angelina once insisted, "I am still at heart—and always will be—just a punk kid with tattoos," her sartorial style has evolved to become much more sophisticated. Whether in character in maillots and cocktail sheaths for *W* 's 2008 "Domestic Bliss" shoot with Brad Pitt or on the red carpet in elegant draped dresses, such as the canary yellow Emanuel Ungaro she wore to the 2007 *Ocean's Thirteen* premiere, Jolie has transformed her growl into glamour.

While Angie may be more stylistically reserved, she still knows how to maximize her assets. Stretchy, high-quality fabrics provide her blouses and tops the appropriate fit, and she is usually spotted in pencil leg or fitted pants to accentuate her lanky gams. If your hips are wider than Jolie's, make sure to pair those skinny pants with a top that is snug at the waist and hits the hip; this will help elongate your body and emphasize your enviable shape.

Though now a mother of six, Angelina continues to wear luxurious, body-skimming basics in mostly black; she even channeled Virginie Gautreau at the eighty-first Academy Awards in 2009 in a silk georgette sweetheart gown by Elie Saab. The ensemble, completed by stunning emerald jewelry from Lorraine Schwartz, provided one of those seminal pinup moments for Jolie: the Siren's star always shines the brightest (and her angles are the most alluring) in full-length formal wear.

Though Sirens have given us some extraordinarily memorable moments on the red carpet—from Rose McGowan's appearance in a totally see-through chain mail "dress" at the 1998 Video Music Awards to Jennifer Lopez's arrival at the 2000 Grammy Awards in a palm-frond-printed chiffon Versace, cut to reveal her navel (garnering major newspaper coverage worldwide the next day)—few have eclipsed the arrival of

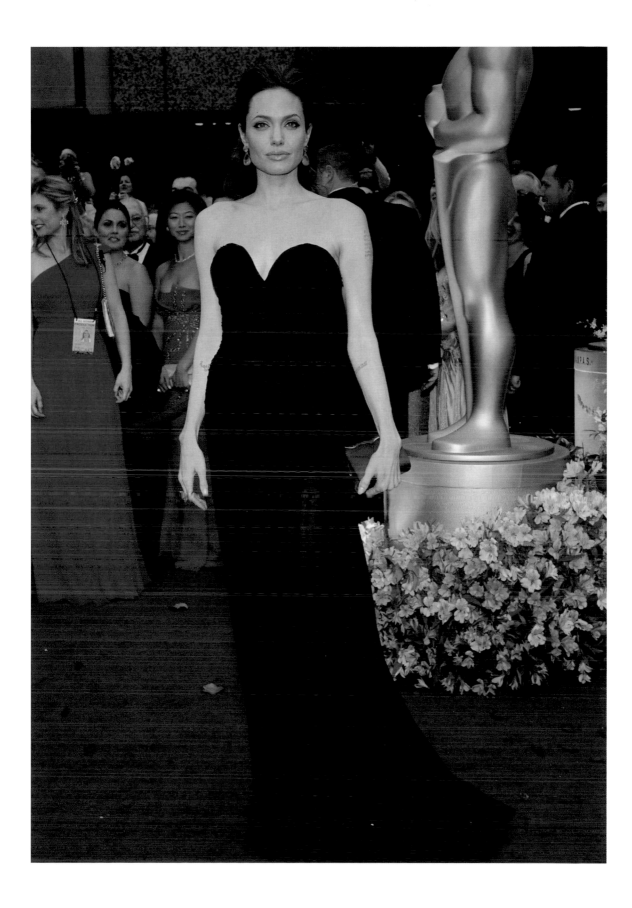

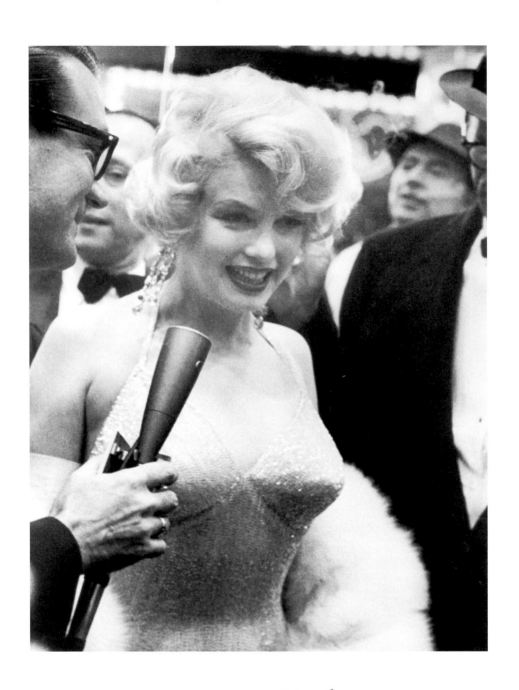

"**t**he body is meant to be seen,
not all covered up."

—Marilyn Monroe

Marilyn Monroe at John F. Kennedy's forty-fifth birthday bash at Madison Square Garden in 1962. Though costume designer William Travilla typically wardrobed Ms. Monroe, she commissioned the former lead costume designer for Columbia Pictures, Jean Louis, to create a "skin and beads" gown of silk and 2,500 rhinestones, which would reflect the stage lights as she sang "Happy Birthday" to the president.

Marilyn frequently glossed her lips and wore white, cream, and champagne-colored dresses to reflect light and "shine" for the public. These colors also flattered her platinum locks and fair skin. If Angelina's darkened palette implies her menacing appeal, Monroe's hues highlighted the actress as a glorious angel. One of Marilyn's shinier moments was on location for *The Seven Year Itch* (1955), when her white halter dress famously blew up over a steam grate, revealing both her gorgeous legs and her stunning full twirl skirt.

Marilyn had a sizzling reputation as a lingerie-clad mistress of many and appeared—more than most actresses of her time—nude in *Playboy* magazine and the Pirelli calendar. She even famously stated, "I've been on a calendar, but never on time." Nonetheless, she prided herself on a pristine and thoughtful sartorial exterior. The actress was reputedly sewn into dresses for her public appearances to ensure that the sheaths clung to every curve; she even instructed her tailors that each buttock should be separately framed in a skirt or dress. While not every Siren has access to a team of seamstresses, Marilyn's rigorous attention to fit demonstrates the importance of good tailoring and clean lines to flatter the hourglass shape.

Monroe famously dressed to attract. She explained, "I don't mind living in a man's world as long as I can be a woman in it."

She was careful to keep her porcelain skin out of the sun and embellished her simple wardrobe of pencil skirts, halter necks, slim-fit cardigans, and Capri pants with lavish white diamonds and cherry red lipstick as her flashy, eye-catching accents. Monroe's red lips, like her famous curves and slinky gowns, have remained a Siren stronghold to the present day.

The Siren typically wears a dark or rich lip color to emphasize her full, alluring mouth. In her book *Beauty Secrets for Dummies* supermodel Stephanie Seymour assured us, "Wearing red lipstick is all about finding the right shade. You'll find blue-reds, orange-reds, even reds with brown undertones. Don't get discouraged if you haven't found the right one. You may have to try several variations, but you will find one for you." Seymour's essentials also include the perfect underpinnings: as the brand ambassador for the French lingerie firm Chantelle, she can wax poetic about the importance of a great bra. She once told *Style.com* writer Maya Singer that she never wore bras in her twenties, explaining, "I didn't like 'em. Then . . . I learned." Stephanie, like many Sirens, has a large bust and a tiny waist, so the right bra or bustier can transform a potentially frumpy-looking dress bodice or top into a winning shape.

Seymour started her modeling career after moving to New York City at fifteen and was featured in the *Sports Illustrated* swimsuit issue just four years later. By 1992, Seymour had appeared in *Playboy*, become the face of Valentino, and signed on as one of the original models for the up-and-coming lingerie company Victoria's Secret. Her sharp features, searing blue eyes, full lips, and rich brown hair made her face unforgettable, but her curves won her raves as well. While short, full skirts and tight-fit tanks or bustiers helped highlight her hourglass shape in the 1990s,

Opposite: Marilyn Monroe at the premiere for *Some Like It Hot*, 1959.

Stephanie proved her figure was still up to snuff when she returned to the runway for Louis Vuitton in 2007, dressed as a sexy nurse in a transparent plastic medical coat. The model even inspired Italian artist Maurizio Cattelan to create a nude bust in her image, which juts out from the wall at the waist. One edition of the sculpture, which is entitled *Trophy Wife* as a tongue-in-cheek reference to Stephanie's marriage to real estate and publishing mogul Peter Brant, went up for auction at Phillips de Pury & Company in 2010.

Though few among us have Stephanie's killer body, we can certainly take cues from her intuitive sense of Siren style. She prefers vintage couture to contemporary designer brands, and kick-started the trend among celebrities for collecting fashion from Christie's International in London and William Doyle Galleries in New York, as such auctions offered a variety of 1950s-era dresses. The 1950s shapes highlight a slim waist and voluptuous bust- and hiplines.

Seymour does support contemporary fashion when it comes to the designs of her friend couturier Azzedine Alaïa. She is often seen on the red carpet or at private fashion and art openings in Alaïa's corset-waisted dresses and full skirts. The designer is well known for creating second-skin knits but has more recently manipulated leathers and heavy wools to configure more sculptural shapes. Stephanie has said, "Azzedine Alaïa is a classicist, possessing a total understanding of the architecture of the female form, of how to drape, and of how to use materials. He doesn't design for a season, he designs for a body." In fact, Alaïa's silhouettes draw a great deal from the 1950s ideal: the full-figured pinup girl. In a transcribed conversation between Stephanie and Alaïa in *Interview* magazine's March 2009 issue, the model asserted, "You want to wear Alaïa, you better respect that dress." When choosing the perfect Siren getup, let Seymour's words ring in your ears: if you find a formfitting dress, make sure to wear a supportive bra, slimming underpinnings, and a smile. If you take these careful steps, your figure—and your dress!—will look their best.

Sometimes, the perfect fit is so elusive that we have to take it upon ourselves to create flattering looks. Even before Victoria Beckham was dubbed the "Posh Spice" Spice Girl by *Top of the Pops* magazine in 1996, she was clothes- and glamour-obsessed. Although her tanned, toned Siren figure has successfully flattered beaded gowns and wrap dresses created by designers from Roberto Cavalli to Giorgio Armani, the songstress premiered her own dress collection in 2008 and has since cultivated a distinctly sultry—if sophisticated—signature for both day and evening.

Wife of soccer heartthrob David Beckham and mother of four, Victoria has written two books, one of which, *That Extra Half an Inch: Hair, Heels and Everything in Between* (2006), is a

SIRENS Never, Ever...

>> Wear A-line or sack dresses. Sirens need structured garments that flatter your shape, not hide it.

>> Go braless, unless the dress is fitted with serious built-in support.

>> Abandon their hair care regime; a Siren's tresses reinforce her power!

>> Be afraid to show a little cleavage, without going over the top. Use your assets; don't exhaust them.

>> Refrain from embellishing too much: a little glitz goes a long way. Choose a single piece of tasteful statement jewelry to pull your look together.

>> Dismiss a fur or feather trim; if you are antifur, faux fabrics do the trick as well.

Stephanie Seymour
in Christian Dior,
Paris, 2008.

how-to guide to adopting her fabulous Siren style. Beckham has guest-edited for *Harper's Bazaar*, collaborated with the Japanese store Samantha Thavasa on a line of handbags and jewelry, and launched a capsule jean collection for Rock & Republic. She then founded her own denim label, dVb Denim, in 2006, which also has an eyewear branch, as Victoria is a self-professed frames addict; she has said, "I'm quite obsessed with sunglasses. I collect vintage Guccis and Carreras—they can make virtually any outfit look cool." Beckham's style is a surefire shortcut to coolness in general: the singer-turned-designer is famous for her collection of Hermès bags, Christian Louboutin heels, and little black dresses.

Victoria's fashion credibility has been amplified in recent years by appearances on three different covers for *Vogue* editions from April 2008 to February 2009. When *Harper's Bazaar*'s Laura Brown interviewed her for the magazine in December 2008, the journalist posed an interesting question to her readers: "They say that to really understand somebody, you need to walk a mile in her shoes. But what if you can't actually *stand* in her shoes?" Though Victoria's footwear, with a five-inch-minimum heel height, is indeed hard to fill, she's made sure that her look is quite accessible. Her dress designs, executed in black silk gazars and wool crepes, complement the hourglass silhouette via internal corsetry, snug lines, and pencil or mermaid skirts. She also offers the zipper, which is accentuated from neck to hem at the back of many of her collection dresses, as a signature design detail, one that coyly challenges the observer to wonder what's beneath the closure. Victoria's look is sleek and cultivated; her example doesn't encourage spontaneity when dressing

"If you haven't got it, fake it! Too short? Wear big high heels, but do practice walking!"

—Victoria Beckham

but instead requires carefully engineered combinations of fitted dresses, high heels, and vintage accessories.

While Beckham's sophisticated silhouette is a contemporary benchmark for high-end Siren style, there are ways to flatter your figure without breaking the bank. If you enjoy a more laid-back look, then search no further than sex kitten Brigitte Bardot's wardrobe of sportswear separates for inspiration. An aspiring ballet dancer as a young woman, Bardot never left those comfortable flats behind, and she remains the only Siren icon who prefers low shoes to a sexy high heel. In 1956, she even asked Repetto, a well-known cobbler, to design a dance shoe for her that could be worn outdoors. She is credited with helping to popularize the bikini early on, when she wore it in Roger Vadim's *And God Created Woman* (1956). With tousled blond hair, an hourglass shape, and full lips, Brigitte, who starred in such controversial films as Jean-Luc

Godard's *Contempt* (1963) was the thinking man's Marilyn.

The actress, who once claimed, "I absolutely loathe luxury. It is the one thing I cannot stand," was always more at ease in Capri pants than pencil skirts. Though she may have been more casual, Brigitte still had tremendous sex appeal. She paid a great deal of attention to her bleached, luxuriously long hair. Though Brigitte often wore her hair down, in tumbling locks, she also frequently put it up in a sort of sloppy beehive hairdo, which later became known as the *choucroute* (or "sauerkraut"). She was also careful to line her eyes heavily in black kohl eye pencil, with a wing that extended out from the lid. Brigitte boasted a twenty-two-inch waistline and a large bust but preferred fitted knit sweaters and lightweight cotton tops to boned bodices or décolletage. In fact, she was so enamored of the boatneck—a wide slit that exposes part of each shoulder—that the cut is sometimes referred to as the "Bardot."

THEN & NOW

The doyenne of *la dolce vita*, Italian actress Sophia Loren has been wooing filmgoers for nearly half a century. In 2008, at the age of seventy-four, she agreed to model for the Pirelli calendar beside her costars from Rob Marshall's cinematic remake of *Nine*—Kate Hudson, Nicole Kidman, Penélope Cruz, and Marion Cotillard among them—and all of them decades younger. Though it's said that Loren once credited her envious curves to her love of spaghetti, she recently denied this assertion, dismissing it as "so silly! Can you imagine?"

While we may never know what "diet" has helped Sophia keep her hourglass silhouette, olive skin, enormous smile, and full, brown locks looking so good for so long, we can try to emulate her classic Italian Siren style. One of the most famous images of Sophia is of her in a sheer full-length black negligee for a brothel scene in *Marriage Italian Style* (1964). While this showed off a bit more than her offscreen ensembles, the actress was always careful to highlight her assets with low-necklines and fitted skirts. It's no surprise then to hear her sartorial advice: "A woman's dress should be like a barbed-wire fence: serving its purpose without obstructing the view."

The actress Monica Bellucci, exactly thirty years Loren's junior, channels the conspicuous sex appeal of the *Two Women* (1960) star. Bellucci, who posed nude during both her 2004 and 2010 pregnancies for the cover of Italian *Vanity Fair*, has compared herself to a "ripe pear." When Terry Gilliam directed Bellucci in *The Brothers Grimm*

(2005), he noticed that "immediately [when Bellucci] comes on-screen, it seems to me the whole film lifts up into another realm, a realm of sex and sensuality and danger. She reminds me of the old divas. . . . Italians create these women. I don't know how they produce them but they do, and they all seem to be incredibly smart, sensuous, and, strangely, they still keep their feet on the ground." Fashionwise, this sensuality translates to a collection of fitted black dresses with plunging necklines, a carefully selected lip color, and a healthy diet to maintain those curves. While Sophia might not owe it all to spaghetti, Bellucci is quick to embrace life's indulgences. In 2003, she told *Time.com*, "I see myself like any Italian girl, because everything is so Italian on me—like the way I love to eat." What else is Italian on Bellucci? A number of Dolce & Gabbana gowns, as she is a regular spokesmodel for the brand.

Opposite: Monica Bellucci, photographed for *Esquire*, 2001. Right: Sophia Loren on the set of *Marriage, Italian Style*, 1964.

This off-the-shoulder look is exemplified today by the style of *Top Chef* judge and cookbook author Padma Lakshmi. Perhaps as a reflection of her Indian heritage and the native sari wrap style, Lakshmi often chooses loose, one-shouldered free-fall gowns instead of tightly corseted dresses. Her makeup is natural and highlights her glowing skin tone. Lakshmi shares Brigitte's attentiveness to hair maintenance, as she knows that long, wavy locks are key to achieving contemporary Siren style. Padma has gone on the record about how she achieves her gorgeous cascading waves: she sprays sections of hair with volumizer, then rolls each up (not under) in a curler and leaves it to set before brushing it out into loose twists.

Padma has become a visible figure in the fashion scene over the last decade, due to her high-profile marriage to (and then divorce from) award-winning novelist Salman Rushdie, her contributions to *Vogue* and *Harper's Bazaar,* and the success of her exclusive gold jewelry collection, "Padma." She told *The Guardian* in 2006, "I love clothes, but really I don't have that much to say about skirts. Before I was writing, I went to fashion shows only when the designer was a good friend and I was there to show support." Padma, like Brigitte, channels her zeal for high fashion by practicing rather than preaching. Her vibrant and eclectic dress collection boasts rich purples, reds, and blues that seem to mirror her passionate embrace of food and cooking. Overall Padma has encouraged women to embrace voluptuousness and even dress it up, rather than try to restrain or neutralize the hourglass shape.

Georgina Chapman, one half of the fashion brand Marchesa and wife of film industry mogul Harvey Weinstein, encourages a similarly vivacious sensibility. Though Georgina's designs are often clarified in a conservative palette, her own

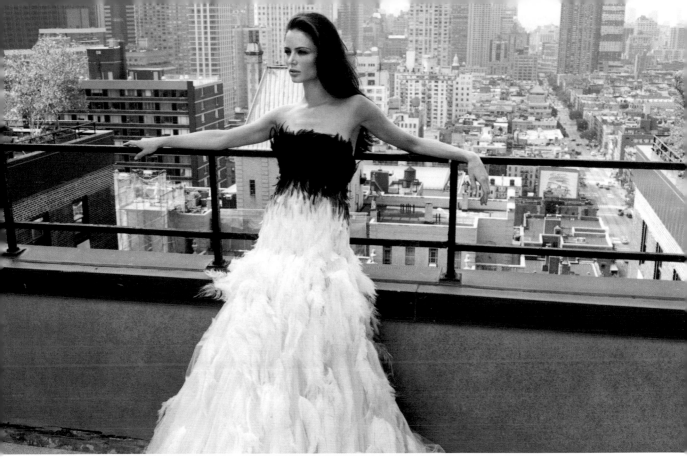

wardrobe includes flirty cocktail dresses in rainbow colors, from daring reds to baby blues. Though sexy blacks and angelic whites are the Siren's preferred tones, a rich fuchsia or chartreuse can demonstrate the confidence necessary to take style risks. Georgina wears dresses of rich duchesse satin or those encrusted with jewels; her look screams "I am not a wallflower!" She typically tempers her dramatic dress code with simple hair and makeup: her long brown locks are softly waved or blown straight, and her eyes are outlined, though not to hyperbolic effect. Her cupid-shaped lips are typically painted a muted red. If Georgina is dressing for a business luncheon, she does wear a fitted palazzo pant, pencil trouser, or tailored blazer, but she makes sure to bring out her livelier side with an oversize brooch or bright silk blouse.

In her fashion collections for Marchesa, Georgina often includes some internal corsetry to ensure that her client's curves are well contained. Her work is more romantic than Victoria Beckham's sharp-as-a-knife aesthetic. Though the mythical Siren was more villain than goddess, Chapman brings out her otherworldliness with Grecian-style silk georgette and gazar evening dresses built for the truly divine. The name "Marchesa" is an homage to Luisa Casati, so it's no surprise that the brand offers more feminine, fettered alternatives to the conservative tailored pieces championed by Angelina Jolie and Stephanie Seymour. Frilly details such as rose appliqués at the bust or gilded embroideries at the hem infuse whimsy and dynamism into straightforward empire dress lines. Georgina's handwork is exquisite, a reminder that the Siren is nothing without her powerful feminine side. While an evening gown may not be a high priority on your list of must-haves, you can achieve the charm that Georgina offers with costume jewelry or belt accents.

Opposite: Padma Lakshmi in her New York City apartment for *InStyle*, May 2009. Above: Georgina Chapman, photographed for *Vanity Fair*, 2008.

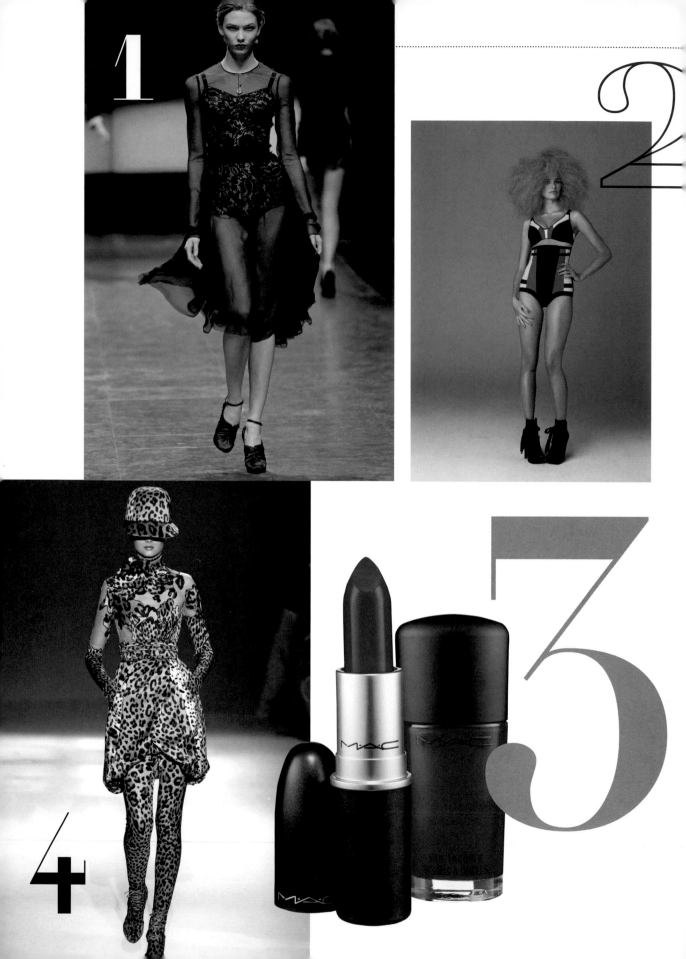

1

2

3

4

A SIREN'S
Must-Haves

1. **A Sexy Black Dress**
 While every Siren has her own style, the little black dress is a must-have for any curvy fashion maven. The right black dress can straddle the sartorial lines of etiquette between day and night, sexy and sophisticated, revealing and more buttoned up, and provides the Siren with a versatile foundation from which to dress up the look with a lush stole, glittery brooch, or sequined belt.

2. **Cleavage-Enhancing Undergarments**
 If you're well endowed, and actually, even if you are not, it's important to give the bust shape and definition with a properly fitted bra. There are many lingerie shops that specialize in fitting bras, and consulting them is well worth the investment in time and money. Though it may seem counter intuitive to buy something padded or with a foam cup, a push-up bra is often the best way to secure your cleavage and give it impeccable presentation in a low-cut or formfitting gown.

3. **Red Lipstick**
 A Siren's lipstick enhances her already pouty mouth and provides another eye-catching accent to draw attention to her irresistible look. Some Siren icons have even created their own makeup: Georgina Chapman, along with her Marchesa partner,

Keren Craig, collaborated with Stila to launch the Backstage Beauty collection in 2008, which included Chapman lipstick in sheer red. Though your lipstick might not carry your name, experiment with a range of different tones and glosses until you find the color and saturation that suits your skin tone best.

4. **Stretchy Foundation Garments**
 Obviously we're not all in need of a cut-in-one leather, vinyl, or rubber suit like the one Michelle Pfeiffer wore when she played Catwoman in *Batman Returns*. But the fashion catsuit, as a one- or two-piece ensemble that is fitted from head to toe, can really flatter the Siren's figure. Jean Paul Gaultier is a master of the luxury catsuit, but if you're looking for some shimmery leggings or a stretchy bodice for less, then dance or active-wear brands can offer you an affordable second skin upon which to layer flirty miniskirts or tailored blazers.

1) Black lace dress by Dolce & Gabbana, Fall/Winter 2010–11; 2) Cynthia Rowley SLIM shapewear, Fall/Winter 2010; 3) MAC Russian Red lipstick and Rouge Marie nail cream; 4) Leopard ensemble by Givenchy Couture, Fall/Winter 2007–8.

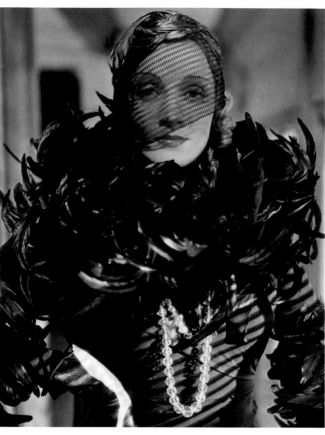

"Darling, the legs aren't so beautiful, I just know what to do with them."

—Marlene Dietrich

Georgina Chapman is a proponent of what Neiman Marcus fashion director Ken Downing has called "high-impact glamour." Glamour is intrinsic to the Siren's wardrobe, and has been since the 1930s and 1940s with the rising popularity of silver screen goddesses and high-end burlesque performers. Marlene Dietrich, the German actress well beloved as one of the most alluring cinematic femme fatales of all time, often adapted her screen looks into a personal wardrobe that was nothing if not dramatic. Her Siren persona, developed by director Josef von Sternberg and costumer Travis Banton on countless films, was conveyed alternately with clingy nude dresses and austere men's tailoring: sometimes the best way to emphasize the feminine is to gender bend with menswear. Dietrich's adaptation of the two- and three-piece suit, complete with 1940s fedora,

affirmed the potency of the "reveal." In *Shanghai Express* (1932), one of Dietrich's ensembles was framed in black crow feathers that danced as she moved. The look was finished with a black veil, which affirmed her role as a woman of mystery. In his novel *Arch of Triumph*, Erich Maria Remarque, an old friend of Marlene's, and an avid admirer, described the actress's "cool, bright face that didn't ask for anything, that simply existed, waiting— it was an empty face, he thought. . . . One could dream into it anything. It was like a beautiful empty house waiting for carpets and pictures. It had all possibilities—it could become a palace or a brothel."

When bedecked in blinding jewels, titillating furs, and swaying feathers, the Siren's appeal is both potent and enigmatic. Such trims and veils provide a good way to attract attention and keep it

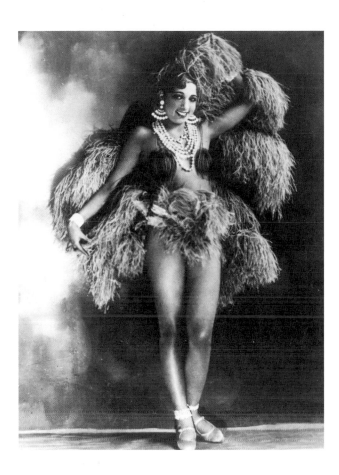

Opposite: Marlene Dietrich in a femme fatale costume by Travis Banton on the set of *Shanghai Express*, 1932. Left: Josephine Baker in a *Folies Bergère* costume, Paris, circa 1930.

while still being somewhat elusive. Like Dietrich, the dancer Josephine Baker boasted costumes of fluttering ostrich plumes, which revealed and concealed according to her movement. Influenced by the Art Moderne, Josephine dressed in satin gowns with clean lines offstage, and saved the feathers for her cuff trims rather than her bust cups. She was alternately nicknamed the "Bronze Venus" or the "Black Pearl" by American audiences but was simply called "La Baker" in Paris, France. Josephine was most well known for her work in *La Revue Nègre* and *Les Folies Bergère*, and for her notorious "Danse Sauvage," and she always wore her short hair slicked down and back, so as not to distract from her gorgeous face or voluptuous body. She wore deep red lipstick and smoky eye shadow when performing her irresistible striptease.

"I wasn't really naked. I simply didn't have any clothes on."

—Josephine Baker

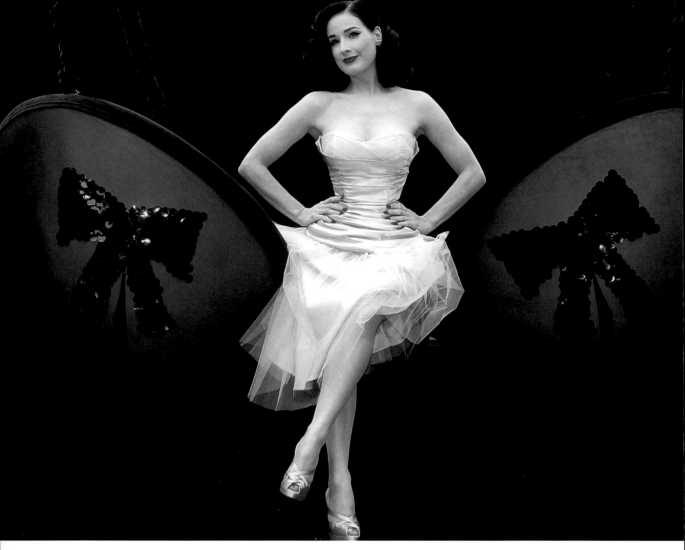

Dita Von Teese
at the launch of
her WonderBra
collection in
Covent Garden,
2008.

Though not all Sirens feel confident onstage, the allure of the burlesque show ensemble is something we can learn from as we dress for an evening out. Showing off your shape rather than covering it up demonstrates that you are comfortable in your own skin, Siren, but too much cleavage or leg looks desperate and tacky. Though both Dietrich and Baker were engaged in a dance of attraction with their audiences, and used their clothing or lack thereof as a means to charm, contemporary burlesque performer and fashion icon Dita Von Teese envisions her wardrobe as a vehicle for self-empowerment. She explained, "I found that dressing in a unique way made me feel less ordinary and more glamorous."

Dita's jet-black hair, pale skin, red-lipped pout, and sexy curves mirror those of her pinup heroine, Bettie Page. Dita grew up in a lower-middle-class home in suburban Michigan as one of three daughters, and embraced her mother's love of film from Hollywood's golden age. Silver screen starlets such as Dietrich

Dita
says

On her look:
I have always tried to emulate the classic "femme fatale." For reasons that I cannot altogether explain, I am enthralled with clothing of different eras, particularly the 1930s and 1940s. If it were reasonably done, I am quite sure I would also love dressing in Victorian, Edwardian, or seventeenth-century dress, too. Thank goodness I'm a showgirl, which helps me act out my fashion fantasies!

On fashion and beauty rules:
When you imagine that there was a time that Marlene Dietrich was not allowed in certain hotels for wearing trousers and suits, and that once upon a time, wearing chic menswear was a big no-no, well, that is a lesson right there of the importance of breaking the rules.

My rules are mostly about wearing things that suit my body shape and not coveting anyone else's style. It's easy to get caught up in someone else's fabulous look, but a stylish woman knows that it's okay to appreciate that look without needing to wear it herself. I generally don't wear skirts above the knee. I am constantly taking down hems to more flattering lengths or requesting designers to drop the hemline of a dress. I have definite ideas about proportion. I also have nearly all of my clothes tailored. I wear a lot of vintage, and you simply cannot expect to wear vintage as is, off the rack.

On the must-have fashion item she can't live without:
I have several perfectly tailored, sexy yet elegant black dresses that I wear many different ways by adding vintage brooches, gloves, a hat, and jewelry. Many of them are 1940s- or 1950s-era dresses that I bought for between $60 and $200, and they look very chic with the right tailoring.

The perfect, well-made black pump is essential. Investing in one great pair of Christian Louboutin shoes is a smart fashion move, and they will be well worth the splurge if you take care to have them resoled and cared for by a good cobbler who can even resole them in that signature Louboutin red, so you never lose that sexy red sole that shows that you care about quality!

On muses:
[If I could be the muse of a designer past or present, I would probably choose] Mr. Dior. I admire his models—like Lisa Fonssagrives and Dovima—all those amazing women that came to shoots having done their own hair and makeup, exuding glamour even on the street. They were real women who knew how to make the clothes look beautiful. They never would have shown up in jeans, barefaced!

On her style mentors:
I admire eccentric women who have dared to be different, like Isabella Blow, Anna Piaggi, the Marchesa Casati, Daphne Guinness, and Marlene Dietrich. I think that Hollywood is overstyled, and it takes a lot of the fun out of fashion. If fashion isn't fun, it's nothing!

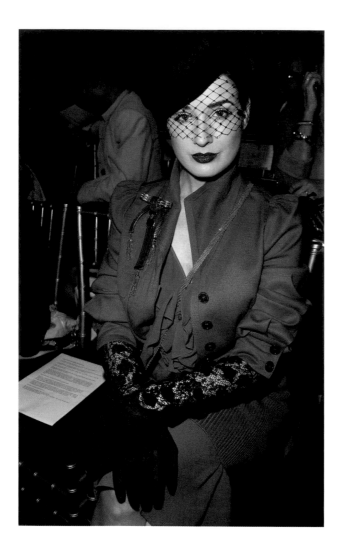

and Grable taught her the importance of a key accessory and a sexy dress: Dita told *Vogue.com*, "I have a huge collection of hats—I have a whole room dedicated to them so that's a lot of hat. Wearing a hat says: 'I have confidence and I don't mind if people are looking at me.'"

Dita is a regular patron of Christian Dior and Marc Jacobs, even appearing in Vivienne Westwood's Spring 2005 advertising campaign and on the runway for Jean Paul Gaultier's haute couture show in 2007. She smartly sticks to what works, and her clothes are tailored perfectly to her figure: fitted jackets with waist sashes, peplums to the hip, and matching pencil skirts.

Dita began doing striptease in 1993 and often incorporates extravagant props such as a carousel horse, a giant face powder compact, and an oversize martini glass into her act. She draws on inspiration from Sirens past and present: she "shined" like Marilyn in $5 million worth of diamonds for a striptease at the New York Academy of Art, and she regularly does a Josephine-style fan dance with oversize feathers in her routine. She also preaches the importance of quality underwear: "I've never equated beautiful lingerie with seduction or sex. It's not about trying to get a man. Not at all. It's about surrounding myself with beauty in my everyday life—whether it's a bra or a notebook."

In fact, if a bra or camisole is ornamental enough, it can peak out from underneath a fitted blazer or sweater to tantalizing effect. Similarly, embroidered hosiery can transform a black skirt suit from conservative to come-hither. These details never go unnoticed. Dita's style is high maintenance: perfect pinup hair, sultry makeup, and sexy, custom-made undergarments hold up her designer duds, no matter the occasion. She endorses

> "It's not about seducing men, it's about embracing womanhood."
>
> —Dita Von Teese

and subscribes to Helena Rubenstein's sage advice: "There are no ugly women, only lazy ones."

Another Siren of the stage, Beyoncé Knowles, reinvigorated the catsuit—a cult undergarment—for her appearance on NBC's *Today* show in 2008. The singer and actress's shiny black stretchy one-piece rounded every one of Beyoncé's curves and was finished by a wide black belt for focus. The design, though chic and perfect for performative movement, sits in stark contrast to the singer-actress's typical stage wardrobe of tailored and embroidered gowns and maillots. The crooning Siren has been quick to identify that her costumes are very different from her day-to-day wardrobe, but whether on the red carpet or in the amphitheater, Beyoncé tends to wear low-cut V-halter or strapless sweetheart necklines, and skirts that hug her narrow waist and wide hips, often with a trailing mermaid or asymmetric hem. Though the cuts are sophisticated, like Victoria Beckham's, Beyoncé goes for more feminine fabrics, such as layered chiffons or bejeweled silks to reinforce her presence as a stage and screen goddess. When going out with her husband, Jay-Z, she often wears her hair in a sleek, more fashion-forward updo, as opposed to her free-flowing red carpet locks, and describes her typical evening-out ensembles as "a pair of sexy heels with jeans, a nice jacket … or a little dress."

Beyoncé walked *Cosmopolitan* through her straightforward rules for figure-flattering dressing: "I [try to] accentuate my waist. I know things that are too loose underneath my hips are not good because I look really boxy. Plunging necks look good on me. My legs are really curved and look longer in straight leg jeans. Tops either have to be really short to show off the top of my midriff, or long. I can't do in between."

Though Beyoncé typically wears Armani gowns to red carpet events, and even appeared as the face of the iconic Italian label's Diamonds fragrance in 2007, she has also served as a spokesperson for L'Oréal, Pepsi, and Tommy Hilfiger. Affirming her dedication to and love of fashion, Beyoncé has designed swimsuits in conjunction with her appearance on the cover of *Sports Illustrated* in 2007, and even created her own label, House of Deréon, with her mother, Tina, in 2005. For Deréon's holiday 2010 advertisements, Beyoncé took on the role of spokesmodel for the brand as well. The images, photographed by Tony Duran and styled personally by Beyoncé and Tina, reflected the singer's tried-and-true Siren style: clingy black dresses paired with silver-buckled black leather heels. For the ads, Beyoncé's typically honey-brown locks were dyed platinum and teased into a curled Marilyn bouffant. Tina described the look as "1960s pinup girl meets futuristic biker chick."

Opposite: Dita Von Teese in a vintage ensemble at the John Galliano Spring/Summer 2011 ready-to-wear presentation, 2010.

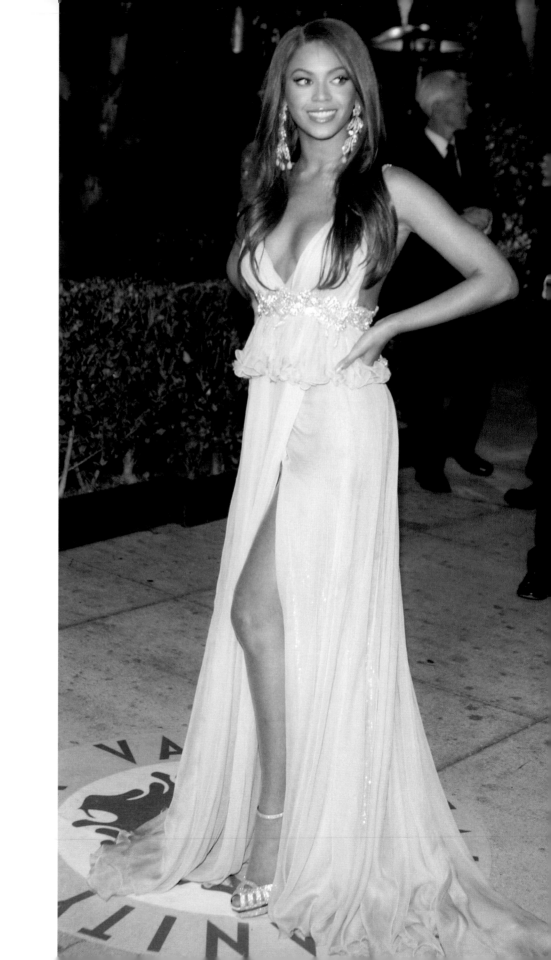

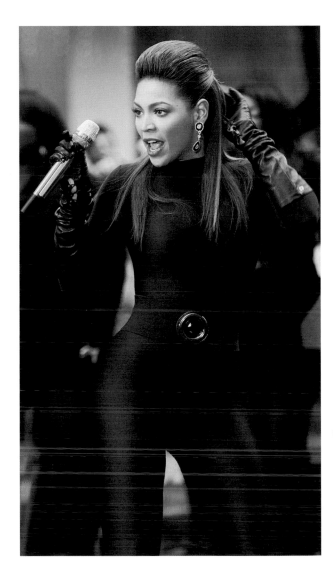

"I like to dress sexy and I carry myself like a lady."

—Beyoncé

As sensational as the Deréon imagery may be, the vision behind the brand is very practical. Beyoncé has explained, "[These] clothes aren't made for the stage, but they're made for women who want to feel like superstars and have eyes on them when they walk into a room."

As a Siren, you draw attention wherever you go. With a better sense of your own style, you will surely make a stunning first impression. Whether outright sexy or somewhat buttoned up, your clothes should be tailored for a form-hugging but not overly tight fit. Make sure to wear the right undergarments—both supportive and pretty—as they will help define your shape. Show off your waistline—whether with a belt or a shapely cut. Slim skirts and tapered trousers will always flatter you more than pleats or wide legs. Pay particular attention to your hair and makeup: even if your style is less sophisticated, the right coif and lipstick imply that you've taken the time to determine what look works for you. Most important, Siren, push your shoulders back and walk with confidence—chances are, all eyes are on you.

Opposite: Beyoncé in a nude gown at the *Vanity Fair* Oscar Party, 2007. Above: Beyoncé in a black Lycra catsuit on the set of NBC's *Today* show, 2008.

Can

lines

"Girls can wear jeans,
cut their hair short,
wear shirts and boots,
'cause it's okay
to be a BOY."
—Charlotte Gainsbourg

With her enormous eyes and boyishly chic cropped hair, she's impossible to miss. Her long limbs emphasize the grace of her slender figure. She wears tailored pants, fitted tops, and flat, conservative shoes. Her modest chest and pronounced shoulders provide a veritable clothes hanger for fashion, so she looks good in nearly everything. She is androgynous: simultaneously girlish and a tomboy. She is demure, coy, and sweet. She is Gamine. She is you.

You may not have the physical assets of the mid-twentieth-century pinup or the contemporary Siren, but your look can be just as iconic. Your lithe predecessors rose to popularity in the 1920s and 1960s when androgyny was the ideal, but many of the same strategies of dressing that they pioneered—A-line dresses with Mary Janes, blue jeans with boatneck tops—still flatter your figure.

From the moment Audrey Hepburn buttoned up her men's dress shirt and tied her kerchief daintily around her fawnlike neck as Princess Anne in *Roman Holiday*

(1953), the waifish figure of the Gamine was born. The Brussels-born actress—most famous for her enviable turn as the mischievous Holly Golightly in *Breakfast at Tiffany's* (1961)—cultivated a unique look based on little black dresses, statement hats, tailored shirts, and equally bespoke trousers. Audrey transformed the shape of chic from hourglass to gazelle, leaping to the forefront of fashion in her signature ballet flat. Her self-assured aesthetic has since become synonymous with the Gamine look, readily identifiable by an independent, casual, and effortless wardrobe of simple shapes and modest separates. Her hair was always tamed into an updo or cropped close to the head; it never looked loose or uncontrolled. She wore a hard line of black kohl on her upper lid, but her lips were usually natural and revealed a large, entrancing smile. Designer Cynthia Rowley once said of Audrey, "I would look at some of the other stars like Sophia Loren and Marilyn Monroe, and I would think—'There's just no way, I could never be like that.' That was a man's idea of beauty, and Audrey was more like a woman's idea of beauty."

On- and off-camera, Hepburn was wardrobed almost entirely by couturier

"**t**hey tell me: 'OK, this is where we're going to push up your cleavage,' and I'm like, 'What cleavage?'"

—Natalie Portman

Hubert de Givenchy, whose recollection of their meeting is telling: "My first impression was of some extremely delicate animal. She had such beautiful eyes, and she was thin. . . . I told her, 'Mademoiselle, I would love to help you, but I have very few sewers, I am in the middle of doing a collection, I can't make you clothes.' So she said, 'Show me what you have already made for the collection.' She tried on the dresses and said, 'It's exactly what I need!' And they fit her too. . . . She knew perfectly her visage and her body, [her] fine points and [her] faults." In Hepburn, Givenchy observed an important prerequisite to the Gamine style: though the look does not always require its wearer to be paper-thin, it does demand a certain trimness and a keen awareness of one's physical presence. A lankiness of sorts doesn't hurt either, but most important, the Gamine must exhibit a willingness to forgo the usual feminine lures.

In addition to the flat shoe, Hepburn was a big fan of Emilio Pucci's Capri pants and wore them as the casual foil to her Givenchy ensembles. Though she was breathtaking in a simple sheath, Audrey's style was most influential when she was seen on holiday or photographed candidly in cotton or silk menswear-inspired separates. She had a girlish allure that endured even as she advanced in years.

When then twelve-year-old actress Natalie Portman made her silver screen debut in Luc Besson's assassin flick *The Professional* (1994), her adolescent, androgynous look was fetishized the world over; she reinvigorated Audrey's Gamine aesthetic in popular culture. Natalie's popularity helped to revamp this physical ideal in contemporary times, catalyzed the fashionability of a host of actresses and models, each more tomboyish than the last. Natalie's delicate features have been an inspiration to many designers as well, from Zac Posen to Alber Elbaz at Lanvin, and more recently to Laura and Kate Mulleavy at Rodarte for formal wear. That said, Natalie's standard wardrobe includes mostly tapered jeans, cotton tops, and a host of artsy scarves and fitted jackets. She wears little jewelry and seems to prefer clothing that's unembellished, save for a print or an embroidered panel for her evening dresses.

The actress became a spokesmodel for Christian Dior in 2010, but fashionwise, she has been most outspoken with regard to her dedication to the ethical treatment of animals. Her antileather, antifur credo led the Israeli-born starlet to develop her own vegan shoe line in 2008, aptly named the Natalie Portman Collection. While showing the designs, Portman picked up one black ballet slipper and shyly explained to a *Style.com* reporter, "These flats are sort of classic . . . sort of Audrey."

Opposite: Hepburn in *Love in the Afternoon*, 1957.

"my look is attainable. Women can look like Audrey Hepburn by flipping out their hair, buying the large sunglasses, and the little sleeveless dresses."

—Audrey Hepburn

"I t's not what you'd call a figure, is it?"

—Twiggy

Though Natalie has of late been wearing her hair straight, long, and lighter, she garnered a great deal of attention for shaving her head for *V for Vendetta* (2006) and thereafter sporting a series of cropped, pixie hairstyles. She has never worn a lot of makeup but does pay a great deal of attention to properly grooming her prominent eyebrows, which frame her large, almond brown eyes. Though Natalie is tiny and fairly flat-chested, she emphasizes her long neck with deep V-necks or sweetheart necklines and usually wears fitted shirts or evening bodices to emphasize her small waist.

The waifishness associated with the Gamine style can be traced almost directly back to a young British girl name Lesley Hornby, who, in the 1960s catapulted to fame for her childlike figure and huge doe eyes framed by "twiglike" lashes. Twiggy created a prototypical Gamine rompishness with a House of Leonard pixie cut, dark kohl around her enormous eyes, and an impossibly skinny frame. She has often been criticized as a template for the extreme thinness of models, an ideal that resurfaced as "heroin chic" in the 1990s with the rise of Kate Moss. Yet rather than looking starved or ill, Twiggy seemed to be a combination between flirty young woman and innocent boy. Her flat chest and narrow hipline lent naturally to this androgyny and were emphasized by an endless parade of Mary Quant baby doll and A-line shift dresses: staples of the Gamine wardrobe. Twiggy's sheath dresses, three-piece suits, and itty-bitty skirts, paired with kneesocks and Mary Janes, became known as "The Chelsea Look." The look has been revived over the past decade as the clean, space-age shapes of the 1960s returned to the runway. Though few of us are as diminutive as

Twiggy, her androgyny is relatively easy to mimic. Her dresses don't break at the line of the body and in fact obscure it to a columnar form. Her choppy blond haircut can be seen most readily today atop the head of model Agyness Deyn.

Twiggy was crowned "The Face of 1966" by the *Daily Express* not long after her sixteenth birthday, and Agyness became the "Face of 1999," according to the *Rossendale Free Press* (another UK publication) at the same age. By the time she was picked up by SELECT models in 2001, Agyness was sporting distinctive Twiggy-esque platinum locks, which had been closely shorn—if not shaved—since she was a teenager. Deyn's long limbs and girlish visage, paired with her unisexual if eclectic wardrobe of combat boots, leggings, and flowy, oversize tops with leather jackets, catapulted her to the fore of the global fashion cognoscenti rather quickly: the model debuted at New York fashion week in September 2006, opened Jean Paul Gaultier's thirtieth anniversary presentation in Paris the same season, and by May 2007 was featured on the cover of *Vogue* as one of the "new crop of supermodels." Born Laura Hollins, Deyn has appeared in an impressive number of advertising campaigns for designer clothing and perfume collections, including Burberry, Giorgio Armani, and Vivienne Westwood, to name a few.

Opposite: Twiggy in a dress of her own design, 1968. Above: Agyness Deyn in "Saint Marks Place" for *V* magazine, September 2010. Page 94: Agyness Deyn in "Boy Meets Girl" for *W* magazine, January 2007. Page 95: Katharine Hepburn in her classic pantsuit, 1939.

The model's fashion choices are the most unpredictable of the Gamine group, as demonstrated by the her inventory of a typical ensemble for the online style site Fashion Indie in March 2008: "I'm wearing men's lace-up boots from a secondhand shop in New York, white punk pants from Trash and Vaudeville, a Clash T-shirt, a vintage spotty shirt, a man's cardigan with an old brooch, a coat from a brand called Buckler, and a leather cap I got in Tokyo." While this pastiche may not seem as straightforward as Hepburn's Capris or Twiggy's baby doll dresses, Deyn's insistence on mixing menswear with finery does recall the sartorial legacy of another iconic Gamine: Katharine Hepburn.

Just as Agyness doesn't leave the house without her lace-up boots, neither did Miss Hepburn come to the film set if not in a crisply tailored pair of slacks. In her article "Two Fashion Icons: Katharine Hepburn and Jackie Kennedy Onassis," journalist Anne Paxton recounted, "It was rumored that MGM was so determined to put Katharine in dresses that they had someone steal her pants out of her dressing room while she was on the set. Instead of panicking, she simply walked around in her underwear until her pants were returned."

Hepburn's progressive upbringing and a bachelor of arts degree in history and philosophy from Bryn Mawr College provided her not only an unwavering belief in women's rights, but also afforded her a somewhat unshakeable confidence and independence. These qualities contributed significantly to her personal style, which was comprised of high-waisted trousers, blazers, and men's shirts, finished off by a pair of loafers or oxfords.

"In Los Angeles, I was eating with four guys and the waitress said, 'Gentlemen, let me show you to your table.' But I did have quite a tomboy outfit on."

—Agyness Deyn

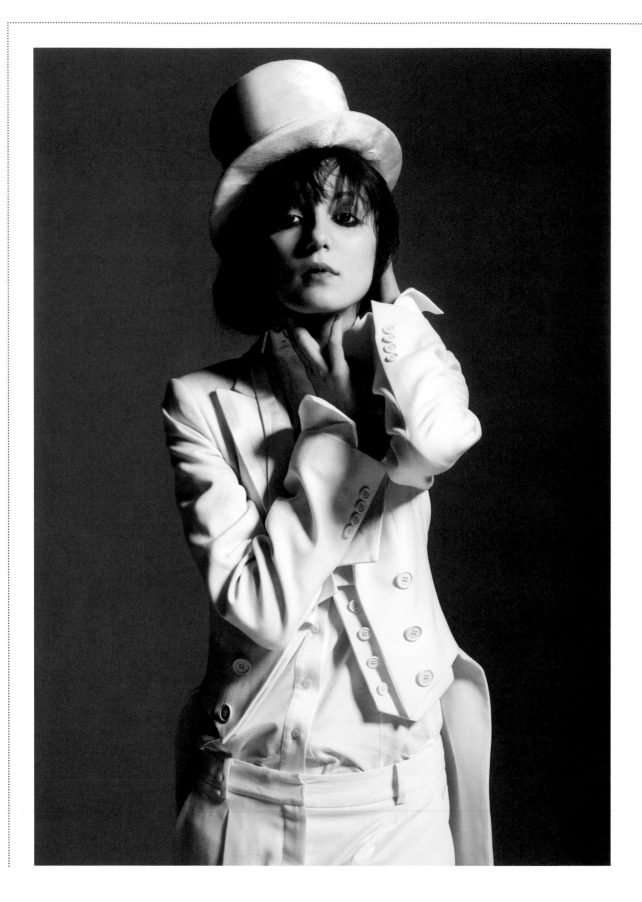

THen & NOW

When Clara Bow was cast as the lead in the Clarence Badger film *It* in 1927, no one could have predicted the powerful impact of this still much-used moniker, which writer Elinor Glyn described as "that strange magnetism which attracts both sexes . . . entirely unself-conscious . . . full of self-confidence . . . indifferent to the effect she is producing and uninfluenced by others." As the first "It" girl, Clara was the inspiration for Max Fleischer's Betty Boop cartoon and the muse behind cosmetics giant Max Factor's "Clara Bow" mouth—which was styled inside the natural lip line to form a darkened heart-shaped pout.

Clara Bow, with her newsboy caps, shorn bob, massive eyes framed by pencil-thin brows, and boyish 1920s wardrobe identified the early signatures of the Gamine style and serves as a crucial Gamine template. The model Irina Lazareanu, who was first cast in an editorial for French *Vogue* in December 2005 by none other than Kate Moss, channels Bow's coyness directly. Where Clara had her cloche, Irina sports her fedora. Bow's drop-waist frocks are reinvented by Lazareanu's own line, Rini, which was launched in 2010 and includes a number of flapper-style dresses. Lazareanu was even profiled as the new "It" girl by Fashion TV in 2006, the year she walked in more than seventy-six runway shows, earning the nickname "the fashion tornado." Karl Lagerfeld once illuminated Irina as a "mix of Coco Chanel and [the French-Romanian poet] Anna de Noailles." Yet with her menswear-inspired coordinated suits, kitsch bob haircut, and tiny lips, Irina proves that whether in the 1920s or the twenty-first century, the Gamine look is still "It."

Opposite: Irina Lazareanu in a Christian Dior tuxedo ensemble for *Elle*, May 2008. Above, right: Clara Bow, circa 1929.

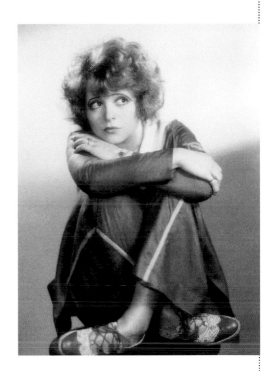

"The masculine/feminine look fascinates me. It is not only an issue of empowering women, but I think the shapes look great."

—Irina Lazareanu

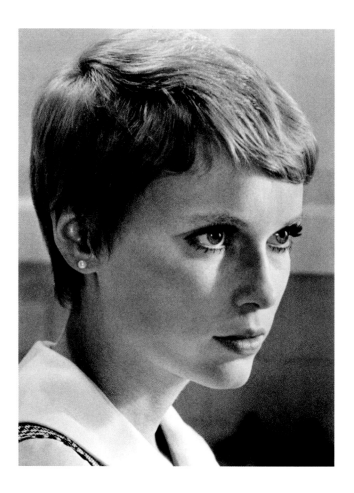

Above: Mia Farrow with a pixie cut, 1960s. Opposite: Jean Seberg in a striped French sailor shirt and blue jeans, circa 1965.

The Council of Fashion Designers of America recognized Hepburn as a nonconformist and fashion pioneer in 1986. In an interview with NBC, the actress once surmised, "I just had good timing. The times fit me: pants came in, low heels came in, the terrible woman came in, who spoke her mind."

Deyn too has from time to time spoken her mind, though mostly about what makes good fashion. Agyness was awarded a guest editorship at *i-D* in May 2008 and launched naag.com with journalist Fiona Byrne in 2010 to pontificate on all things culturally and sartorially beautiful. Deyn's tomboyish quirkiness, which the model might dub "proper mad," and Katharine Hepburn's rigorous dedication to progressiveness together classify the more avant-garde proponents of this style group. Whether simple and chic or more exploratory, the Gamine is accessible and attainable, and her clothes convey approachability rather than seductiveness.

Though Katherine and Agyness embody the more womanly, assertive end of the Gamine spectrum, the more typical example of this style also exists as a progressive, if dichotomous, figure: Gamine is equal parts on-screen ingénue and offscreen radical. Take Mia Farrow, for instance, who would later become an outspoken humanitarian activist but was introduced to the public via her role in the television series *Peyton Place* and as Frank Sinatra's third wife. In *Rosemary's Baby* (1968), Mia's boyish figure—flattered by lush trouser suits and sweet Peter Pan collars—nearly stole the show from the eerie satanic plot. Her pricy Vidal Sassoon pixie cut may have come off as spontaneous in the film, but in fact it embodied the childlike innocence that Mia's Gamine style projected. She wore oversize peacoats and knickers in a sort of English schoolboy look, but if her clothing

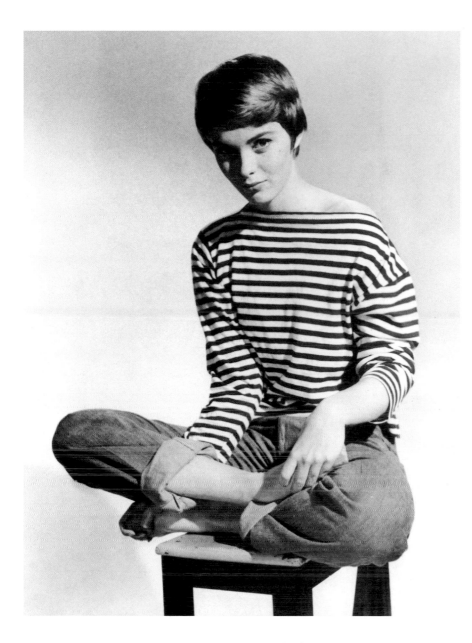

implied naïveté, her behavior was far more proactive and liber-
ated, in keeping with the feminist trend of the 1970s.

Jean Seberg's style also lent Gamine the socially conscious
reputation that she earned in the mid-twentieth century:
her striped sailor tops and tapered black pants became the
rage of the feminist and activist generation, and have since
become a staple of the modernist's closet. Before traipsing
down the Champs-Élysées in a chic white and black *New York
Herald Tribune* sweater as the literary Patricia in Jean-Luc
Godard's *Breathless* (1960), Jean played Joan of Arc for Otto
Preminger, and her short locks only reinforced the persona of
the courageous, independent central character. The actress

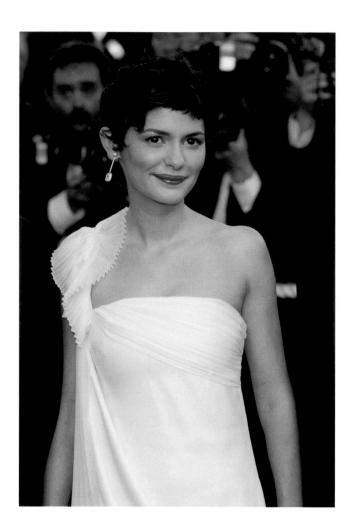

Above: Audrey
Tautou in Balmain
at the premiere of
The Da Vinci Code
in Cannes, France,
2006. Page 102:
Charlotte Gainsbourg,
photographed by
Deborah Turbeville,
2001. Page 103:
Gainsbourg in
Madame Figaro,
2009.

was rumored to have supported the
Black Panthers, which landed her on an
FBI watch list before her suicide in 1979.
Though Seberg was born in Iowa, her
style and the mystery of her personal life
were both quintessentially in the vein
of the French laissez-faire, an attitude
reinforced by her collared tops, muted
colors, and knickers—all favorites among
the revolutionary set. Both Jean Seberg
and Mia Farrow popularized the trend for
natural complexions with light-colored
lipstick and minimal eye makeup, and both
inserted the sense of social advocacy into
the Gamine character.

Petite Frenchwoman Audrey Tautou
exists as the contemporary iteration of
Seberg's 1960s Gamine, and her chestnut
locks and unassuming posture channel
another Audrey we know. Tautou played
Gabrielle Chanel in the popular film Coco
Avant Chanel (2009). Audrey explained
that she was drawn to the opportunity
to play the legendary French couturiere
"because . . . her modernity fascinates me,
her spirit, her ambition, and the position
she gave women." In tandem with the
launch of the film, Tautou replaced Nicole
Kidman as the face of Chanel's iconic
No. 5 scent and starred in commercials
directed by Jean-Pierre Jeunet for the
perfume. Jeunet also oversaw Tautou in
her breakthrough role as Montmartre
waitress Amélie Poulain in *Amélie* (2001).
As Amélie, Tautou championed a severe
Louise Brooks-esque bob and made up
her already large brown eyes to nearly
cartoonish size. The character's collection
of 1960s-inspired shifts and bookish
sweaters seem lifted from Tautou's own
wardrobe: the actress is typically spotted
in an A-line skirt or dress, a filmy blouse
and ruffled collar, or one of many chic
blazers or modest cardigans.

GAMINES NEVER, EVER...

>>
Affect an hourglass shape. Your silhouette is streamlined, so try not to break the line.

>>
Go overboard with their palette; the Gamine sees eye to eye with the Minimalist here. Too much color will muddy your effortless aesthetic.

>>
Wear their hair too long or in an overly feminine style: it will compete with the androgyny of the rest of your look.

>>
Go for supergirly details, such as ruffles or cute prints. Stick to a fairly unfussy construction and stay away from surface decoration, unless it's used as a focal point or highlight of your ensemble.

>>
Hesitate to borrow a man's sweater, or even his jeans. The oversize look reads as intentional and stylish on the Gamine body.

As a certain je ne sais quoi seems to underwrite the Gamine personality, it's no surprise that Charlotte Gainsbourg—a woman who was once described as a "haricot vert" by *New York* magazine—has become the quintessential twenty-first-century arbiter of this style. Charlotte has always been somewhat of a fashion plate; it is said that the luxurious Hermès Birkin bag was named for her mother, Jane, who used the leather and gold tote to carry her daughter's diapers! Charlotte's father is the famed director and singer-songwriter Serge Gainsbourg, and she has certainly followed in his footsteps, having debuted three albums over the last seven years. Between her musical career and her critically acclaimed performances in *21 Grams* (2003), *The Science of Sleep* (2006), *I'm Not There* (2007), and *Antichrist* (2009), among others, it seems impossible that Charlotte might have time to be a fashion muse as well. Yet she has appeared on the cover of French *Elle* and French *Vogue,* and is practically the official muse of Balenciaga's Nicolas Ghesquière.

Except for Balenciaga's glamorous Fall/Winter 2008 advertising campaign, which featured Charlotte in precious silk and embroidered suit and dress ensembles—each tailored and sculpted within an inch of their lives—her own look is somewhat messy. Her hair is consistently tousled, and her face is nearly free of makeup. She clearly prefers a wide-legged pant and tuxedo jacket to a strapless gown, or a pair of worn jeans and a T-shirt to a miniskirt and blouse. This is not to say that Ms. Gainsbourg can't be found in a mercilessly high heel on occasion. Her intrinsic chic is born from this dichotomy: she is both fashion darling and misfit, hopelessly sloppy and ultimately enviable.

When Ghesquière created Balenciaga's signature scent in 2010, Charlotte was his inspiration. The couturier, in an interview with *W* magazine, reflected upon violet as the prominent note within the fragrance: "There is a bitter thing with violet," he said. "We call it *un faux ami*—a false friend—because it's nice but it's strange, strong." So too does this describe the lure of the Gamine Ms. Gainsbourg and her equally rangy peers.

Teetering between child and woman, masculine and feminine, prim yet disheveled, the Gamine defines herself often as a misfit, but one with an impeccably engineered wardrobe of effortlessly tailored separates and signature accessories. These women continue to impact fashion by immortalizing their own basics—Agyness's combat boots, Audrey's ballet flats, Jean's sailor shirts, Charlotte's blazer-and-jean ensembles—each demonstrates the elegant restraint of the Gamine style.

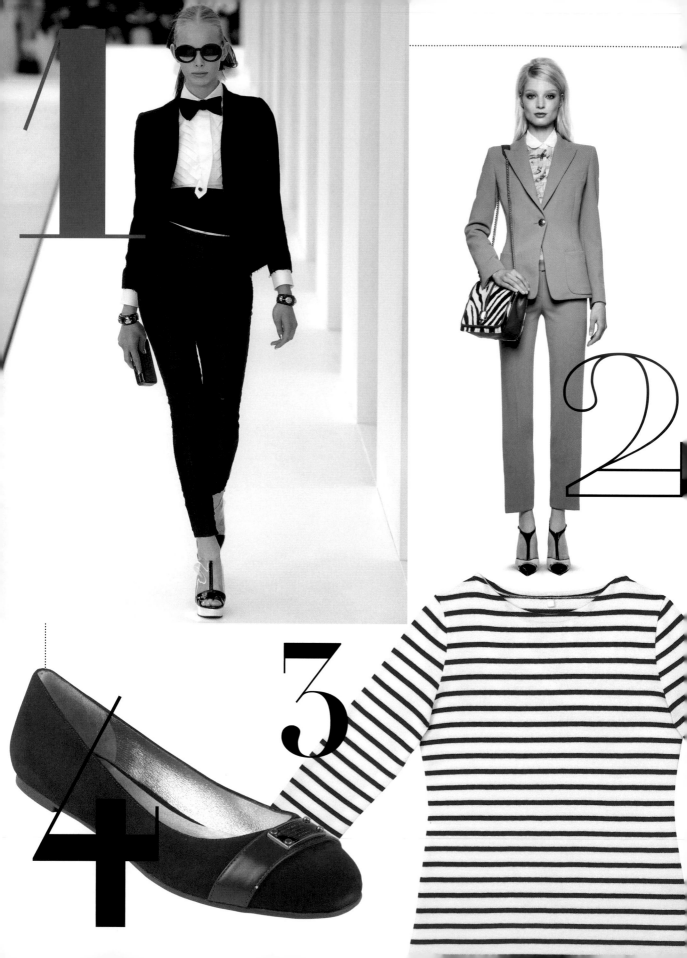

1

2

3

4

A GAMINE'S
Must-Haves

1. The Tuxedo

As a men's dress ensemble, the tuxedo is a symbol worldwide of machismo and charm, yet when adapted to the Gamine form, it presents a potent magnetism through its assertiveness and virility. Whether executed in velvet or traditional black wool, the tux can flatter a boyish shape, allow the comfort that the Gamine wardrobe requires, and still provide the elegance that formal wear demands.

Though certainly not the first men's dress suit engineered for a woman, Yves Saint Laurent's 1966 "Le Smoking" is the most iconic. Helmut Newton's 1975 photograph of a model wearing a Le Smoking and smoking beguilingly in a darkened alley is one of the most enticing fashion images of all time. Though Saint Laurent's tuxedo has always been cut impeccably to the female form, its menswear fabrics, rigid lapel, and crisp, high-waisted pant continue to classify it as a favorite of those who prefer an androgynous look. Adapting a tailored look for formal wear instead of a dramatic gown ensures that you'll always be au courant. To imbue the ensemble with an added flirtatiousness, you can open a button or two on the shirt, and leave the tie hanging to reveal your décolleté.

2. Capri Pants

These pants are named for the isle of Capri, where Emilio Pucci first opened his Italian fashion house and where countless jet-setters vacationed in the 1950s and 1960s. The tapered pant, which hits somewhere between knee and ankle, reflect this casual, holiday style. Though the cut was a favorite of Marilyn Monroe, the Capri pant looks more natural on the Gamine figure, as it reinforces her carefree manner. The pants can be worn with loafers or ballet flats, and while a simple white button-down shirt is perfect to pair with the Capri for daytime, a fitted sweater can dress the pants up a bit for a dinner or drinks.

3. The "Navy" Tee

Though Jean Seberg's sailor tops often featured an authentic wide collar, the "navy" pattern—a repeating thin, contrasting stripe on a solid ground—is best when worn on a semifitted cotton long-sleeve tee, usually with a boat neck. The palette can range from white-on-navy to navy-on-white to even black-on-beige, but the playful simplicity of the look is retained, and the horizontal pattern looks best on the slender Gamine physique. These tops can be worn over a cotton skirt or khaki shorts in the summer, or jeans in the winter months.

4. The Comfortable Chic Shoe

The Gamine is active, so her footwear must suit her lifestyle. Though ballet flats have made a comeback in recent years, the Gucci or Tod's loafer is also a viable option. For a more extreme look, you might even adapt Agyness's combat boot, whose look can be softened by a brown or beige leather, as opposed to black.

1) Chanel tuxedo ensemble, Spring/Summer 2007; 2) Emilio Pucci Capri pantsuit, Resort 2012; 3) Petit Bateau top; 4) Marc by Marc Jacobs red suede ballet flat.

nians

"I like blends of styles
and things that have
nothing to do with
each other. I like
SURPRISES,
things that clash,
are unexpected,
break unity,
disrupt monotony."
—Loulou de la Falaise

We've all seen her: she's swathed in scarves; her hair is wild and unkempt, yet somehow beautiful; she's wearing leggings or a miniskirt, or both leggings and a miniskirt, but she looks interesting rather than foolish; the bangles that jingle around her wrist are unique, and one can only imagine that they're from a diverse and valuable collection of vintage jewelry; her peasant top falls perfectly across her torso, and it's hard to tell whether it was made by a street peddler in Guatemala or the late couturier Yves Saint Laurent. She is well traveled and earthy, but unapologetically hedonistic. She conveys an air of wealthy eccentricity. She is a Bohemian.

The Bohemian look is widely attainable, as its accoutrements are more likely to be found at the local flea market than on the most recent runway. The Bohemian style was immortalized in Western fashion during the 1960s and 1970s, when the rock-and-roll culture of drugs, travel, and unbridled sexuality manifested sartorially as layers of eclectic separates and conflicting prints. Yet the word *Bohemian* was used to describe a type that dates back to early-twentieth-century style icons such as Dorothy "Dorelia" McNeill. She was the muse and second wife of the Welsh painter Augustus John, who had long depicted the Bohemian lifestyle in his canvases. McNeill was notorious for her full skirts and bright palette, which became known in London as the "Dorelia Look."

Augustus's granddaughter and Dorelia's step-granddaughter, Talitha Pol-Getty, must have felt the influence of her famous relatives, emerging in the late 1960s as a quintessential Bohemian figure. Talitha married oil magnate Sir John Paul Getty in a mink-trimmed miniskirt, and the two, though known heroin addicts, became part of London's fashionable elite. Even as such, the Dutch-born actress is more commonly associated with the exoticism of Marrakesh, where the British photographer Patrick Lichfield immortalized her in what is now an iconic portrait for *Vogue*'s January 1969 issue. Lichfield's image captures Getty perfectly: a tumble of chestnut brown locks, large eyes, and lanky limbs, all cloaked in a lavishly embroidered caftan, large white harem trousers, and white leather boots.

Opposite:
J. Paul Getty Jr. and Talitha Getty on the roof of their home in Marrakesh, circa 1970.

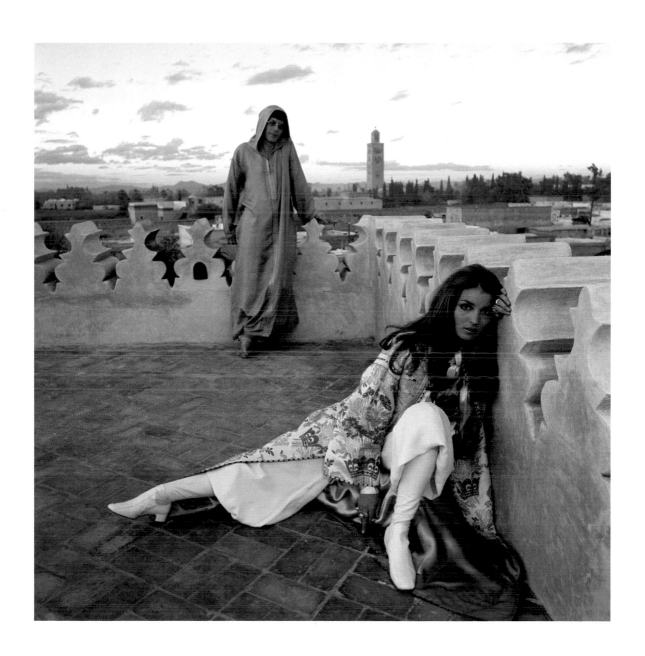

Her husband, who lurks in the background in a beige djellaba of sorts, exists in stark contrast to Talitha's rich tapestry. If John Getty dressed as a peasant in his modest local robe, then Talitha cultivated the "peasant look" by absorbing the indigenous shapes and colors of Morocco's rich landscape into a couture-quality garment. Much of the Bohemian's wardrobe is gathered from around the globe, so the next time you find yourself at a street market in Bangkok, pick up a pair of Thai fisherman's knickers; paired with an asymmetric jacket by Rei Kawakubo for Comme des Garçons, those three-dollar cotton pants might be the perfect item to complete a knockout fashion ensemble.

Now, the Bohemian isn't all regional palettes and native embroideries. Her look has a solid British rocker element as well, one that is probably owed in large part to Getty's costar in the 1968 cult classic *Barbarella* and Rolling Stones' muse: Italian-born actress and model Anita Pallenberg. She styled the Stones in dandyish velvet suits and large platform heels that complemented her own feather boas, oversize fur coats, miniskirts, and floppy hobo hats. Though she, like Talitha, appreciated a well-cut tunic and a long peasant skirt, after years as a touring groupie, Pallenberg also introduced some exaggerated accessories into the Bohemian wardrobe. She diversified simple shift dresses with chunky studded belts and numerous strings of beaded necklaces. Pallenberg was constantly photographed in oversize sunglasses and gladiator sandals—both are items that continue to find their way into our closets. Though Anita's longtime best friend Marianne Faithfull once classified her style as "evil glamour"—a nod perhaps to the actress/model's reputed obsession with black magic—it would make more sense to acknowledge her wardrobe as a reflection of her personality; perhaps "reckless abandon" would have been more suitable. Anita was inspired by everyone and everything from Oscar Wilde to the Vietnam War, and her look was ultimately so magpie that she is considered the original Wild Child.

Pallenberg's carefree styling is revived today in the Boho-cum-hipster look pioneered by Sienna Miller, "It" girl/actress, on-again/off-again girlfriend of British actor Jude Law, and designer of the clothing line Twenty8Twelve. Though raised in England, Sienna Miller became a beloved American style icon under Anna Wintour's watchful guidance. Miller regularly dons a pair of shorts over a set of leggings or tights and is consistently deified for her ability to pull off a worn T-shirt on a red carpet. She is credited almost universally with bringing back Bohemian style in the twenty-first century.

BOHEMIANS Never, EVER...

>>

Shy away from accessories; your add-on accoutrements set you apart from the crowd.

>>

Wear flats, unless they're thigh-high boots; your footwear should emphasize your long legs, and what better way to do so than with a pair of platform or wedge shoes?

>>

Wear anything with boning. The Bohemian look is about freedom, not restraint.

>>

Cut off their hair. Your long tresses show off your romantic side.

>>

Forgo color: even though a cream caftan or sundress may suit them nicely. You'll need to add flashes of color via wraps, tights, jewelry, or scarves to really convey your Bohemian vibrance.

Anita Pallenberg
with Marianne
Faithfull at Heathrow
Airport, 1967.

Miller is modest about her flare for Boho styling, having remarked, "I don't plan outfits. It's quite thrown together and I often look disheveled." In fact, the actress does sport a mane of jumbled blond locks, and her most identifiable fashion strategy is her somewhat haphazard layering of T-shirts and blouses over designer jeans or small skirts, with an animal print scarf thrown casually around her neck from time to time, as if to pay homage to Pallenberg. Fashion designer Matthew Williamson, who appropriates Indian and Asian decorative motifs as prints on playful sundresses, has repeatedly named Sienna as his muse, but perhaps more for her free-spiritedness and her integration of exoticism into a sartorial foundation of hipster separates.

Part of "going Bohemian," if you will, seems also to be a sense of freedom with one's own body. Pallenberg was consistently photographed topless, and

Miller got her first public nod as a mostly nude playgirl (save for a pair of boots and a thong) in the 2004 remake of *Alfie*. When she received criticism for wearing a pair of somewhat Spanx-like black underpants over black tights to the 2007 *Factory Girl* premiere, she joked to the *Guardian*, "I wanna see England in their [under]pants. I would like to set a trend where everybody in London walked about just in their [under]pants. I'd love it. We're going back to Adam and Eve's time. I want to see London naked. Why not? People get really funny about nudity and I think it's a beautiful thing."

Miller's Twenty8Twelve clothing line, named for her birthday of December 28, and designed with her sister, Savannah, is also a thing of beauty and has been labeled "the essence of cool, modern London dressing—[full of] slick tailoring, rock-chick cool and romantic vintage pieces."

THE
BOHEMIAN
MUSE:
VERUSCHKa

If Talitha Getty and Anita Pallenberg both championed a progressive Bohemian wardrobe in the 1960s, their status as icons of upper-crust society and rock and roll royalty respectively served to mythologize the women as goddesses rather than proselytize the masses to their Boho stylings. The mass absorption and celebration of the Bohemian movement is owed in large part to the popularity of Prussian-born Countess Vera Gottliebe Anna Gräfin von Lehndorff-Steinort, better known as the model Veruschka.

Veruschka was a blond bombshell, but she also epitomized the over-the-top fashion editorials of the 1960s, later parodied in Michelangelo Antonioni's 1966 film *Blowup* and outright mocked in Mike Myers's spoof of that era, *Austin Powers: International Man of Mystery* (1997). Laugh as you might, Veruschka's sculptural hairstyles, feathered headdresses, and expansive caftans (to cover her six-foot-one inch frame) clarified the Bohemian look for the readers of popular fashion magazines worldwide in the 1960s, effectively transforming the style into a fashion phenomenon. If the model's look

seems at first too kitschy to adapt today, think again: Veruschka recently appeared in the remake of the James Bond film *Casino Royale* (2006) and was the muse for Michael Kors's Spring/Summer 2003 presentation for Céline, entitled the "Veruschka Voyage." Though Kors focused on gold embroideries and a kaleidoscope color wheel, Veruschka's look was comprised of fur pelts and tailored leather separates as well. While few among us want to strut around with a cheetah skin covering our shoulders, we can certainly channel the model's animal sex appeal: a perfect leather jacket or fur Cossack hat can offer a more conservative outfit a Boho edge.

Opposite: Veruschka in leopard skins on a shoot, circa 1969.

"I'm not especially inspired by fashion. . . . I was always being different types of women. I copied Ursula Andress, Brigitte Bardot, Greta Garbo. Then I got bored so I painted myself as an animal."

—Veruschka

"She covered herself in jewelry and was free in how she dressed . . . I love that."

—Sienna Miller, on Janis Joplin

Between washed leather jackets, denim dresses, and sleeveless tie-dyed day frocks, the label seems a good launching point for any Boho wannabe.

Sienna's popularity is owed in large part to the popularity of actress Ali MacGraw, the first Bohemian "It" girl. Thirty-five years before Miller graced the cover of *Vogue*'s now notorious September 2007 issue (the subject of the documentary *The September Issue*), MacGraw was *Vogue*'s Boho cover girl of choice. Male and female moviegoers alike became obsessed with MacGraw in the film *Love Story* (1970), in which her quirky hippie falls for Ryan O'Neal's rich preppy. In *The Getaway* (1972), MacGraw played the wife of an ex-con (Steve McQueen), sporting chic three-quarter suede trench coats, wrap-top silk ensembles and chain-link belts that seemed to be restrained variations of Ali's offscreen wardrobe. Built from flea market peasant tops, Holly Harp jersey gowns, silk head scarves, knee-high leather boots, and slinky Halstons, Ali's own look was cultivated during her years as Diana Vreeland's assistant at *Harper's Bazaar* (1960 to 1966) and as a model and stylist for photographer Melvin Sokolsky at *Vogue* thereafter. MacGraw was the cool girl-next-door: the one that had those cute, offbeat clothes you were dying to borrow if you could only get up the nerve to ask her. Her natural dark brown hair, typically parted down the middle, reflected what Calvin Klein once dubbed her "rich hippie" style.

MacGraw's is a romantic Bohemianism, and is best clarified today by Lou Doillon, one of France's premiere models and half sister to the coquettish and gamine Charlotte Gainsbourg. Doillon, labeled a "louche, chain-smoking Bohemian beauty" by journalist Jess Cartner-Morley, designed a nostalgic 1970s-style collection for the

British denim company Lee Cooper for
Spring 2008. Lou cited her inspirations
as "half Artful Dodger, half Boulevard
Saint-Germain. High-waisted trousers are
borrowed from old-fashioned bellboy
uniforms, frock coats from Oscar Wilde
and Sgt. Pepper, and mini-dungarees from
old-fashioned nursery wear."

Doillon is a perfect balance between
fashion insider and quirky outlier: though
she has been the face of advertising
campaigns for Chanel, Givenchy, and Miu
Miu (among others), her style always walks
the line between Boho and hobo; she cites
Charlie Chaplin's "The Kid" as one of her
most beloved fashion images. Lou inspired
Romano Ricci, the grandson of the famed

couturiere Nina, to create the scent Juliette
Has a Gun, in 2010, which is comprised of
"woodsy patchouli, amber, and iris root"—a
hippie's scent if there ever was one!

Lou's eclectic style has attracted a very
famous list of cohorts, from indie actress
and model Milla Jovovich to Laetitia
Crahay, the head of accessories at
Chanel and creative director of milliner
Maison Michel. Lou became close with
Crahay after her favorite hat, a classic
black *moche* ("ugly" in French), was
stolen and she needed a reconstruction.
In fact, Lou wears a lot of hats, a detail
that further allies her with Bohemian
icons like Pallenberg or Marianne
Faithfull. Lou's *moche* in particular is a

signature worthy of Loulou de la Falaise, who would have approved of its off-kilter quality and its general lack of "neatness."

Boho Loulou, daughter of Maxime de la Falaise, a former model for Elsa Schiaparelli, became one of Yves Saint Laurent's most influential muses. She was somewhat responsible for the ultimate success of Saint Laurent's ready-to-wear line and boutique, Rive Gauche, having inspired the designer to bring a more youthful, eclectic sensibility to his designs. She once remarked, "Yves had a terribly bad habit of liking things too well-cut. I don't like neatness—it doesn't look natural. I taught him to let go and to be less formal."

"What attracts me is something broken, something a bit off. I never comb my hair or make anything pretty. When people look too beautiful, it's too easy."

—Lou Doillon

THeN & NOW

Though the Bohemian look crystallized in popular culture in the 1960s and 1970s, it finds its precedent a century earlier. Jane Morris, an English model and the wife of artist William Morris, embodied the physical ideal created by the Pre-Raphaelite painters. Morris's long, cascading hair was always let down, and her flowing medieval-style robes—as the adopted wardrobe of the aesthetic movement—were long and pleated with a natural drape, as opposed to the tailored and corseted gowns of the typical late 1800s fashion plate. In place of a collar, Morris often wore multiple strands of beads. The lone figure in such Pre-Raphaelite works as *The Blue Silk Dress* (1868) by Dante Gabriel Rossetti, Jane was depicted as a pale goddess framed by the accoutrements of nature, such as a length of ivy or even the pelt of a forest creature; this positing presented her as wild and unrestrained when in actuality Morris was a voracious academic, an accomplished pianist, and an accepted member of London's upper class.

Arden Wohl, with her layering of loose tunics and shawls and Morris-esque locks, has fashioned herself as a modern-day aesthete and is the premiere Bohemian socialite of twenty-first-century New York City. She wraps Lanvin jumpsuits or Balenciaga dresses with eclectic vintage scarves and 1970s platform shoes. Arden is the granddaughter of the late Manhattan society art collectors Ronne and Joseph S. Wohl, and the champion of cultural institutions such as the American Museum of Natural History and the Art Production Fund, founded by Yvonne Force Villareal

and Doreen Remen. At a fund-raiser for the latter, Wohl noted, "That's one good thing about the art world: you don't get many borrowed dresses or personal stylists in this crowd."

And Wohl walks the walk: her looks are almost always a mishmash of her own creation. Her signature, a brightly colored or textured headband fitted neatly as a Bohemian crown, prompted a global frenzy for the accessory among celebrities such as Nicole Richie and Mischa Barton in 2005. Wohl's mother, Denise, even adapted the headdress into preppier, more adult iterations in 2007 and sold them under the moniker of the "Wind Toss."

Opposite: Arden Wohl, photographed by Jonathan Becker for *Vogue*, July 2007. Right: Jane Morris was the muse for *The Day Dream* by Dante Gabriel Rossetti, 1880.

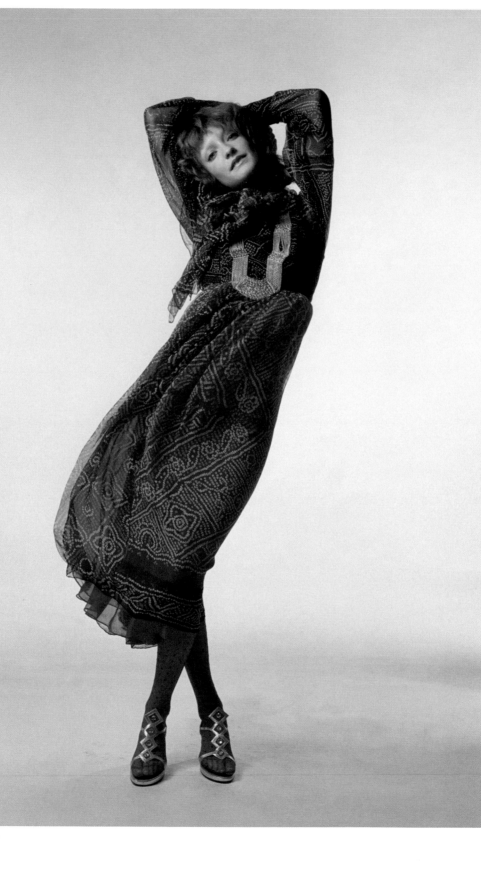

> "I love color.
> Color is life."
>
> —Loulou de la Falaise

Where other 1960s Bohemians were exploratory and carefree, Loulou was interested in extracting the refreshing palettes and textures of regional dress and street style and filtering them into cohesive high fashion looks. She is said to have inspired Saint Laurent's iconic 1976 "Russian" collection as well as his extravagant ensembles based on Chinese empresses or Turkish dervishes.

In other words, Loulou's influence brought about the stylization of the Bohemian look, where a clashing of textures and a keen attention to palette were highly engineered rather than created through layering one ethnic garment over another haphazardly, or throwing on a boa over a suede jacket. Her apartment in Paris's Montparnasse district, where kilims and blankets from the Atlas Mountains became tapestries to throw over priceless vintage furniture, had walls painted in a neutral eggshell in order to exact some aesthetic balance. Loulou insisted that the apartment was "a gypsy" (the literal translation of the French *bohémien*) and its beauty was conveyed through texture—in other words, countering simple shapes with exuberant colors and intricate embellishments. Loulou took on the role of the in-house jewelry designer for Yves Saint Laurent in 1972, but in 2010 she launched her own collection of charms at the French retailer L'Eclaireur: a line of "Gaudí-esque" pieces named "Reverie d'un Soir d'Eté" ("A Midsummer Night's Reverie").

As the fashion insider who helped legitimize Bohemianism as a proper trend in the late 1960s and early 1970s, Loulou undoubtedly served as an inspiration for today's Boho mavens. Among them are the actress twins Mary-Kate and Ashley Olsen, who have emerged as champions of the contemporary Bohemian look and entrepreneurs of its market. They entered the field of fashion via a clothing line at Wal-Mart in 2001 and a beauty series for Claire's, but have since premiered three additional brands: the JCPenney line Olsenboye; a more fashion-centric collection entitled Elizabeth & James; and an even higher-end label called The Row. The latter two were launched in 2007. The high-end collections, though much more restrained and separates-driven, function similarly to the twins' own wardrobes, as an endless series of mix-and-match luxury items interspersed with a contemporary basic here and there to demonstrate relevance and trend awareness.

Though the duo easily leverages their star power to ensure their continued presence at fashion events and runway shows, their individual styles are so evolved that we would sit up and pay attention either way. The twins grew up dressing identically but

Opposite: Loulou de la Falaise in a peasant dress, 1970.

"I think you're either born with a sense of style or you're not. Either you care or you don't. And we . . . love fashion."

—Ashley Olsen

Opposite: Ashley Olsen (left) in vintage Givenchy and Mary-Kate Olsen in a vintage ensemble of her own styling at AmFAR's Cinema Against AIDS gala, 2005.

as young women have explored various Boho looks: Mary-Kate's Goth eye makeup, oversize sweaters, and statement jewelry embody the darker side of the Bohemian, while Ashley's gold-threaded gowns and classic fur outerwear reinvigorate the 1970s' romanticism of the British boutique Biba as well as the decade's Art Nouveau renaissance.

The Olsens are masters of high-low eclecticism: their wardrobe includes a host of designer gowns and ready-to-wear pieces from the likes of Balenciaga, Chanel, and Galliano, to name a few, but the more interesting—and more Bohemian—components of their closets are unattributed: the label-less 1920s vintage beaded bag or the African mud cloth turban, the 1960s mink stole or the Irish lace sundress. Mary-Kate and Ashley have such an impressive breadth of vintage clothing and accessories that one would think they have a team of stylists trolling through secondhand shops in every major fashion city (and perhaps they do!). Part of acquiring their look is about recognizing that choice vintage find, but the other part simply compels you to embrace your imagination, without a fear of mismatching or sticking to a preordained "look." In a word: diversify!

The over-the-top ensembles of Mary-Kate and Ashley Olsen remind us to experiment with our own closets, not to mention inform the collections of even the most revered couturiers. The sisters compiled a volume of their favorite designers and collaborators in 2008, aptly titled *Influence,* which simultaneously affirmed their status as style makers and set them apart as icons.

The Bohemian relies on heterogeneous inspirations, some ethnic and multiculti, and others more fashion-forward. In formulating the Boho wardrobe, travel and an eye for the unique vintage treasure are musts. A headband, patterned scarf, or an armful of bangles will always position you squarely in line with the Boho crowd, but if you're looking for something subtler, an updated caftan and a tall leather boot will go the distance as well. The key to the Bohemian look is open-mindedness: draw inspiration from anything and everything. Look to high fashion as a guide but supplant those hefty price tags with flea market and vintage boutique finds to lend your look greater depth and tempered eccentricity. The Bohemian is framed by layered color, texture, and adornment. Let your creativity and versatility guide you.

1

2

3

4

A BOHEMIAN'S
Must-Haves

1. Baby Doll Dress

The empire-waist dress, with a cropped hemat midthigh, instantly conveys the romanticism and playfulness of the Bohemian look. It also provides the perfect foundation for costume jewelry and layered scarves, and frames the legs so that they look mile-long in those suede platform boots.

Since her first runway presentation in 1991, Anna Sui has championed a diversity of regional dress styles fused with high-fashion silhouettes, but she always returns to the baby doll dress. From Sui's early 1990s grunge-era sheaths to her more contemporary colorful sundresses, the designer's digs will always offer a patchwork of fabrics, colors, and prints worthy of the most dedicated Bohemian. These dresses can be worn easily with tights in a contrasting pattern, or even over the right pair of tight-fitting pants.

2. Heaps of Jewelry

In the Bohemian's eye, all that glitters can be gold: a healthy layering of costume jewelry chains and baubles can provide an ensemble texture and free-spiritedness. What's important isn't that these charms are valuable but that they lie correctly on the body; pendant, lariat, or long-linked chains should fall past the bustline and can peek out from beneath a scarf. The website Charm & Chain, founded in 2008, offers high-end and more affordable costume jewelry from a wide range of brands and styles, so it's a great place to build a collection that seems as if you've accumulated it on travels far and wide.

3. Offbeat Headwear

Whether you wear a floppy leather hat à la Anita Pallenberg, or Lou Doillon's more fashion-forward *moche*, the right piece of signature headwear can really complete the Boho look. In recent years, the Bohemian headpiece of choice has been the headband. Though the craze is reported to have been initiated by Arden Wohl, who is certainly the style's most dedicated follower, on-again/off-again Boho charmer Nicole Richie designed a gold multilink chain mail headpiece for her House of Harlow 1960 brand that took the style to new, classically inspired heights. The good news is that Richie's look is attainable by simply draping and pinning a long-strand necklace in your free-flowing locks. You can acquire Wohl's hippie headband look via DIY style as well, by tying a silk scarf or ribbon around your forehead for an added Bohemian flair.

4. The Messenger Bag

Sure, a beat-up leather messenger bag complete with worn leather edges is ideal to revive that 1970s Boho hippie. But if you're looking for a more up-to-date (that is, cleaner) look, there are a number of contemporary leather shoulder bags that will do the trick as well. Anything with a large, wide strap and sac-shaped body will affect that over-the-shoulder, on-the-go Boho flair. A rich brown or amber tone is ideal, but muted greens or blues can also work. On the luxe end of the spectrum, Bottega Veneta's woven leather shoulder bag conveys the attention to artisanal detail that Bohemians crave but still brings the cachet of the luxury fashion accessory— thereby fulfilling the Boho decree to mix high and low.

1) Anna Sui sundress, Spring/Summer 2007; 2) Gemma Redux necklace (left), House of Harlow necklace (right); 3) Nicole Richie wearing a gilded House of Harlow headband; 4) Bottega Veneta woven leather handbag.

"We live in fast
modern times
and we have to
SIMPLIFY.
And that includes
how a woman
gets dressed."
—Donna Karan

You've got your classic shade of red lipstick, your androgynous perfume, an enviable collection of tailored clothing, and some stellar T-shirts and fashion jeans to boot. The sight of a ruffle on a neckline makes you a bit queasy, and sparkles, stripes, and polka dots are headache-inducing confections. If you're conflicted about what to wear to a cocktail party, you pull out your trusty black dress—notable not for its ostentatiousness, but for its restraint. Should you go to a job interview, rather than risk dressing inappropriately, you select a straightforward, well-tailored suit. Cooler than a perfectionist, you are a Minimalist; when it comes to dressing, less is best. Although strict Minimalist dressing is hard to adhere to consistently, there are easy strategies to paring down your look to maximum effect.

Women's wardrobes over the last thirty years have turned to easy, interchange- able "basics" to convey what is generally perceived of as a sense of universal good taste. But beyond the basics, your attention to a neutral palette, classic shapes, and more architectural, bespoke constructions can lend a crispness to your wardrobe that is sure to make an impression.

Fashion has long embraced minimalism's rigor: in recent seasons at Balenciaga, Nicolas Ghesquière has sculpted knits, plastics, and leathers into abstract body armor; Raf Simons has continued to deconstruct and pare down women's tailoring at Jil Sander; Phoebe Philo has amped up Céline's sophistication with stiffened sheath dresses and starched palazzo trousers in heavy linens and soft skins; and Francisco Costa at Calvin Klein has effectively embraced the founding spirit of that house by showcasing liquid bias-cut gowns and sculpted planar jackets as separates that straddle the aesthetics of futurism, androgyny, and minimalism. This renaissance of simplicity owes everything to minimalism's first coup in the 1980s, and to the undercurrent of minimalism that has surged through Western fashion and lifestyle design ever since.

While the minimalist movement in art originated in the 1960s as abstract and avant-garde shapes, minimalism in fashion adversely gained its momentum two

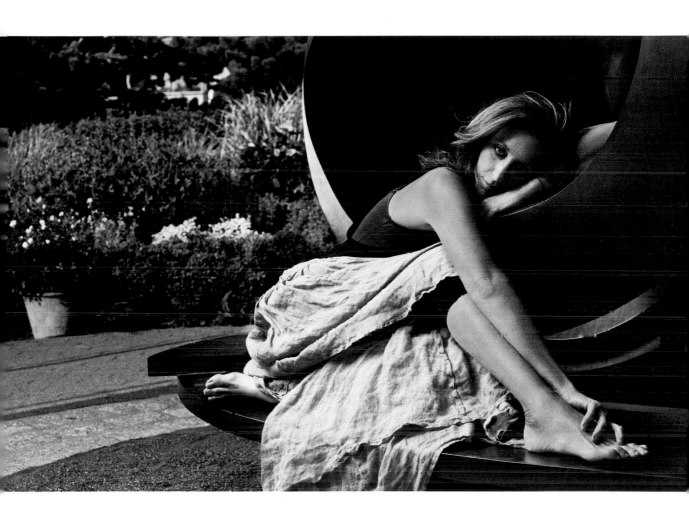

decades later in the service of comfort, simplicity, and wearability. Though many American, Italian, and Japanese fashion designers contributed to the emergence of minimalism, its philosophy—even today—is best defined by one collection: Donna Karan's 1985 premiere line, entitled "Essentials."

Karan's "Essentials" consisted of her famous "seven easy pieces": bodysuit, coat, jacket, blouse, skirt, pants, and wrap garment for the evening, which could be interchanged to accommodate requirements of both work and social situations as a fully integrated wardrobe. With a reserved palette of white, black, grays, and neutrals, Karan's minimalism championed versatility and modernity while still dictating clearly defined aesthetics. She insisted that her clothes were meant for a new working woman who didn't want to dress like a man in severe, unflattering tailored shapes, yet required clothes that were both fashionable and serious. The designer's dear friend and fellow sartorialist Calvin Klein once told *Glamour* magazine, "There is a certain serenity to the kind of clothes that [Karan] does. But ultimately, what she has always been inspired by are American women—they're working, they're raising families, they're involved in every way. She appeals to what we like to think of as the modern woman. She *is* that woman." Donna has often said that she feels a woman should be so comfortable in her garments that she should "be able to sleep in them," and perhaps this philosophy extends to aesthetic comfort as well as physical: Karan's are confidence clothes—they never seem out of place or over the top.

Karan said in 2007, "I love uniforms. People look better in uniforms." Over the past twenty-five years, Karan's designs have provided a Minimalist uniform that is simultaneously straightforward and "easy," and distinctly high in quality. Karan's collection clothes are configured from impressively engineered silk crepes and wool knits. She even named her house perfumes for a favorite luxury textile: Cashmere Mist, Black Cashmere, and Pure Cashmere. When Karan launched DKNY (from Donna Karan New York) as her lower-priced line in 1989, she clarified that women can achieve the Minimalist aesthetic without paying a hefty price.

In fact, Donna's approach to dressing clarifies a general style rule: muted palettes and form-flattering shapes are always going to affect a cleaner aesthetic than obscuring the body with oversize, blocky clothing or alternately complicating its line with unnecessary frills. Whether or not one chooses to accessorize Karan's clothing, the effect of her draped, planar panels and wraps is intriguing yet understated. The designs, like minimalism itself, rely a great deal on balance: between accessible and exclusive, unique and reserved, urbane and natural.

"I happen to be very American, look very American. That helps, to fit right into [Calvin Klein's] sense of design and style."

—Kelly Klein

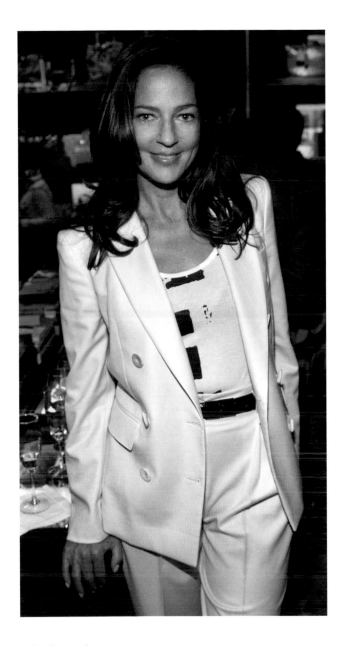

Kelly Klein at the
CH Carolina Herrera
New York boutique
opening, 2010.

Though Donna herself often counters the simplicity of her designs with a statement jewelry piece such as a large necklace or chandelier earrings, a stricter Minimalist might be content to allow the contrasting textures of her separates to create visual interest. Rather than using excessive jewelry to match or enhance an ensemble, try scaling back to one exquisite jewelry item that, in its opposing intricacy, will serve to highlight the simplicity and elegance of your look as a whole.

If Karan's mission has been to translate a minimalist brand of luxury to the masses, then it is perhaps fair to say that Calvin Klein's legacy is the high standard of luxuriousness to which the average Minimalist aspires. Klein took a working man's denim and transformed its consistent, utilitarian structure into the unisex wardrobe staple of the designer jean. He launched the iconic fragrance CK One for both men and women in 1994, as if to affirm his brand's dedication to androgyny and the cool quality that his de-gendered clothing offered. Klein's muse for many years was his (now ex-) wife, Kelly, whose tanned skin, light brown hair with sunlit highlights, and slender frame gave her an all-American look that epitomized Klein's casual, confident style. From the moment the two were married in 1987, Kelly Klein effortlessly modeled her husband's creations, demonstrating to thousands of women that you don't need to be a professional to wear chic basics with elegance and flair.

An avid equestrian, Kelly was often photographed in jeans, riding boots, and Calvin's cable-knit sweaters, as if to convey the ease with which one could acquire his look and its versatility. She was particularly adept at channeling luxuriousness through this simplicity by infusing trace symbols of extreme wealth

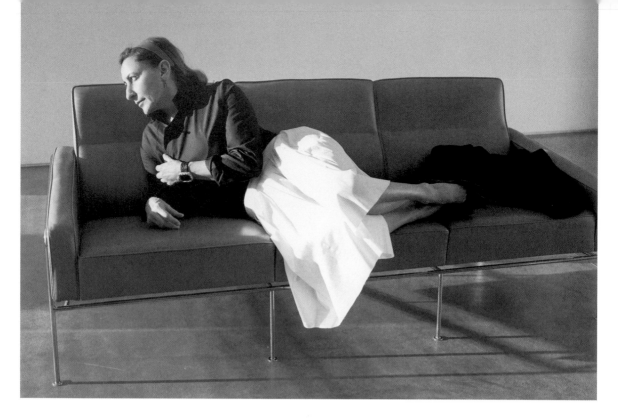

"My idea is always to avoid nostalgia."

—Miuccia Prada

into her otherwise covertly opulent wardrobe. Her engagement ring, which the *New York Times* identified as "mind-boggling," was part of the Duchess of Windsor's jewels and was named "Eternity" by Prince Edward—a moniker that would ultimately be associated with a very successful Calvin Klein fragrance. The ring, much like an impressive set of pearls that Kelly wore quite regularly with a basic white T-shirt or button-down silk blouse, demonstrated the significance of a focal point in the Minimalist wardrobe. Though your outfit may consist of a very simple gray cashmere sweater and black wool gabardine pencil skirt, an expensive pump, watch, or calfskin leather handbag can elevate the look, and thereby communicate your style as discerning— an intentional fusion of high and low wardrobe classics—rather than commonplace.

As self-effacing luxury is an important part of the Minimalist look, it's no wonder that Miuccia Prada, creative director of the eponymous brand and granddaughter of its founder, has often been hailed as the highbrow Minimalist. As a collector of minimalist art and a lover of minimalist architecture and interiors, Miuccia infuses Prada, her premiere collection, with a structural simplicity while highlighting the unique materials from which her designs are constructed. Unlike Donna Karan's or Calvin Klein's collections, Prada designs are not translated directly to a lower-priced line (Prada Sport does not seek to mimic the original collection, for example); Miuccia's lesser-priced Miu Miu brand reflects a different aesthetic entirely.

MINIMALISTS
Never,
EVER...

Wear more than one piece of statement or vintage jewelry.

Wear more than one or two garments with details such as pleats, smocking, or tucks; the goal is to keep the silhouette clean and streamlined.

>>

Dress according to seasonal trend; while your look should of course be up-to-date, the Minimalist wardrobe is one that is typically suited to endure many fashion seasons (if not years!).

Dress with an overly festive or eclectic range of color. Minimalist dressing is about understatement— that means in its palette as well.

>>

Spend too much energy on their hair. Get a cut that lets you wash and go: "less is more" doesn't just apply to one's choice of dress.

In 1985, the same year when Karan launched "Essentials," Prada created an accessory item that not only changed the face of luxury handbag design but also became a minimalist accoutrement par excellence. Her black nylon backpacks were celebrated for their functionality and creativity, yet criticized for their expense, given nylon's typical cost-effectiveness. When she launched her clothing collection in 1989, she used a similar strategy of investing simple, straightforward designs and everyday fabrics such as cotton shirting or wool twill with added luxury value by simply affixing the Prada label. As an Italian heritage house that originally opened as a luggage and small leather goods supplier in 1913, the Prada name provided Miuccia the global cachet to pose as an authoritative tastemaker. The Prada method of dressing suggested that the contemporary Minimalist buy just a few principal luxury garments each season—a black cashmere turtleneck, a taupe silk blouse, a pair of classic black trousers— that could be worn with a variety of choice accessories and paired with more pedestrian basics to create diversity. This was not a wholly new concept, as Gabrielle "Coco" Chanel insisted that a woman could get by with just one good black dress each season, but by the early 1990s, the consumer cult of Prada gave Miuccia full license to call the strategy her own.

Another important dictum of both the Prada philosophy and Minimalist ethics is a willingness to disregard fleeting trends in favor of a more timeless, more resilient, and more resolute aesthetic. The uniform, as a benchmark of ordered dressing and standardized fit, inspires Prada as well. Her own wardrobe always incorporates elements of the brand's collections—a print here, a bit of beading there—but is a selection of precise silhouettes that consistently work well for Miuccia's body: a below-the-knee full skirt and a fitted (but not tight) sweater or blouse. She always emphasizes her waist and covers her knee, as she feels this conservatism flatters an older woman. Her footwear is the most arresting part of her silhouette, as it usually diverges from the Minimalist's typical pump in variations on the espadrille, platform, or geisha's sandal. She'll wear the odd necklace or string of pearls but otherwise embellishes with little makeup and leaves her hair in a straight bob or pulled back into a tight ponytail. Just as she insists upon the maintenance of a rigorous orderliness in the brand's corporate offices, so too does she hold tight to the consistency and reserve of her own sartorial uniform.

Consistency is also the lesson to be gained from formidable fashionista Inès de la Fressange, who was voted chicest woman in France by the readers of *Le Figaro* in 2009, nearly thirty years after her debut as the model and muse of Karl Lagerfeld at Chanel. Fressange rose to popularity for her styled shoulder-

"french women have a kind of arrogance. It's: 'I ignore fashion, I do my own thing.'"

—Inès de la Fressange

length hair, high cheekbones, large brown eyes, and lanky frame. But underneath her intimidating looks, the former model and brand ambassador for Roger Vivier and Jean Paul Gaultier is down-to-earth and very candid about the elegant separates wardrobe that she's championed her entire life. She has cited the Minimalist look that emerged with Armani in the late 1980s—"round collars, girls with square-cut hair, almost no makeup, no jewelry, no nail polish"—as an influence, but she reaffirmed her self-imagined mission to combine offbeat Minimalist separates early in life when she spoke to *Interview* magazine: "[As a younger woman] I'd take my father's V-neck sweaters and some topsiders, which were the ancestors of Converse sneakers, and I'd wear those with jeans and a fur coat." These days, we're more likely to spot de la Fressange in a luxe Chanel tweed jacket with a tailored shirt and her signature pencil-leg pant, which she has worn for decades with a pair of simple leather flats.

Actress Selma Blair channels de la Fressange's brand of preppy minimalism, and her easy grin and auburn eyes even mirror the French icon's features. Blair has starred in several blockbuster films, including *Cruel Intentions* (the updated remake of *Les Liaisons Dangereuses*) (1999), *Storytelling* (2001), *Legally Blonde* (2001), and *The Sweetest Thing* (2002), in which her character's sleek Minimalist wardrobe stood in stark juxtaposition to the more trend-based looks of costars Cameron Diaz and Christina Applegate. Selma's style has been labeled "Old Hollywood," but more for its timelessness and classic good taste than for any grand sartorial gesture on her part.

Blair credits her conservative clothing to her mother's restrained tastes, but it's clear from countless ensembles of tastefully

partnered separates, sweet cardigans, and basic boatneck dresses that the actress has an aesthetic gift of her own. Whereas de la Fressange holds fast to her Chanel, Blair has her favorites as well: Narciso Rodriguez, Behnaz Sarafpour, and Marc Jacobs all keep her in good supply of prim dresses and tapered pants. Though Selma has cropped her hair into a platinum Mohawk, a turned-under bob, and a pixie cut, of late she has cleverly updated de la Fressange's classic style with a spiky brunette hairdo that suits the crispness of her wardrobe perfectly. It seems that, for the Minimalist, hair must either be worn fairly short and perfectly coiffed or, if worn long, seemingly altogether ignored so as not to be too fussy and primped.

Blair is not a big fashion risk taker, and perhaps that's the point: the clever actress has isolated a style that works for her and abides by it. She said, "I know what I like, but I don't really know what's in fashion." And that is one of the keen advantages of a minimal wardrobe: it never really goes out of style. Even when Inès walked down the runway at Jean Paul Gaultier's Spring/Summer 2009 Haute Couture show at the age of fifty-one, she was one of the most envied models onstage in an asymmetric tuxedo dress—a design that boasted Gaultier's flair for quiet, elegant tailoring rather than the over-the-top showmanship or intricate embroideries that have also become signatures of his presentations.

De la Fressange and Blair both seem to have a sobering effect on whatever look they try on: decorousness is discarded or muted in order to highlight natural beauty and confidence. While we can take cues from the consistency of the preppy Minimalist's aesthetic and her strong sense of personal style, we can also glean a sort of tempered adventurousness: Blair is brilliant at centering her look with an odd bohemian accessory, while Inès, in her work for Roger Vivier, is forced to embrace the house's hallmark inventiveness. She throws in a small bow here, or a splash of color there. Minimalism is about restraint, but it doesn't have to be bleak. Inès explained, "While I veer toward the classic, near-Minimalist aesthetics—white walls, soft, muted pastels, etc.—there's a part of me that *loves* color. And not just any color—offensively bright, super girly *pink*. I think it's why I'm so drawn to Sofia Coppola's *Marie Antoinette*."

Perhaps in *Marie Antoinette*'s overwhelming opulence, Inès de la Fressange in fact sensed the kindred spirit behind the lens: Sofia Coppola, daughter of legendary director Francis Ford Coppola, is a respected filmmaker and director in her own right and has emerged as one of the most influential Minimalists of the twenty-first century. Sofia, like de la Fressange, projects accessibility despite a privileged upbringing and an impressive career to date.

"anyone who wears a brand name on the red carpet is a fashion icon now. I just shop in my friends' closets and pull things that are not vintage, not chic, not anything."

—Selma Blair

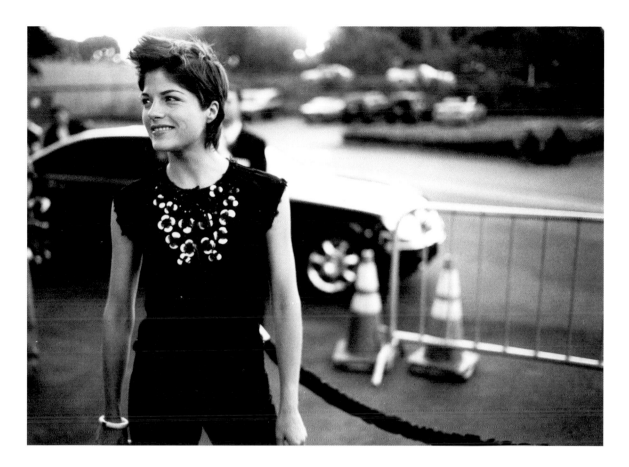

Though Coppola began polishing her minimalist sensibilities early as an intern for Chanel at the age of fifteen, she was also a poster child for the grunge end of the minimal spectrum in the years to follow; she was rarely photographed in anything but a worn T-shirt, jeans, flip-flops, and a ratty sweater. She actually designed a series of T-shirts—entitled Milkfed— in collaboration with her friend Kim Gordon of Sonic Youth in 1998. Coppola's follow-up designer collaborations came to fruition in the decade to follow and showcased how her personal style had been refined and evolved by years in front of the camera. She created a line of chic hipster sweaters for the brand Lutz & Palmos for Fall/Winter 2005, and collaborated with the French luxury brand Louis Vuitton on an accessories capsule collection for Spring/Summer 2009

and Fall/Winter 2010, respectively. The latter collaboration is unsurprising, given Coppola's ongoing status as artistic director Marc Jacobs's muse.

Jacobs designs his namesake brand as well as the Louis Vuitton collection, and happily provides Coppola with an endless array of chic but chaste cocktail dresses from each in black, white, or the occasional red. Other Jacobs favorites are the schoolgirl button-down blouses and vintage-inflected boxy jackets that have come to define Coppola's aesthetic in recent years. She rarely wears trousers, except in a coordinated suit or tux. If she is on set, she dons tapered jeans or cotton pencil-leg pants. She, like Audrey Hepburn and Natalie Portman, embraces the ballet flat as her daily footwear, and outerwear favorites include the vintage mink stole and the classic trench coat.

Page 134: Inès de la Fressange on the runway for Jean Paul Gaultier's 2009 haute couture Spring/Summer collection. Page 135: De la Fressange at Chanel's Spring/Summer 2011 runway show at the Grand Palais, Paris, 2010. Above: Selma Blair at a screening for *The Good Girl* in Los Angeles, 2002.

Page 138: Sofia Coppola in a Dior Homme "le smoking" tuxedo, photographed by Inez van Lamsweerde and Vinoodh Matadin, 2004.
Page 139: Coppola, photographed by Craig McDean for *Vanity Fair*, 2006.
Left: Coppola leaving the Louis Vuitton Spring/Summer 2009 runway show, Paris, 2008.

"My mother was always very understated and low-key, too. It's not something I deliberately cultivate, but I think there are people who want to be looked at. As a writer or observer, I'm more interested in looking."

—Sofia Coppola

That is not to say that Sofia doesn't have her own eye for minimalism: upon seeing his boutique designs for the French minimalist fashion company A.P.C., she commissioned French architect Laurent Deroo to create her vacation house in Belize. At her request, the home was to be configured entirely of an amber-toned wood, and was constructed with intersecting planes as roofs and walls, as in the mid twentieth-century modernist style popularized by Frank Lloyd Wright. Coppola also dressed Bill Murray's protagonist in the minimal designs of Helmut Lang for her Oscar-winning 2003 film *Lost in Translation*, thereby playing up the character's loneliness and introversion.

As an industry insider and a veteran Hollywood kid, Sofia understands the power of expressing a great deal in the simplest, most direct way possible. Her wardrobe embraces minimalism in a manner that seems well thought-out and natural. Her hair and makeup look nearly effortless. A natural brunette, she has on occasion lightened her hair but has almost never styled it formally. Slightly wavy, it usually hangs just below her shoulders. Similarly, her makeup is spare, if noticeable. On occasion, she will put on a rich red lip tone to create a contrast with her otherwise neutral face.

Although Sofia has cited Tina Chow and Lauren Hutton as style muses, the secret to her look is its lack of cultivation: she is always well put together but never appears to be trying too hard. She achieves this laissez-faire minimalism by remaining consistent with her silhouette, pairing classic luxury goods with street fashion, and adding vintage accessories or outerwear to seasonal designs. Nothing is overly polished, but it's clear that her styling is thoughtful and intentional.

Sofia Coppola's cool minimalism is echoed by a younger but equally intriguing star: the blond beauty Clémence Poésy, came into the spotlight as Fleur Delacour in *Harry Potter: The Goblet of Fire* (2005) and as Chloë Villette in *In Bruges* (2008). As of 2007, Poésy has been affiliated with another couple of "Chloës" as well; she, Chloë Sevigny, and Anja Rubik are the spokesmodels for the fashion brand Chloë's fragrance. As the daughter of French theater director and teacher Etienne Guichard, Poésy has always been an actress, but her uncanny ability to make a smocked shirt and a pair of leggings look avant-garde has landed her the role of fashion muse as well. She has been featured on the covers of *Nylon*, *i-D*, *Jalouse*, and *Cosmopolitan*, among others, and her look—even in editorial form—is never overstyled or fussy. Her lithe frame is consistently emphasized by light cotton skirts and plain blouses. Her hair is usually worn down, a bit tousled and parted in the middle. Her accessories, however unembellished, are luxe—from Birkin bags to chic slouchy leather boots. These fashion forward touches, which only fortify her style of relaxed minimalism, earned Poésy a walk-on as Chuck Bass's girlfriend during the fourth season of the CW's *Gossip Girl*.

Poésy may be in the know when it comes to emerging trends, but she also knows how to stick with something when it works: she wore the same pair of Chloë Myrte sunglasses for three years, as they flattered her face and completed her look better than any new acquisition might have. We can also really learn from Clémence's natural palette: with less black, white, and gray and more pastel and earth tones in her wardrobe, she offers an update on the classic minimal monochromism.

Even though Clémence has worn Valentino, Chanel, and Gaultier in fashion editorials and on film, her clothes in person rarely showcase a brand name. Her most recognized fashion coup was when she wore an anonymous black bowler to the Balenciaga Fall/Winter 2007 runway show, and in doing so conveyed a willingness to add an offbeat element to her otherwise downplayed style. She told *Interview* magazine in 2008, "[fashion] has to be a game. I went grunge as a teenager. I put holes in all my clothes. I think it's too bad when teenagers become conformist in terms of fashion, because it's the ideal time to go off into your own crazy thing without looking completely idiotic." Though she has certainly reined in her look to project a bit more control as an adult, her experience clearly encourages experimentation. Whereas some Minimalists convey rigidity

in their adherence to simplicity, both Coppola and Poésy give off a vibe that's much more relaxed and intuitive. Their respective styles encourage us to trust our own sensibilities, with an important caveat: play it cool. Stick with what's classic and stay away from anything too garish.

Though that may not have been exactly the message that Ellen DeGeneres conveyed when she closed designer Richie Rich's Spring/Summer 2011 fashion show for Heatherette in a silver iridescent suit, white high-tops, and a miniature hat set askew, the beloved comedian and daytime talk show host has been steadfast in her embrace of an unwavering Minimalist style since her rise to fame in the mid-1990s. While most Minimalists thrive on a wardrobe of simple separates, Ellen has always pursued total-look ensembles by iconic reductionists like Gucci, Raf Simons

for Jil Sander, and Marc Jacobs. Whether dressing in velvet and satin tuxedos for the red carpet or in simple black or white broadcloth suits for daily appearances, DeGeneres's trademark austerity is a definitive fashion statement. As the cover model for *W*'s February 2007 issue, Ellen told the magazine, "I feel myself more of a person than a gender. When people show me clothing that seems very, very feminine, it's hard for me to embrace that, because it just doesn't feel like me." Though few among us can afford the variety of bespoke ensembles that Ellen's closet must offer, her look demonstrates an important dictum of Minimalist fashion: androgyny. Ellen's suits are less masculine tailoring than actual men's suiting adapted to her female form. Paired with her short blond hair and spare makeup, her wardrobe removes gender from the equation. Though Ellen's style is impressively polished and speaks to minimalism's rejection of nostalgia and gender stereotyping, it doesn't provide a great deal of flexibility in terms of emulation, only inspiration!

The prototypical androgynous model since her 1993 debut in the British *Vogue* editorial "Anglo Saxon Attitudes," photographed by Steven Meisel, Stella Tennant abides by many of the same style cues as Ellen DeGeneres in terms of severe tailoring and an absence of embellishment but has a slightly softer and more fashion-forward look. When she emerged on the fashion scene with a nasal septum ring, choppy hair, and the facial features of a pubescent boy, the gangly Tennant provided a look that complemented the monochromatic tailored separates of 1990s minimalism. By the middle of that decade, she had become the muse of Karl Lagerfeld, who touted her "modern allure."

"I think they should have a Barbie with a buzz cut."

—Ellen DeGeneres

A MINIMALIST'S
Must-Haves

1. The Fitted Blazer

A tailored jacket is the perfect Minimalist throw-on for a casual dinner or day at the office. When worn over a tee or even smartly tailored shirt, it presents a crispness crucial to the Minimalist silhouette. Riccardo Tisci, Givenchy's current creative director, is a master of the perfect fall jacket. Whether worn matter-of-factly with a T-shirt and jeans, or over a taut black cocktail dress, Tisci's collections afford an unwavering minimal chic, gift wrapped as the classic wardrobe staples of the tuxedo jacket and the fitted blazer.

2. The Fashion Tee

Every minimal wardrobe requires affordable basics to anchor the more luxury items. Owning a good tee—fitted but not skintight, worn without being tattered or soft, and in a fashion-forward color such as gunmetal gray or bone is paramount to building a Minimalist look. In James Perse's collections, the basics are star: his short- and long-sleeve tees, tanks, and shirt dresses are manufactured in luxury cotton weaves that leave the fabric soft, body skimming, and amenable to styling. When it comes to comfort and affordability, no Minimalist can avoid picking up one (or four) of Perse's tees to layer under a blazer, sweater, or even a piece of statement jewelry. His tees can be dressed up or down, and they never really go out of style.

3. The Basic Pump

Though the classic flat is also a viable staple for Minimalist dressers, the basic pump in a variety of colors and textures can take the stylish Minimalist from day into night, year-round. Marni designer Consuelo Castiglioni has been known to use stiffened leathers and synthetics to induce volume in otherwise body-skimming dresses, and her attention to sculptural shape is enlivened by a consistently surprising palette of warm, celebratory tones to temper the more primary ones. Like her clothing, Castiglioni's shoe collection is architectural and imaginative without being dreamy or sentimental. Color block hues and shiny, hardened materials provide a shoe that easily diversifies the Minimalist ensemble, without veering away from its mandates to simplify and reduce.

4. The Box Bag

Miuccia Prada's 1985 nylon backpack was nothing short of a fashion phenomenon: it inspired countless minibackpack knockoffs and offered a legitimacy to the "lowbrow" luxury fashion design while still providing a go-to accessory that could be paired with nearly every outfit. Sofia Coppola's leather handbag collection for Louis Vuitton occupies this role in contemporary fashion. The bags are high-quality leather and suitable for day or for cocktails. With their classic, vintage shapes, they are the quintessential accoutrements for today's Minimalista. The quilted leather box bags made famous by Chanel are also suitable as a Minimalist carry-all, and though they have been knocked off ad infinitum so as to be affordable, they haven't lost their impact.

5. The Sheath Dress

Whether worn as a stand-alone slip for a summer party or underneath an oversize sweater, the reductive sheath provides a crucial basic. As such, the sheath has been a part of the collections at Calvin Klein since the late 1980s, and it has mutated from Calvin's countless iterations of silk, cotton, viscose, and even lace tank and strapless dresses to Francisco Costa's more recent efforts, which appear more as engineered sleeveless panels across an androgynous body. Whether soft or

1) Givenchy blazer ensemble, Fall/Winter 2010–11; 2) James Perse cotton T-shirt; 3) Marni Mary Jane pump; 4) Sofia Coppola for Louis Vuitton handbag, 2010; 5) Calvin Klein shift dress, Spring/Summer 2011.

A custom-made wedding gown designed by Helmut Lang for her 1999 ceremony only reinforced her dedication to Minimalist styling. Though Tennant is well known for her somber stare—having never smiled in a fashion image previous to a 2010 portfolio for *V* magazine—and the clothes she wears are frequently Minimalist staples such as the trench coat, the tuxedo, or the fitted sheath dress, she always appears spirited and fresh. Stella's look is as impactful as ever in recent years, demonstrated amply by her star turns in the advertising campaigns of Balenciaga, Burberry, Pucci, Vera Wang, Marc Jacobs, and Salvatore Ferragamo, among others.

The granddaughter of the Duke and Duchess of Devonshire, Tennant possesses a look that owes much to a certain repressed elegance characterizing the traditional British beauty. The model readily embraces this "plainness" with a minimum of makeup and a seeming indifference to her personal styling that belies the icon she has become. Tennant's face is so synonymous with Minimalist design and culture that the model was featured in a cameo appearance for Francisco Costa's Fall/Winter 2010 Calvin Klein presentation, which journalist Nicole Phelps deemed "pared down in the extreme." Tennant's trick seems to be her mastery of the interplay between classic and punkish, boy and girl, luxurious and everyday. She will happily wear an oversize sweater on top of a pair of impeccably tailored trousers. Though usually spotted in flats, the model's gait looks as effortless in a pair of unadorned leather stilettos. If she dons a kilt skirt, a sharply tailored overcoat might hide most of its patterning, save for a glimpse. Tennant's style is a balancing act, and in many ways, she is an amalgam of all of the great Minimalists in this chapter.

There are several universal lessons we can learn from the Minimalists, regardless of their individual bent. Though a light tan is not discouraged per se, wearing gobs of makeup is a no-no: Why overdo your face if you're looking for a streamlined body? Pick a hairstyle and stick to it—make it your signature. Try to stay away from anything too girlie, as it won't suit your more basic sartorial sensibilities. Strive for consistency in your wardrobe, for if you play your cards right, your Minimalist classics can last you a lifetime. Though the bulk of your clothing will be understated, don't be afraid to throw in an odd accessory here or there, or to infuse a splash of color into an otherwise neutral palette. Finally, luxury is your friend: learn how to discern quality in the simplest things. In the end, this will allow you to make fewer purchases that will contribute more to your closet. Though some might insist that a Minimalist is born, not bred, paring down might be the best—and simplest—fashion decision you'll ever make.

Opposite:
Stella Tennant, photographed by Craig McDean for *Harper's Bazaar*, February 2002.

R

KERS

"Sometimes you
have to sacrifice your
performance for
HIGH HEELS."
—Gwen Stefani

Opposite: Cher wearing a Bob Mackie headdress and sequined gown on *The Sonny and Cher Comedy Hour*, 1973.

ndy Warhol once said, "If you want to know all about [me], just look at the surface of my paintings and films … and there I am." So too does your personality exist, Rocker, in the countless costumes that you configure. Constantly reinventing yourself, you shine in complete-look ensembles driven by self-expression; these looks are often both a combination of different styles or personas, and just as often, extreme in decoration or fit in order to detract attention from anyone and everyone. You might create your own clothes or just embellish preexisting designs; either way, your look is always unique. If you're under the weather one day and hot and bothered the next, your blue hair is quickly dyed a fiery red. Sequins, leather, rubber, and snakeskin are your "basics," and a corset is always more comfortable than a twin set. As you forge ahead with your next look, take note of the dress-up strategies that help keep beloved center-stage gurus in the limelight.

The tradition of rock style is nothing if not self-referential, and after four decades on *Billboard*'s Top 100, Cher—born Cherilyn Sarkisian—is one of the most iconic Rocker

prototypes. The "Goddess of Pop" first made a name for herself as a performing and romantic partner to Sonny Bono with early hits such as "Baby Don't Go," "The Beat Goes On," and "I Got You Babe," all released between 1965 and 1967. By 1971, the raven-haired beauty and her quirky husband had landed roles as the hosts of *The Sonny and Cher Comedy Hour*.

Cher has been consistently recognized as a mainstream talent, with hit singles such as "Take Me Home" (1979), "If I Could Turn Back Time" (1989), and "Believe" (1998), not to mention an Academy Award nomination for her role in *Silkwood* (1983) and a Best Actress win four years later for *Moonstruck*. But if her work has been easy to celebrate, her style is more controversial. She first sparked conflict while still at CBS, when her navel-exposing tops and low-rise bell-bottom pants caught the attention of censors. She drew her early outfits and had a friend construct them, but before long, her straightened black hair, squared fingernails, and sharp wit had caught the attention of designer Bob Mackie, who dressed Cher for the four-year duration of the TV comedy hour. His elaborate crystal beading, sheer fabrics, and penchant for applied feathers have since become the cornerstones of her

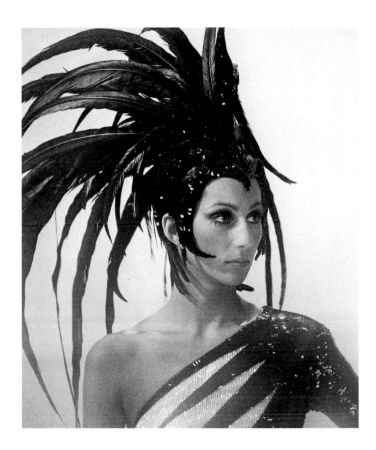

" **I**'ve always taken risks, and
never worried what the
world might really think of me."

—Cher

most memorable looks—on- and off-camera—
over the last forty years. Mackie has said of
the pop sensation, "She was like a big Barbie
doll. . . . She had such an unbelievable
body. . . . She could wear anything."

And she did: in the years that followed,
she sported a feathered Cherokee
headdress for "Half Breed" (1973), a black
lamé midriff-baring dress with a matching
spiky feather headpiece for the 1986
Academy Awards, and a sheer fishnet
bodysuit with black detail for minimal
frontal coverage only for the "If I Could
Turn Back Time" video, which was banned
from airing on MTV before 9 P.M. when it
was released in 1989 (due to the raciness
of her costume). The latter ensemble
was readapted for her appearance at the
2010 Video Music Awards, where she
poked fun at MTV and at once reaffirmed
her status as one of the original Rockers.
She explained, "I'm the oldest chick with the
biggest hair in the littlest costume. I have
shoes older than most of these nominees."

Cher often performs in Las Vegas and
still looks most at home when inhabiting
those fantastical feathered frocks derived
from the classic showgirl. She has wisely
stated, "Until you're ready to look foolish,
you'll never have the possibility of being
great." For Cher, success stems from one's
ability to impose an individual phantasma-
goric persona, creatively and sartorially.

Karen "O" (for Orzolek), lead singer of
the Yeah Yeah Yeahs, aspires to the same
presence. Though currently based in Los
Angeles, Karen identifies most strongly
with New York after having grown up
in New Jersey and attending New York
University's Tisch School for the Arts. She
has collaborated musically with a diverse
range of artists—from Johnny Knoxville
to Ol' Dirty Bastard—and composed the
magically inventive soundtrack for the
film adaptation of *Where the Wild Things*

Right: Karen O onstage in Reading, England, in a custom-made costume, 2009. Page 154: Patti Smith in a men's white shirt and tie, 1975.

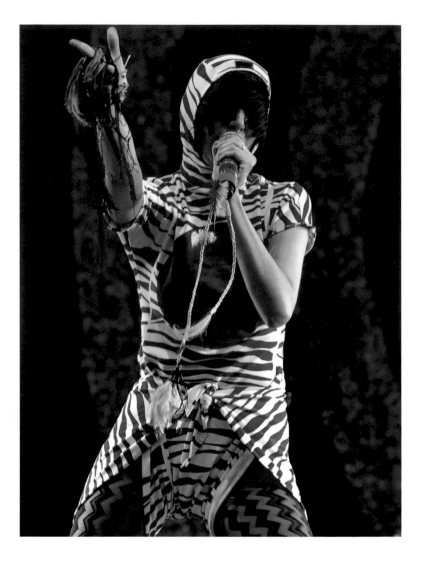

Are (2009), directed by her ex-boyfriend Spike Jonze. When she contributes background vocals, they're often screams and primal noises, as with the Flaming Lips's 2009 album *Embryonic,* and complement her wild and unpredictable onstage persona. Unsurprisingly, KO and bandmates Brian Chase (on drums) and Nick Zinner (on guitar) signed with Interscope, a label that Karen has insisted breeds deviant "rock star personas" like Gwen Stefani with No Doubt and Marilyn Manson.

Karen met designer Christiane Joy Hultquist in 2001, and "Christian Joy" has been creating found-object, stuffed, painted, embroidered, and torn ensembles for Karen O's appearances ever since. The costumes have earned Karen a reputation as a quirky fashion icon: *Spin* magazine gave her its Sex Goddess awards in both 2004 and 2005. Her style exploits the glam-rock tradition with cotton jersey jumpers, vintage prom dresses, ripped fishnets, painted leggings, and collectible sneakers—all in Day-Glo colors. Joy explained, "I like lots of color.... Orange is so good because you can wear [orange tights] on your legs and not feel like you're wearing an entire orange outfit. It's more about punches of color here and there. It makes your outfit look more exciting, and it makes you feel better too."

Like Cher, Karen O is a bit of a sartorial rebel, and while she might adhere to Christian Joy's style bible religiously, she flatly turned down an interview request from *Vogue*, as she viewed the magazine as being too conformist and imposing a narrow view of fashion. She has divulged, "Like everything else with this band, [the clothes] are all like experiments or case studies. It's like seeing how much I can get away with."

Karen's look, which is do-it-yourself to the max, is more attainable for the everyday Rocker than Cher's Mackie-engineered concoctions. It's about pairing a one-of-a-kind jacket or dress with casual accessories or clothing staples such as All-Star sneakers or leggings. And don't be afraid to overglitter, overstud, or oversequin that unique piece. Having reflected on her wardrobe, Karen told *Elle* magazine in 2009, "It's definitely battlewear, which is usually complemented by an outlandish makeup job that I've done myself, like war paint.... The armour helps me prepare for the performance."

If Cher paved the way for fantasy and exaggeration within the Rocker wardrobe and Karen O has evolved that legacy through the costumes of Christian Joy, the latter indie Rocker has also drawn from the DIY stylings of "Godmother of Punk" Patti Smith. Smith, a rock legend and revered poet, has called her look "expensive bum," but her careful coordination of oversize blazers and duster coats, "the thinnest, lightest, if-a-spider-wove-them-they-couldn't-be-thinner" T-shirts, skinny jeans, and worn leather boots could never be considered spontaneous or wanting for distinction. After the T-shirts tore, she held them together with safety pins. Though she didn't smoke regularly, she posed for various photographers with a lit cigarette, and confided in a friend, "I know I'm a fake smoker . . . but I'm not hurting anybody and besides I gotta enhance my image."

Smith was a cornerstone of the early New York punk scene in the 1970s. Having dated photographer Robert Mapplethorpe and playwright-actor Sam Shepard, debuted the album *Horses* (1975) with the Patti Smith Group, and cut her hair like Keith Richards, Smith was considered a compelling figure of that era and labeled a "gothic crow" by an admiring Salvador Dalí. After an extended hiatus to raise two children with guitar player Fred "Sonic" Smith in Detroit, Patti returned to New York and released the critically acclaimed albums *Peace and Noise* (1997) and *Gung Ho* (2000). She has been cited as an influence on artists as diverse as Sonic Youth, U2, and actress Ellen Page, and was the subject of the 2008 documentary *Patti Smith: Dream of Life*.

Smith's fashion sense has always been a bit androgynous, as she's paired androgynous tailored clothing with chic Minimalist accessories. Though she has said "artists are traditionally resistant to labels," she has also championed tailored coats by Ann

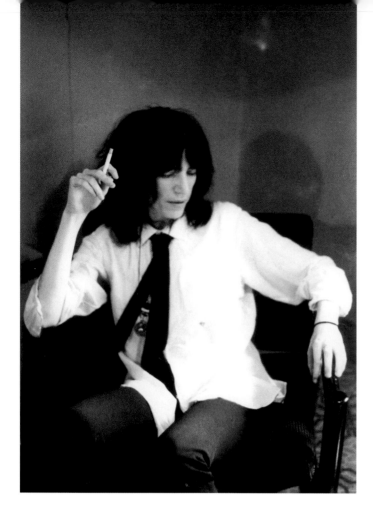

"my sunglasses are like my guitar."

—Patti Smith

Demeulemeester or trousers from Dior as luxury foils for her nondescript white shirts or mannish pants. Patti is influenced equally by the Rocker threads of John Lennon and Bob Dylan as well as the neat dress wardrobe of Audrey Hepburn in *Funny Face*. Smith professed her dedication to well-fit jackets in Oprah's O magazine, musing, "They have a certain nobility about them."

The Rocker's vogue is expressive, overstated, and well attended to at all times, but it's also defiant and seeks to shock. Smith confessed that part of her love of performance comes from the stylistic freedom she is allowed, even if it's studied dishevelment: "I decide what I want to wear, whether I want to comb my hair. No one ever told me what to do, and no one tells me now. . . . Even as a child, I knew what I didn't want. I didn't want to wear red lipstick." Patti engineered a sort of American bohemianism for the female Rocker, which was as much about comfort, function, and a magpie pairing of luxury fashion and secondhand duds as it was about resistance and the rejection of mainstream femininity.

If you're into rebellion, steer your wardrobe more toward the punk end of the style spectrum. Your jeans might be a bit faded or tattered, and that's okay— they'll help your look along. While the more outlandish Rocker might claim a feather collar or a printed bodysuit as a signature, the right pair of boots or the right taut pant can have the same effect.

Alison Mosshart, one half of the über-cool duo the Kills and singer for the Dead Weather, subscribes to the Patti Smith strategy of dressing. Like Smith, Mosshart likes her couture: she wears a signature pair of boots designed by Hedi Slimane at Dior. She purchases two or three pairs of the Dior boots in different colors each season, and

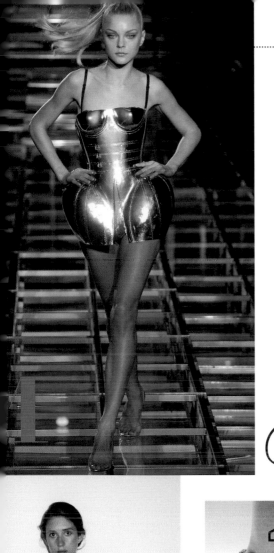

A ROCKER'S
Must-Haves

1. The Corset

Nothing makes a controversial statement like underwear worn as outerwear. If a slip dress or a brightly colored bra aren't having the impact you had hoped they would, a bustier or slinky corset dress will definitely do the trick. When Madonna wore a custom-made Jean Paul Gaultier cone bra and corset dress for her Blond Ambition tour in 1990, the world took notice—and famous Rockers have been mimicking that look ever since. A corseted bustier can be worn under a fitted blazer and above a tailored pant to maximum effect for cocktails, or you can brave the reviews in a body-skimming corseted dress for evening.

2. Extreme Footwear

The platform pump, thigh-high or cowboy boot, and geisha's sandal have all been favorites of the Rocker set at some point or another, as nothing gets a head to turn faster than a hot pair of shoes. When Lady Gaga wore Alexander McQueen's ten-inch jewel-encrusted platform ankle boots in her "Bad Romance" music video, she affirmed her status as a Rocker and a fashion icon simultaneously. If you're looking for extreme footwear that you can walk in, anything with a lift of more than four inches in an exotic leather or a bright palette is sure to garner attention.

1) Dolce & Gabbana corset dress, Spring/Summer 2007; 2) Alexander McQueen platform shoe, Spring/Summer 2010; 3) Cynthia Rowley black nailhead tights, Fall/Winter 2009.

3. The Spandex Pant or Legging

Though a basic colored spandex legging in a shiny or matte finish will suffice, many designers have created more exquisite versions of this Rocker staple over the last few seasons. Cynthia Rowley's nail-head heat-embossed black tights feature black shiny baubles that reflect as you move your legs to create an effect both titillating and rock-and-roll.

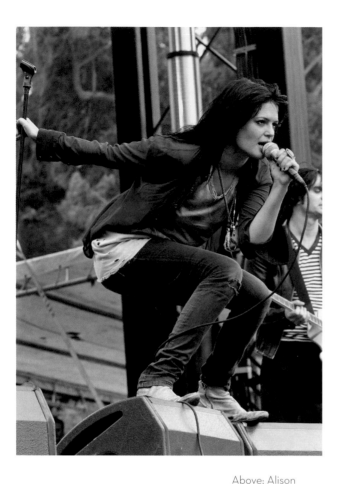

Above: Alison
Mosshart in her
signature gold Dior
boots, onstage in
Golden Gate Park
with the Dead
Weather, 2009.
Opposite: Rihanna
in a custom-made
stage ensemble at
the 2009 American
Music Awards.

is also dedicated to Marc Jacobs T-shirts, among which the "Photo Studio" design of 2006 is her favorite. Alison, like Patti, has a keen eye for pairing luxury signatures with tattered, punk duds. To emulate their style, it's important to find those foundation basics—the worn T-shirt or stovepipe pant—that will become your fashion uniform, and then offset these items with different high-fashion accessories.

In a 2010 conversation with Derek Blasberg for *Interview* magazine, Alison admitted that she had been wearing the same jeans for her last three tours. When Blasberg also noticed that he'd seen her leopard blouse before as well, Mosshart explained, "Yeah, I get hooked on things. Mainly that's because of temperature reasons and movement reasons. T-shirts and really thin shirts are good because I get hot and sweaty when I'm jumping around." Though Alison claims to reject the moniker of fashion icon, she has cultivated a distinct style that is both practical and removed from the fashion system, yet ultimately attentive to its whims. She explained, "To me, someone walking down the street in head-to-toe Gucci says to me they have no imagination and lots of money. That's not blowing my mind." Styling is paramount when emulating the punk-hipster look. Alison is particularly adept at off-kilter layered combinations: she's been known to cover a band T-shirt with a lumberjack plaid followed by a Navajo blanket, all over a pair of ripped jeans and her Dior boots.

Alison's style owes a great deal to the subversiveness of street fashion. Yet the trappings of punk—ripped, torn, and aloof—aren't the only qualities that can convey grittiness in the Rocker wardrobe. Though the Barbados-born beauty and Def Jam recording artist Rihanna has recently blossomed into a high-fashion magnate, her early studio albums *Music*

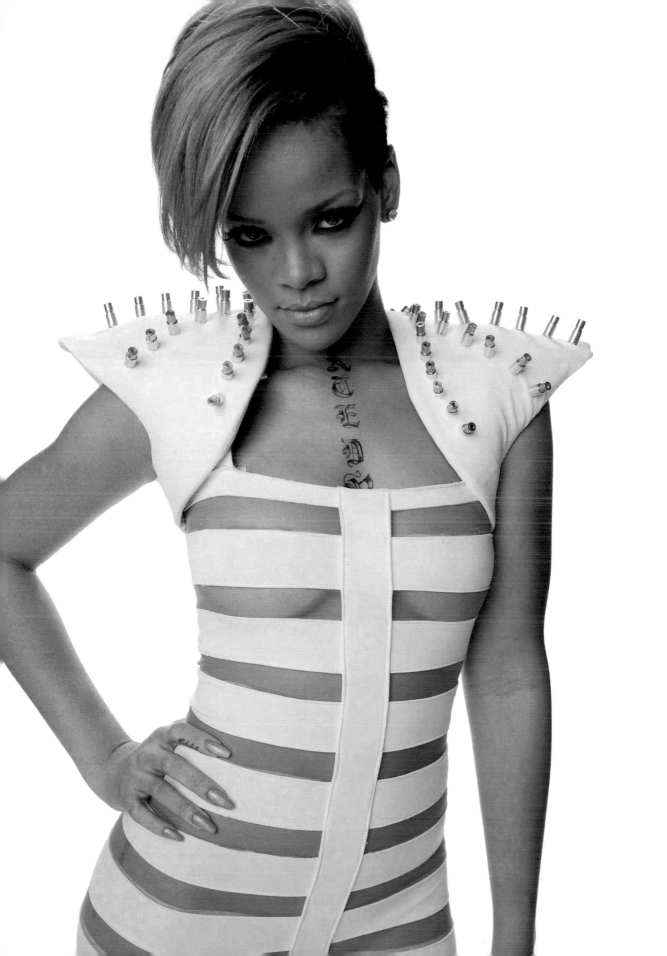

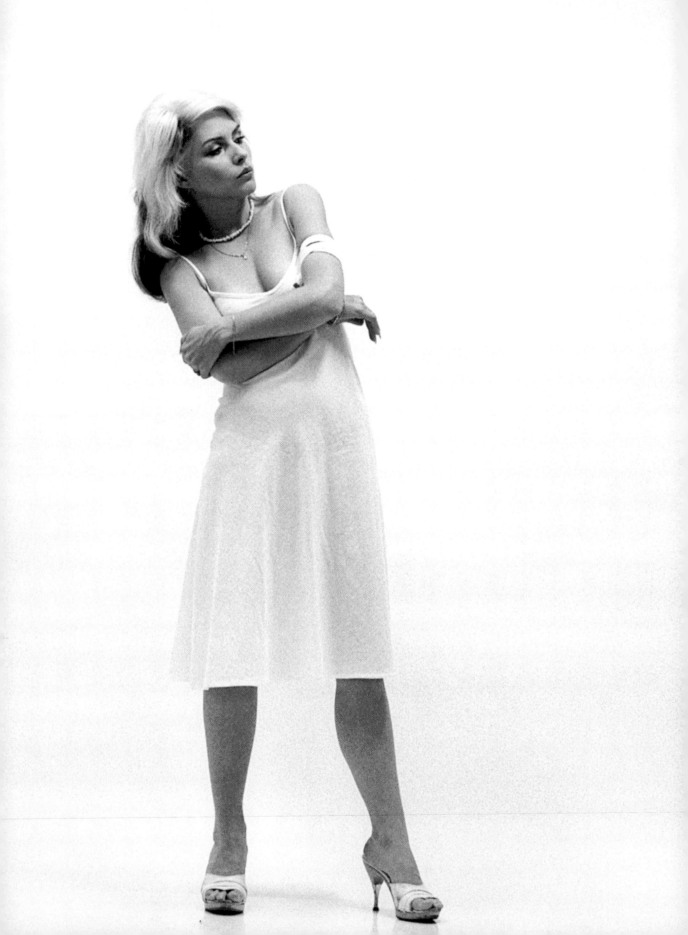

of the Sun (2005) and *A Girl Like Me* (2006) championed a young star that was more interested in a style-y sneaker than a leather boot or platform pump. Rihanna was frequently seen in pricy denim, fashion-fitted hoodies, midriff-bearing tees, big sunglasses, and high-tops: a style that intertwined her teen superstar persona with urban street fashion. Her tough-as-nails look was helped along by multiple tattoos, including Roman numerals, a trail of stars, a skull with a pink hair bow, and, most famously, a handgun along her right side.

As Rihanna's style evolved, she began to incorporate a key material into her closet of Rocker duds: leather—in every color and cut imaginable. While the leather jacket has become a part of many a mainstream wardrobe, Rihanna drew inspiration from the coordinated jacket and miniskirt ensembles, covered in studs and buckles, championed by Tina Turner in the 1980s. Tina's lightened Rocker locks may have also influenced Rihanna to cut her hair into the asymmetrical, short, spiked style that has ultimately become her signature.

Hair is as important a consideration as any single part of the Rocker look; a hairstyle can identify a star all the way through her multidecade career. Cher's hair has always been long and black as coal, while Karen O is notorious for her hipster bowl cut. Patti's Keith Richards–style hair put her on the map as a trendsetter, and Alison's unkempt, shaggy bangs have been one of her few consistent signatures. Sometimes all it takes is a particular color to conjure the essence of a specific Rocker, as with Deborah Harry. While some crooners prefer a more extreme cut, for Harry it was all about showing off those sexy platinum locks.

Whether worn under a bandanna, teased for a more vampish look, or dyed two different tones, Debbie's hair remained blond throughout her career and was imitated by fans the world over during the late 1970s and early 1980s. The name of Debbie's New Wave band, Blondie, was often mistakenly assumed to be a reference to her tresses, which inspired the band to produce a button in 1979 that read BLONDIE IS A GROUP. The singer also helped popularize hot pants, bodysuits, and over-the-knee leather boots, and she is a figurehead in punk fashion and queen of New York City's downtown set, influencing many Rockers to go platinum after her, including Madonna and Courtney Love, not to mention numerous women around the world. Harry told *New York* magazine in a 2008 interview, "I don't want to see everybody dressed the same. I want to see somebody who's got some color, who makes a statement about who they are, and is prepared to be sneered at. When I used to go uptown, before punk became acceptable and fashionable, it was a rough trip, with people staring and making nasty remarks." While she adopted the tight black clothing of the British punks some of the time, her explorations with bright colors and contrasting fabrics helped her create her own unique style. She also wore a great deal of makeup onstage, including typically smoky eyes with plenty of black eyeliner, and red, hyperglossy lips.

Though he is perhaps more well known now for his graffiti designs for Louis Vuitton handbags, Stephen Sprouse designed Debbie's stretch bodysuits with contrasting chiffon skirts and layered pieces in electric colors. The look is easily adapted today via the endless cotton jersey and stretch separates that are available at fast fashion outlets and activewear stores, but back then, the Harry-Sprouse collaboration between rock star and fashion designer was unique, akin perhaps only to Vivienne Westwood's work with the Sex Pistols.

Opposite: Debbie Harry at the Parallel Lines album cover shoot, 1978.

THen & NOW

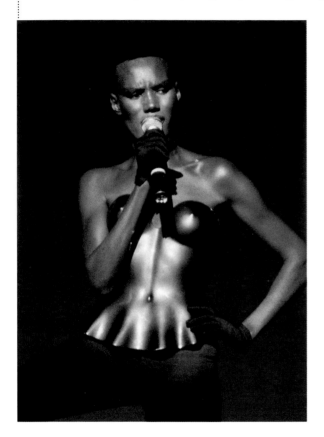

Though most of us will temper our Rocker tendencies to get along in the real world, two formidable-style demigoddesses that seem to exist only on stage will forever serve as inspiration. Grace Jones once told an early-show host that she was "cramping her style," as the divine performer is more nocturnal vampire than "morning coffee." Grace's sharp cheekbones and piercing eyes are only enhanced by the razor-edge flattop hairdo that she has consistently sported since the mid-1980s. Jones doesn't look particularly female or male in any given look and, like many Rocker icons, is a heroine of the gay and transvestite communities worldwide.

Jones's unique look, which draws on primitive and exotic themes, was initially a product of the styling genius of one-time romantic partner Jean-Paul Goude and has since benefitted from the somewhat degendered sculptural designs of Issey Miyake. Jones has collaborated sartorially with the late Keith Haring and Viktor & Rolf, and the latter commissioned Jones to perform "La Vie en Rose" at a party for the release of their Flowerbomb fragrance in 2010. Jones's only costume requirement? "I want bare legs."

In fact, Grace is more frequently than not seen without pants, a style decree that has recently been adopted by Lady Gaga, who has catapulted to fame as a result not only of her volatile lyrics but also of her no-boundaries wardrobe, has called Jones "Jesus" and cites her as her most significant fashion influence. Though Gaga has worn the blond hair, leather jacket, and dark brows of Madonna circa her Blond Ambition Tour (1990), and drawn from the electric glam-rock costumes of David Bowie and Queen, Jones's willingness to forgo "pretty" for "extreme" is alive and well within Gaga's stylistic fantasy. Gaga has worn everything from a meat dress to Alexander McQueen's famous ten-inch-high python skin fetish platforms.

Nicola Formichetti, now the creative director at Thierry Mugler, has been instrumental to Gaga's stylings. The performer told *Style.com*, "Blood pumps through Nicola's veins like perfume and cigarettes. His brain throbs with misfit royalty, glamour as punk survival, attitude as liberation, style as revolution. . . . Nicola Formichetti is Fashion's Freedom."

While Grace accompanied Andy Warhol to Studio 54 regularly, Gaga idolizes the late artist as an untouchable deity. She created her own Factory-esque entourage, "Haus of Gaga," and calls her collaborator and on-again/off-again paramour Matt Williams "Dada." Gaga champions the power of self-invention, the creative willingness most crucial in the development of Rocker style. The Haus of Gaga may be built on bits and pieces of the sartorial innovations of many performers, present and past, but as Grace Jones has herself said, "One creates oneself."

> "I've always been a rebel. I never do things the way they're supposed to be done. Either I go in the opposite direction or I create a new direction for myself, regardless of what the rules are or what society says."
>
> —Grace Jones

Opposite, left: Grace Jones onstage in Australia in Issey Miyake's "Plastic Body," 1980. Opposite, right: Lady Gaga in Alexander McQueen at the 2010 MTV Video Music Awards.

Today many stars of the stage have their preferred designers, both to help brand their look and to compound their celebrity prestige. Though Leigh Lezark started out as a Hunter College dropout and one of the members of the underground DJ trio the Misshapes, she has established herself firmly as a fashion-world fixture, having produced runway music for Calvin Klein, House of Holland, L.A.M.B., Cynthia Rowley, Tory Burch, Chanel, Sophia Kokosalaki, and Jeremy Scott.

As a DJ in the underground club scene in New York, Lezark became known for her clingy ripped leggings and glittery glam-rock tops, her formfitting minidresses, and her higher-than-high heels. She has cited Debbie Harry as an influence and has certainly reinvigorated her stretch separates look. Leigh's most consistent feature is a shiny onyx, straight, shoulder-length bob, which earned her the role of spokesperson for Charles Worthington's styling range "Front Row." Though she has been featured in a vast array of magazines including *Vogue, Nylon, Self Service, V,* and *Vanity Fair,* appeared in advertisements for Roberto Cavalli's H & M and Levi's X Henry Holland collections, and inspired a Matthew Williamson limited edition caftan design for Belvedere Vodka, Leigh has attained the highest status as an icon within the fashion industry via her connection to Karl Lagerfeld at Chanel.

Though Leigh admitted to the *London Evening Standard* that her favorite little black dress is a body-clinging Hervé Léger, she's got no shortage of Chanel staples in her wardrobe. She is a regular fixture at the Chanel ready-to-wear presentations and reputedly was given one of only two hundred pairs of Karl's gun-heel stiletto shoes. Some may consider Chanel to be too stuffy for rock style, but Leigh's picks

always include feather and fur trims and elaborate beading and champion the more adventurous side of Lagerfeld's collections. When questioned about her affiliation with the brand, Lezark tartly replied, "An old-lady brand?... Have you worn it, ever?" Leigh's unique ability to take high-voltage fashion designs and make them appear youthful and cutting edge stems from her willingness to let the clothing take center stage. With her hair in its consistent bob and very little makeup to detract from what she is wearing, Leigh lets her clothes speak volumes. Perhaps she extracted this ability to appropriate from her culture guru, Andy Warhol, and his Factory. She explained, "They made it their own and made it last. They kept moving forward."

Like Leigh, Rihanna used high fashion as a means to transform her style from subversive to sublime. While Lezark might have embraced the untamed elements of haute couture, Rihanna paired a standard Chanel bouclé skirt with a denim bustier and strings of Chanel's signature pearls. Rihanna's signature has always been melding high fashion and street style. As Rihanna began to sign endorsement deals for Nike, JCPenney, Clinique, Gucci, and Cover Girl, she also started to trade in her jeans and hoodies for some serious designer duds. But while most songstresses might be happy to receive the gift of couture, Rihanna has taken one style risk after another to make sure that each red carpet ensemble speaks to her sartorial personality. She has boasted an impressive wardrobe of leather, vinyl, and net bodysuits, often decorated with the traditional studs or buckles of Rocker leather gear. She wooed onlookers at the Costume Institute at the Metropolitan Museum of Art benefit in 2007 by accessorizing a full-length Georges Chakra gown with Michael Jackson-style black leather gloves. When she showed up to

"I wouldn't want to go down the path of somebody else . . . I want to find my own way."

—Leigh Lezark

that gala in 2009, she put the skirted fashionistas to shame in a cutting-edge leg-o'-mutton sleeve tuxedo suit by Dolce & Gabbana, her angled bob combed over hyperbolically.

Rihanna has consistently cited Madonna as one of her biggest influences, musically and stylistically. She has said, "[Madonna] has reinvented herself throughout her career and moved into different areas. I want to be the black Madonna." The young pop star—who, like Madonna, has her own music, film, fashion, and modeling company, entitled Rihanna Entertainment—makes a point to switch up her hair color and styling constantly and to accessorize with heaps of gold jewelry. She has appropriated Madonna's "Like a Virgin"-era bustier on more than one occasion and is well on her way to filling the icon's shoes.

One of the most important elements of Rocker style is the chameleonlike ability to take on different looks—whether high fashion or mainstream street trends—and make them your own. This means knowing when to put on bright makeup and sculpt an outlandish hairdo, and when to let your personal styling take a backseat to the eccentricities or embellishments of your outfit. While Patti Smith used to come up with clever themes for her ensembles, such as the "Song of the South" look (straw hat, Br'er Rabbit jacket, beat-up leather boots, and rolled-leg trousers) or her "tennis player in mourning," which consisted of all-black separates paired with white Keds, the more contemporary breed of rock star, pioneered by Madonna, references iconic characters and looks from history, such as the *Seven Year Itch* Marilyn Monroe or a disco-era Afroed and bell-bottomed dancer. Rihanna directly channeled Madonna's 1996 *Evita* premiere Frida Kahlo look in 2010: for an appearance on the *X Factor*, she adorned her hair with the large, colorful flowers for which the famous Mexican painter was known.

Madonna Louise Veronica Ciccone debuted her first album, *Madonna*, in 1983, beginning her transformation of the pop music panorama. Her personal style—from the teased, dyed blond hair, white and black lingerie, and tulle tutu days of *Desperately Seeking Susan* (1985) to a platinum blond and red-lipped turn as a Monroe-inspired "Breathless Mahoney" in *Dick Tracy* (1990) to her "modern-day geisha" look for the Grammy Awards in 1999 to her urban cowgirl for the *Music* album (2000)—has always informed and guided Madonna's star. The *Sunday Times* acknowledged Madonna's "revolution amongst women in music.... Her attitudes and opinions on sex, nudity, style and sexuality forced the public to sit up and take notice." These "attitudes," apart from being elaborated in her lyrics, have shown through costumes such as her 1990 Jean Paul Gaultier cone bra, or her leather and vinyl S & M gear for *Erotica* (1992).

ROCKERS Never, EVER...

➤➤
Fear being the center of attention.

➤➤
Dress too conservatively.

➤➤
Shop only current seasonal trend: buy vintage or make your own clothes!

➤➤
Worry about wearing an outfit more than once. The more people see your look, the stronger and more cohesive your fashion identity will seem.

➤➤
Shy away from a haircut. Hair always grows back!

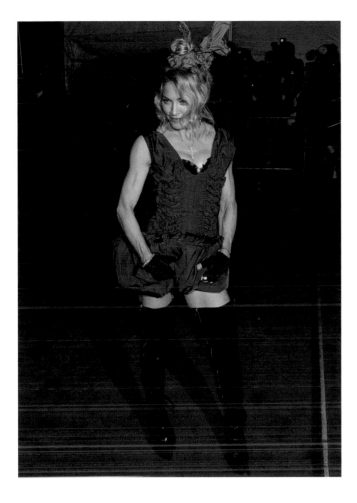

While Cher, Patti Smith, and Debbie Harry might have had their distinct signatures, Madonna changed the rules for contemporary Rockers. Being in the spotlight as a rock fashion icon is now all about reinvention. Draw inspiration from a decade or figure (as Madonna did for her "Take a Bow" video, which boasted the late 1940s suits and veiled hats of Eva Peron's reign in Argentina), and transform your look accordingly. Madonna has said, "I am my own experiment. I am my own work of art." So, if the Rocker look is your aim, you must experiment too: don't get too attached to any one hairstyle, lipstick, or trend. The mission is to keep your audience on its toes. Ultimately, rock style is commanding and impossible to ignore.

When asked what has driven her, Madonna said, "I have the same goal I've had ever since I was a girl. I want to rule the world." And rule she has, for more than twenty years. But as of late, the Material Girl has been wearing mostly ready-to-wear from Versace, Stella McCartney, and Prada, or from Dolce & Gabbana or Louis Vuitton, both of whom commissioned her as a spokesmodel in recent years. Consequently, she has been criticized for neglecting her raw, theatrical style and abandoning her controversial costumes.

Gwen Stefani has long since acknowledged the impact that Madonna has had on her personal style. She told *Elle* magazine in 2007, "A lot of my influence came from her early work, like directly, like a Xerox. . . . Show me one girl my

Madonna in a Louis Vuitton ensemble and Anna Hu Haute Joaillerie at *The Model as Muse: Embodying Fashion* gala at the Metropolitan Museum of Art, 2009.

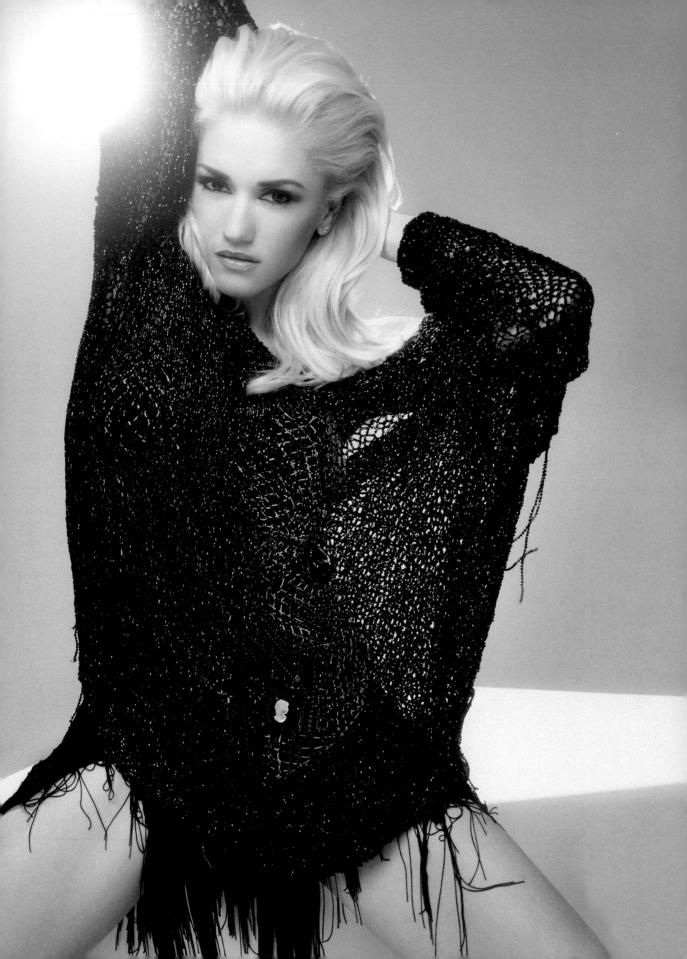

age who was not influenced by her." Stefani created most of her early stage wardrobe and universalized exotic trends like the bindi dot or midriff-baring sari ensemble during the popularity of her band No Doubt's breakthrough album, *Tragic Kingdom,* in 1995. Though Stefani is still known for revealing her abs, her eclectic homegrown style—a combination of ska and street punk looks—has transformed over the years with her introduction to haute couture (her wedding gown was designed by John Galliano) and her forays into fashion design. Her brand, L.A.M.B (an anagram for "Love. Angel. Music. Baby."), is named after one of her solo albums, and with its Guatemalan, Japanese, and Jamaican style influences, has helped further Stefani's style clout. She explained, "Growing up I was always playing dolls and dress up, so it's like I'm still doing the same thing as when I was eight years old."

Gwen's theatrical look, which has always included the platinum hair, arched brows, and red lipstick of her icon, Jean Harlow, has certainly benefitted as well from the styling expertise of Andrea Lieberman, who encouraged Gwen to use couture creations from Lacroix and Dior as luxe foils to counterbalance the edgier aspects of her look at any given time, even her lyrics. Gwen's look always retains her core aesthetic as a toned, California blonde, layering elements of high fashion and countercultural style that coordinate to seasonal or current trends. Stefani draws on many of the same stylistic influences that Madonna has—exotic, vintage, infra-apparel—yet, while the elder pop star changes clothes faster than most people blink an eye, Stefani has retained consistent threads to her style as it has evolved. Stefan Lindemann of *Grazia* magazine has labeled Gwen "the ultimate twenty-first-century pinup. . . . She's modern-retro—she plays on the pinup thing with her vintage aesthetic, but she's also ultra-modern. Like her music, her style is sexy but also out there—eclectic, almost aggressive. She's no victim, and certainly no fashion victim."

Ultimately, a Rocker can be androgynous or uberfeminine, revel in the reveal or keep everything buttoned-up. But whether you're a T-shirts-and-jeans kind of girl or infuse your look with the complexities of historical or cultural trends, your style has got to be about pushing the limits. Your hair and makeup provide the ultimate styling tools to keep your look fresh and new, but they can also be used to ground it if you have a tendency toward quick "costume" changes. Your style has never been about following the crowd, so don't start now: your electric palette, fishnet stockings, and leather bustier are never going to resonate with the faint of heart. The good news is: no matter what the mainstream fashion, the Rocker is always able to make it her own. You don't need to overembellish, dye your hair, or show too much skin to be a Rocker, but you have to be fearless about setting yourself apart.

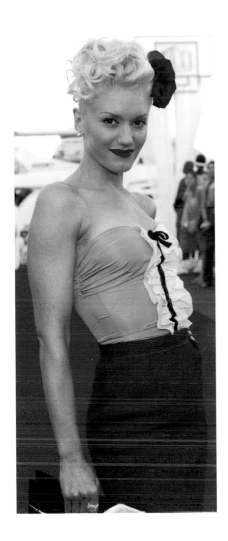

Opposite: Gwen Stefani styled by Andrea Leiberman for *Elle,* May 2011. Above: Stefani at the 2004 MTV Video Music Awards.

"I think I was born in a
WHITE SHIRT."
—Carolina Herrera

m

ost of the styles clarified in *The Style Mentors* are amalgams of different fashionable eras and can be interpreted in a range of ways, depending on your willingness to explore and innovate. The presence of the Bohemian or the Rocker, the Gamine or the Siren—though constantly revived—waxes and wanes according to the decade and its fashionable ideal.

Clothing never escapes the zeitgeist of its time, however, even if it is derived from fashions of a bygone era. Yet in examining the leaders of today's style panorama—particularly those who encompass the society doyenne and the politico—it's clear that certain mavens can convey a true timelessness: a look so tenderly cultivated and cared for, so rigorous in its attention to each moving piece, so classic that it perseveres as a nearly unaltered model through each and every decade. This style is attentive to age appropriateness and speaks to one's role of prominence, whether in society, politics, or stardom.

Dressing in the classic manner takes effort. A Classicist always makes sure her clothes are pressed, her jewelry is untarnished, and her leather pumps are well polished. She attends to every detail, and the impeccable results afford her authority, confidence, and, of course, influence. The elements of the classic look—a tailored jacket or sweater, a conservatively fitted skirt or trouser, a delicate blouse, statement jewelry—are available at many mainstream retailers, so cultivating this "timelessness" is attainable for all women. This look is all about pairing the right basics and selecting cuts and colors that will remain current, no matter which direction the winds of fashion blow.

As prim and proper as the classic style may appear at times, its proponents are often controversial and brave public figures. Their mischievousness translates into unexpected wardrobe flourishes: elaborate embroideries, lavish fur trims, or oversize pearls, to name a few. Bessie Wallis Warfield, better known as the Duchess of Windsor, was so beguiling that King Edward VIII abdicated his kingship just shortly after he ascended the throne in order to marry her in 1937, charmed as he was by the American divorcée's authoritative presence and exquisite taste.

Opposite: The Duchess of Windsor, Wallis Simpson, in her "Wallis Blue" wedding gown by Mainbocher with Edward, the Duke of Windsor, at their marriage ceremony at the Château de Cando, 1937.

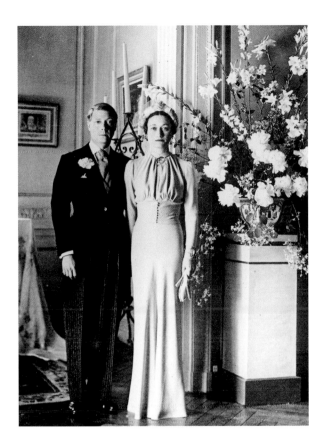

"**n**ever explain.
Never complain."

—Wallis Simpson

Wallis was a dedicated member of the international café society in the late 1930s, patronizing the couture houses of Elsa Schiaparelli and Mainbocher and later, Givenchy and Dior in the 1950s and 1960s. She was named to many "best dressed" lists and was awarded the title of Woman of the Year by *Time* magazine in 1936 for her worldwide influence, stylistically and culturally. Wallis wasn't afraid of extravagance or statement dressing. She wore Schiaparelli's monkey (made entirely of the animal's fur) and lobster dresses to great notoriety, and in Paris she reputedly wore a three-piece hot pant ensemble by Madame Grès to cha-cha in when she was well into her sixties.

There have been two impressive costume exhibitions dedicated to the duchess's sartorial sensibilities: *Wallis: Duchess of Windsor* (1999) at the Maryland Historical Society and *Blithe Spirit: The Windsor Set* at the Metropolitan Museum of Art (2003). Kohle Yohannan, who curated the former, has called the duchess an "iconic rule-breaker," and mused admiringly, "She stuck with her own style for fifty years, and there's something impressive about that in itself. . . . She broke every rule in the world, and she never apologized." But if Wallis broke the tried-and-true laws of fashion, she never bent her own. Her dedication to the elegant restraint of the British-bred couturier Mainbocher, who created her royal wedding dress in a "Wallis" blue, reflected her growing interest in a somewhat conservative architectural style, highlighted only by small flashes of color or decadent jewelry pieces. The duchess favored high necklines and columnar skirts of muted wools and pale silks, and her hair was usually set into rigid waves and carefully pulled back. Her makeup was never

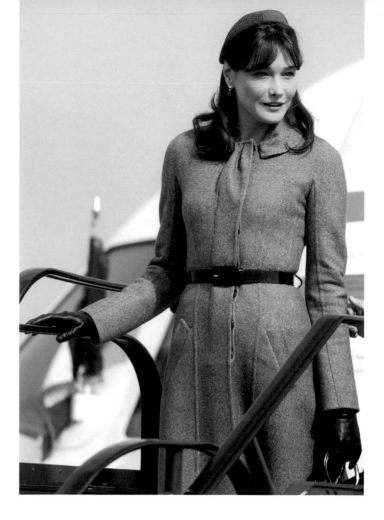

Carla Bruni Sarkozy
in Christian Dior
arriving at London's
Heathrow airport
for an official state
visit, 2008.

garish; in fact, save for the hint of crimson on her lips, her maquillage was rarely visible. Her personal style was so expertly reined in that the society and fashion photographer Cecil Beaton stated that she was "as compact as a Vuitton traveling case." In a 1966 *Harper's Bazaar* interview with her friend the writer, editor, and artist Fleur Cowles, the duchess explained her aesthetic evolution: "I began with my own personal ideas about style and I've never again felt correct in anything but the severe look I developed."

But if Wallis's wardrobe was tastefully tuned for country excursions and state dinners alike, her younger, more adventurous sartorial spirit shone through her extraordinary jewelry collection. The most iconic pieces—a Van Cleef & Arpels diamond and sapphire cuff worn on her wedding day, a hot pink Cartier flamingo

brooch, or the famous Cartier panther bracelet—continue to fetch outrageous prices at auction, but moreover, they offer a crucial perspective on the classic dresser: though her clothing must be occasion-appropriate and well fit, key accessories that are coordinated and thoughtful can both provide and convey her personality, and should be used to great effect.

The Duchess of Windsor's iconic style was "*soignée, not degagée*" ("polished, but not relaxed"), as the great *Vogue* editor Diana Vreeland once explained, and continues to influence many contemporary first ladies. Carla Bruni, who married French president Nicolas Sarkozy in early 2008, is a Classicist convert who, like the duchess, has grown into her tailored style. Carla is the heiress of the Pirelli tire manufacturing

fortune and the daughter of Brazilian grocery magnate Maurizio Remmert. She was discovered by Guess? Inc. president Paul Marciano in 1988 and had an impressive career as a runway model for Christian Dior, Givenchy, Christian Lacroix, and Prada, for whom she was a spokesmodel in 1992. Among others, she has also worked with Karl Lagerfeld at Chanel, who described the newly minted first lady as "imaginative, clever, educated. She knows how to behave. She speaks many languages. It must be an embarrassment for the wives of other heads of state to see this beautiful creature who can wear anything and speak like that." A prominent model in fashion magazine editorials worldwide for many years, she also appeared in the films *Prêt-à-Porter* (1994) and *Unzipped* (1995) as herself. Though she has since transitioned into music, Carla's background as a muse always provided her the capability to infuse glamorous ball gowns and tailored suits alike with a girl-next-door sex appeal. While, as Lagerfeld said, she can "wear anything," as France's first lady, Bruni Sarkozy has been careful to configure her public wardrobe carefully, while still retaining her mass appeal. She wears her hair down more than up, and her brunette locks hang long with flirty bangs cut to graze her brows. She always dons a tailored dress or suit for public appearances, but her on-the-go style is equally polished; it consists of fitted blazers and fetching tees tucked into new jeans or crisp palazzo pants, the latter reminiscent of the Duchess of Windsor on the French Riviera.

If the duchess appointed Mainbocher as her veritable court couturier, Carla Bruni Sarkozy has similarly anointed John Galliano. She has worn his designs—from a purple suit on Bastille Day to a gray flannel wool ensemble with necktie and pillbox hat for a state visit to the United Kingdom—quite intentionally, as they speak to her dedication to the French haute couture. Yet Carla's wardrobe, while made-to-order, offers many of the same design details that have been a signature of the styles of political wives for decades. Her look requires a lot of investment—these pieces aren't, for the most part, mix-and-matchable—but they are accessible at more affordable prices: you might find a double-breasted gray walking suit with wide-legged pant, a matching A-line dress and peacoat ensemble, or certainly a little black dress with fetching bib buttons at almost any major department store. Carla hardly ever accessorizes, save for a solid-color leather handbag (usually a Furla or a Birkin, in her case) and a pair of matching flats. Perhaps to nullify the controversy of nude photos that emerged from early in her career or to neutralize the sensationalism of her pop albums, she shies away from any glitziness or surface embellishment, even for evening wear.

THEN & NOW

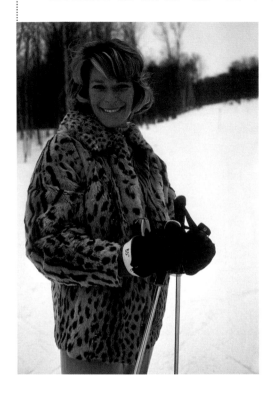

"Always remember
the finishing touches.
Hair back, a good clutch,
and tasteful diamonds
spell e-v-e-n-i-n-g."

—Lauren Santo Domingo

As a muse for Tom Wolfe's "social X-rays" in his novel *The Bonfire of the Vanities* due to her bone-thin frame and lavish Park Avenue lifestyle, Nan Kempner was one of the most notorious socialites of all time. A San Francisco native, Nan married financier Thomas Lenox Kempner in the early 1950s and gave birth to three children. In an impressive wardrobe of Bill Blass and Madame Grès, and one of the largest personal collections of Yves Saint Laurent in the world, Nan moved seamlessly through New York's party circuit and once quipped that she "wouldn't miss the opening of a door." Before her

death in 2005, Kempner's cause célèbre was the Memorial Sloan-Kettering Cancer Center, for which she raised over $75 million.

Besides being an avid clotheshorse, famous for her fusion of sportswear and haute couture, Nan was also a figurehead in the global fashion industry, having held positions at French *Vogue* and *Harper's Bazaar*, as well as being a consultant for Tiffany & Co. and Christie's art auction house. Diana Vreeland acknowledged Nan's impact as a benchmark for classic, effortless style, when she said, "There are no chic women in America. The one exception is Nan Kempner." Nan flew back and forth to Paris as frequently as some of us get on the subway, and she was well known for purchasing the better part of entire couture collections. She famously mused, "I spend way more than I should … and way less than I want." Her extensive wardrobe was on full display at the Costume Institute at the Metropolitan Museum of Art in 2006, in an exhibition entitled "Nan Kempner: American Chic." What distinguished Nan's fashion sense from those of her wealthy friends was her inventiveness with costume jewelry and her interest in and attention to menswear. Her lithe frame suited the tailored jackets and trousers of Saint Laurent's collections perfectly, and even into her early seventies, she would pair one of his nearly see-through blouses with a pair of linen palazzo pants, to taunting effect. Of Saint Laurent's influence on her, she explained, "He taught me a very important thing: All a woman needs is a good trench coat, a pair of black pants, a long black skirt, a short black skirt, and lots of tops." Even with her basics defined, Nan's style was all about the drama and playfulness of high fashion. She even stripped down to her slip while lecturing to a class of fashion students in New York in the 1990s, in order to show them the immaculate stitching of her skirt.

Today only Lauren Santo Domingo, the supremely well-groomed *Vogue* contributing editor and wife of Colombian beer heir Andres Santo Domingo, is equipped to fill Nan's Louboutin pumps. Like Kempner, Santo Domingo ceaselessly supports her favorite designers, among them Proenza Schouler, Balmain, Balenciaga, and Chloé, though Olivier Theyskens for Nina Ricci fashioned her extraordinary 2007 wedding gown. Santo Domingo is an avid fashion enthusiast, but she also finds time for philanthropy as the chair for the Frick Young Fellows Ball and a contributing officer to the Costume Institute's Party of the Year Gala at the Metropolitan Museum of Art.

Though Santo Domingo's look is always well coordinated, and generally consists of fine wool skirts, cashmere sweaters, and fur coats for the colder months and paper-thin tees and cotton sundresses for warmer times, it rarely boasts a pattern or embroidery. Her shoes are generally more expressive—even trendy—and are rarely below four inches in heel height. Lauren generally wears her hair back in a ponytail or let down unfussily and insists that she chooses one good handbag per season. If Nan was at the cutting edge of fashion for her time, recognized for her ability to look as chic in sportswear on the ski hill or at the pool as in formal wear (in any number of Saint Laurent's smoking ensembles with sheer blouses beneath), then Lauren is similarly at the forefront of fashion. Her advocacy of young designers like Nicholas Kirkwood assures their success in mainstream fashion, and her attempts to bring high fashion to the masses have been crystallized by a recent venture called Moda Operandi, which allows shoppers to order directly from the runway. Both women have demonstrated that taking impressive risks within the classic wardrobe can still ultimately achieve a chic, streamlined aesthetic that appears both luxurious and timeless.

Opposite, left: Nan Kempner in a snow leopard ski ensemble, 1960. Opposite, right: Lauren Santo Domingo at the Spring/Summer 2010 Chanel Haute Couture presentation.

"**G**lamour is not about how good women can look. [It is] about how much good women can do."

—Queen Rania of Jordan

Though Carla's designer labels are conveyed to the press through covert channels, if not mentioned outright, Queen Rania of Jordan believes in a more anonymous approach to classic dressing. The two women share a love of bold color choices: Carla in her total-look ensembles and Queen Rania in flashes here and there on a jacket or a shoe. Though both embrace timeless shapes, like a belted jacket or tailored pant, Carla always stresses that her wardrobe is up to the minute, while Rania is content to accrue pieces that elude a seasonal date.

Born in Kuwait, Rania earned a degree in business administration from American University in Cairo, and met her husband-to-be, King Abdullah bin Al-Hussein, at a dinner party in 1993. A mother of four, Rania oversees countless charities and philanthropic funds, including the Madrasati platform to refurbish Jordan's public schools, the Jordan River Foundation venture, and UNICEF, who named her an Honorary Global Chair of the United Nations Girls' Educative Initiative (UNGEI) in 2009. Perhaps her most tireless cause is the advocacy of Islamic women, both within the Middle East and around the world. Rania has made a personal choice not to wear the traditional Muslim veil but has been vocal about the misconceptions and stigmas associated with the head-to-toe garb. She told *Elle* magazine in 2006, "I always say about the veil: 'We should judge women according to what's going on in their heads rather than what's on top of their heads!'"

It's exactly this practical regard for dressing that drives the configuration of Rania's enviable wardrobe. Her selections are based on modesty, which translates to demure jewel or sweeping sculptural necklines and below-the-knee skirts. Though many of her evening dresses are

beaded or elaborately embroidered, they
are always in reserved and tasteful hues,
as opposed to being garish or showy.
She almost always belts her ensembles
(especially for cocktail or eveningwear)
to show off her lean figure. She has been
called "the Jackie O of the Middle East"
and in fact employs the same logic as
the former American first lady: just as
Jackie entrusted American designer
Oleg Cassini to design the majority of
her White House wardrobe and wore
European couture only very selectively,
Rania chooses her clothing with a mind
to diplomacy. She insists, "I realize that

I'm not just dressing for myself, especially
when I am abroad, I'm representing my
country, I'm representing my people."

When Michelle Obama accompanied
her husband to his inauguration as the
forty-fourth president of the United
States of America in January 2009 in
an ornate chartreuse Isabel Toledo
walking suit, she too was representing
the interests of her people. The Obama
platform was emphatically about change,
and Michelle's inaugural ensemble, as have
many of her looks since, represented a
sea change from previous first lady styles.
Michelle graced the cover of *Vogue* just

Opposite: Queen
Rania of Jordan,
1999. Above, left:
Michelle Obama in a
custom-made Isabel
Toledo suit with her
husband, Barack, at
his 2009 presidential
inauguration.
Page 178: Obama in a
signature embellished
J.Crew cardigan on
a presidential visit to
England, 2009.

two months into her husband's term, and that style bible dubbed her "The First Lady the World's Been Waiting For." The Toledo suit—loved by some, abhorred by others, but discussed by all—was made of overembroidered Swiss wool lace, backed with netting for warmth, and lined in French silk, all in the same chartreuse hue.

Obama's patronage of designers such as Toledo, Thakoon, Jason Wu, and Narciso Rodriguez, among others, demonstrates her attention to and interest in fashion; she even wore an ensemble by the Indian-American designer Rachel Roy to a state dinner in New Delhi, and an Alexander McQueen blouse the week that the designer tragically took his own life. Noting the dedicated attention that the American media has offered her closet, Michelle responded, "I'm not going to pretend that I don't care about [fashion]. But I also have to be very practical. In the end, someone will always not like what you wear—people just have different tastes."

Though Michelle's look is about finding pieces that make her feel comfortable and strong regardless of general opinion, her clothes have also been carefully coordinated to her newfound role. The Chicago-based stylist Ikram Goldman has reputedly engineered Michelle's fashion choices for some time, and has been careful to refer to the first lady's lifelong career as a lawyer and status as a democratic figurehead by incorporating more accessible "working" fashions from J.Crew and The Gap, as well as the bigger ticket items. J.Crew in particular has provided Michelle countless variations of her signature cardigan sweater, to be worn on election night over a black and red Narciso Rodriguez sheath dress, or coordinated to silk skirts and camisoles

"*f*or me fashion is fun, and it's supposed to help you feel good about yourself. I think that's what all women should focus on: what makes them happy and feel comfortable and beautiful. I wear what I love. Sometimes people like it, sometimes they don't. I'm fine with that."

—Michelle Obama

for state visits abroad. As Mikki Taylor, the beauty director and cover editor of *Essence* magazine reflected on Michelle's sartorial choices for the presidential campaign, "Every woman I talked to was saying how she has this confidence that is empowered. The purple dress, the legs that I have to believe were bare and not wearing the prerequisite suntan stockings, all say, 'I'm here to do business'... [and] those are not little *Breakfast at Tiffany's* pearls. Those are large pearls. Those are pearls you have to deal with."

Where Carla Bruni Sarkozy's ensembles are usually executed in monochromatic head-to-toe color or in various muted tones, Michelle embraces both a wide range of interacting hues and an array of delicate embroideries and beading. In the end, her look is about infusing glamour into the classic wardrobe through surface embellishment and statement jewelry. In addition to her signature oversize pearls, which seem an update of Jackie Kennedy's famous beads, Michelle has often worn the designs of CFDA award-winning jewelers Alexis Bittar and Tom Binns, respectively. Taking a page from the Duchess of Windsor's style-book, Obama often wears high-impact jewelry—from a large poppy pin to a carved bee brooch—to offset her more conservative garb.

Due to their simple shapes and flattering cuts, Michelle's clothes are readily imitable, as evidenced by the blockbuster sale of a Donna Ricco dress that she wore on *The View* in 2008 (the dress went into reproduction and sold out at the boutique White House/Black Market for a reasonable $148). Though you may not want to adapt Michelle's style stitch for stitch, you can emulate her look for the long term by incorporating her signatures: the cardigan, the oversize

pearls, the fitted sheath with bare arms, and the fashionable belt.

In fact, the "signature" item is intrinsic to the Classicist's wardrobe. The Venezuelan-born designer Carolina Herrera is perhaps best known for her floor-sweeping gowns of stiffened silk, but a lifelong dedication to the white shirt is the cornerstone of her unique classic style, which juxtaposes primly tailored elements with dramatic, feminine ones. She told journalist Suzy Menkes of the *International Herald Tribune*, "I have been wearing a white blouse all my life.... It's like my security blanket—take a white blouse and mix it with something. When I went to school it was a blouse with a Peter Pan collar. I remember for dressage that all my shirts and blouses were very fresh and crisp. They are classic with a modern twist and they are very feminine, for a real woman. It is about simplicity—they don't look complicated—it has to look effortless." She has rules for the white shirt as well: the collar must be high; the fabric must be a starched cotton (no silk); the cuff detail is crucial, so one must be attentive to the occasion-appropriate style: French, rolled, or just regular and buttoned. Herrera pairs her white shirts with ball gown and pencil skirts alike, depending on the occasion.

Of her fashions, which have clothed both political wives and Hollywood celebrities, Carolina says, "I want women to really look like women from today. It's not from the past and not from the future, because I don't know what happens in the future. It is the woman of today [who] I think is a seductive woman." In order to buttress this modernist pitch, Carolina has been known to weave traditional menswear details such as a houndstooth or glen plaid pattern into her tailored

separates wardrobe. When these formal designs are paired with intricate, even delicate prints and embroideries of flowers or mementos on silk duchesse and taffeta, Carolina strikes the perfect balance between composure and sweetness, masculine and feminine.

The incorporation of traditional men's tailoring, whether a white button-down shirt, a shapely blazer, or pressed trousers is crucial to the classic wardrobe. These bespoke details are exemplified by the iconic society staple of the Chanel suit. Chanel's boxy jacket, whether cropped or three-quarter length, with its high, fitted armhole, textured wool fabric, gilded or enameled buttons, and lavish trim has long provided the Classicist with the perfect finishing touch to a casual (jeans and a tee) or formal (via a coordinated tweed skirt) ensemble.

Though Annette de la Renta, the daughter of industrialist and Metropolitan Museum of Art benefactor Charles W. Engelhard, is happily married to American designer Oscar de la Renta, her embrace of Chanel's suits for daytime and cocktail affairs is nearly absolute. De la Renta is an avid philanthropist and serves on the boards of the New York Public Library, the Morgan Library and Museum, and, like her father, the Metropolitan Museum of Art. Such activities afford her an active social life of benefits and board meetings, so ultimately her personal style must be very authoritative and incredibly well executed.

Chanel may not be within your financial reach, but the couture house has been knocked off regularly since Gabrielle reopened her atelier in the 1950s. As such, it's not too difficult to find a tailored tweed or bouclé coordinated wool ensemble, preferably in a rich palette and with some sort of textured trim in order to emulate Annette's immaculate style. Such ensembles are best when paired with a quilted box bag and two-tone leather pumps, also staples of Chanel's iconic look. Annette's classic look is made complete by her carefully sculpted brunette bob, curled under to rest on her shoulders, or drawn back into a tight ponytail or bun. Her makeup is impeccably applied with ample foundation and careful lining of the lip and lid, as if to indicate that she is rarely, if ever, out of control.

Though Annette's refined style is adaptable to evening wear, with the full taffeta skirts and bejeweled bodices of her husband's design, her wardrobe doesn't exhibit the kind of versatility that most women require for day or night (in other words, some of us need classic clothes in which to go grocery shopping or spend an evening on the couch!). So when Tory Burch, ex-wife of real estate heir William Macklowe and then-wife of venture capitalist

Christopher Burch, launched the label TRB by Tory Burch in 2004, the retail market embraced her as a society figure who was finally able to translate the classic style of the elite to the everyday consumer. Tory had a fashion pedigree long before founding her own brand, as she had worked previously with designers Zoran, Polo Ralph Lauren, and Vera Wang as well as at *Harper's Bazaar* magazine. Eventually she dropped the "TRB by" from her label and embraced the widespread branding of her own name as synonymous with trendy, modern classics. She crowns her accessory designs with the iconic *T* logo medallion.

Tory's look has often been called "WASP-chic," as it reflects the clothes that grew out of traditional fashionable etiquette,

> " **t**here are no rules about what you can and can't do anymore.... Women are more empowered than they've ever been."
>
> —Tory Burch

but ultimately, her printed day dresses, silk crepe blouse and pencil skirt ensembles, cardigans, and tailored jeans are offered up with the caveat that a true Tory Burch follower styles her look according to her own tastes. Of Tory's sartorial sensibility, retail heir Peter Nordstrom told the *Los Angeles Times*, "She's not designing for some fictitious woman. She's a woman of great style and taste and she's speaking to her friends."

When Tory spoke to the *Huffington Post*, she isolated the Classicist's basics: "Packing is easiest when you edit yourself, so I like to bring chic, easy pieces that are versatile—things I can layer and wear day-to-evening. No matter where I am going, I always bring tailored jeans, cardigans, a blazer, and printed dresses. They are all pieces you could wear during the day, but also dress up in the evening with a bold piece of jewelry or a high heel." Burch won a Council of Fashion Designers of America (CFDA) award in 2008 for collaborating with Justin Giunta on a line of statement jewelry, which imposed the final Classicist touch upon her timeless silhouettes. The designer has waxed poetic on the import of the perfect pair of sunglasses—aviators or round Jackie-Os—as well as those essential accoutrements that a stylish woman shouldn't live without. On a short list of the latter is the trench coat, which should ideally be purchased in black and beige so as to suit any occasion, and of course Tory's "Reva" ballet flats, named after her mother.

The *New York Times* wrote that Tory's "clothes recall the all-American chic of the sportswear queen Anne Klein considered through more worldly Rive Gauche eyes." In fact, Tory's style might not have blossomed if not for the innovative iterations of Yves Saint Laurent's Rive Gauche

A CLASSICIST'S
Must-Haves

1. A Gorgeous White Button-Down Shirt

Whether tucked into a slimming pencil skirt, tied and paired with a full-length ball gown skirt or left open over a fitted tank and jeans, the button-down shirt, particularly a fresh white one, is the Classicist's friend. This look is tailored yet casual, masculine in its associations, and should be fitted to your form in a flattering cut. Keep a couple of button-down shirts on hand, as they can quickly dress up a simple ensemble.

2. The All-Purpose Trench

A long-standing tradition in British bespoke menswear, stemming from military outerwear of the early twentieth century, the trench coat can provide the perfect conservative foil to a flirty printed dress or beaded evening sheath. Just make sure your trench fabric suits the occasion: a silk trench will work better for evening, while a cotton sateen will lay nicely for a luncheon or for going to work. Make sure the trench coat falls below or at the same length of your skirt hem if your skirt is flowy, or just above the knee for a pencil skirt or trousers; the wrong fall can appear sloppy and inattentive. If you're going for a more casual, playful look, the trench coat can be draped casually over your shoulders or sized a little larger, while a more properly tailored look requires the coat to be closed and perfectly fit. Either way, the trench belt should be left hanging or tied closed—never buckled.

1) Carolina Herrera white shirt ensemble, Spring/Summer 2011; 2) Burberry Prorsum trench coat, Fall/Winter 2009-10; 3) Calvin Klein Collection clutch.

3. The Demure Clutch

Though the Rocker can get away with a studded shoulder bag, every Classicist needs a clutch. Both smaller and more understated, the clutch maintains the tailored lines of the classic wardrobe and can be jeweled for evening. Further, its diminutive frame won't detract from any jewelry or color accents you may want to highlight.

label and Catherine Deneuve, the muse who championed the designer's youthful classics for American audiences. Deneuve, who speaks French, Italian, English, and German, has been hailed as the "thinking man's Brigitte Bardot," as her films are generally more intellectual than her compatriot's and her style is more classically appealing than siren-sexy. Her breakthrough roles in film include Roman Polanski's *Repulsion* (1965) and Luis Buñuel's *Belle de Jour* (1967), and it was on the set of the latter that she met Yves Saint Laurent. The couturier designed her clothing for *Belle de Jour*, as well as *La Chamade* (1968), *Mississippi Mermaid* (1969), *Liza* (1972), and *The Hunger* (1983). Deneuve has said, "I think the clothes in *Belle de Jour* are very important to the style of the film. Even today, [they are] still timeless."

Saint Laurent paired A-line and columnar cocktail and day dresses with buckled Roger Vivier flats and black satin trenches. He gave her a signature black beret. The fabrics of each design were lush but were never embellished with any surface decoration that might detract from Deneuve's striking beauty. She wore her hair either in a ponytail, a loose bun, or half up, to emphasize the lushness of her blond tresses. Her eyes were generally rimmed in black kohl, and her lashes were extended. Though these touches affected the typical 1960s sex kitten look, Deneuve, via Saint Laurent's designs, was careful not to show too much skin.

As the classic beauty of the era, Deneuve became the face of Chanel No. 5 in the late 1970s, prompting sales of the perfume to skyrocket. Some thirty years later, the actress and style icon Nicole Kidman occupied the same role in print as well as a three-minute commercial for the fragrance by director Baz Luhrmann. Kidman is not a traditional Classicist. She has been as praised for her choice of lavish evening gowns by John Galliano for Christian Dior, Nicolas Ghesquière for Balenciaga, and Karl Lagerfeld for Chanel as much as for her more conservative walking suits and dresses.

Nicole first garnered attention for her impeccable taste on the red carpet at the 1997 Academy Awards, where her chartreuse silk Christian Dior gown, embroidered with chinoiserie at the edges and trimmed in mink, upstaged her then-husband, the superstar Tom Cruise, and raised the bar for dress on the red carpet from ready-to-wear to haute couture. The House of Dior has since provided her with other dresses. But this gown, along with a crimson Balenciaga sheath and a full-length black slip dressed up with an elaborate crystal L'Wren Scott necklace, was a real standout style moment for the actress.

CLASSICISTS Never, EVER...

>> Wear too many layers. While a blazer over a blouse or tee may look clean and fresh, too many sheer layers will come off as fussy, nostalgic, and old.

>> Pile on jewelry. A Classicist's accents should be few and should make an impact without the help of other accoutrements.

>> Wear big hair. Though huge cascades of curled locks might work for the Siren, the Classicist's hairstyle has clean lines that mimic her wardrobe. Wear your hair tied back neatly or down in loose waves or blown straight.

>> Shy away from a little sun. A good tan complements the Classicist's luxurious simplicity.

>> Show off cleavage, especially during the day. Though a décolleté neckline might be all right for a formal evening out from time to time, a revealing neckline will cheapen a streamlined silhouette and detract from the impact of your carefully selected jewelry.

Left: Catherine Deneuve on the set of *L'agression*, Avignon, France, 1974. Page 186: Nicole Kidman in a red Balenciaga gown at the 79th Annual Academy Awards, 2007. Page 187: Nicole Kidman in a pale blue silk Chanel Haute Couture gown at the 2004 *Vanity Fair* Oscar Party.

Though dramatic, these evening looks share a common silhouette: they hug Nicole's long, narrow frame and fall to floor length in a straight skirt, without much in the form of frills or flair. For the most part, she uses the dramatic shoulder or neckline details of a garment in place of statement jewelry and pairs her frocks with very understated accessories so as to affect a clean, unfettered look. This look can be a real success for the narrow-hipped Classicist, as it tends to streamline the wardrobe into clean, chic shapes.

Nicole was first recognized for her part in the Australian thriller *Dead Calm* in 1989 and has since received accolades

(including an Academy Award and a Golden Globe) for roles in *To Die For* (1995), *Moulin Rouge!* (2001), *The Hours* (2002), *Cold Mountain* (2003), and *Rabbit Hole* (2010). She has also evolved personally: after divorcing Cruise (with whom she adopted two children) in 2001, she married country singer Keith Urban in 2006, and the couple now have two children of their own. In the face of this second motherhood, Kidman has said, "I'm less interested in fashion now and more interested in simple chic." Yet while Kidman's public appearances are more often marked by a casual wardrobe of jeans, button-down shirts, and blazers, her red carpet wardrobe is just as

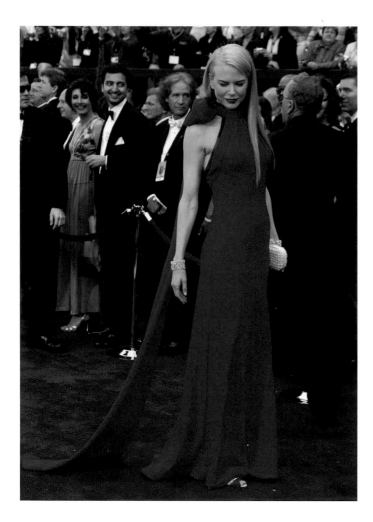

"**n**ow I can wear heels."

—Nicole Kidman, on divorcing
Tom Cruise in 2001

carefully cultivated. Though Nicole's style may be more fashion-forward than many of the Classicists addressed here, both her chic separates and formal gowns exhibit the elegant restraint intrinsic to the classic wardrobe.

Ultimately, whether you're inclined to decorate the Classicist's simple shapes with a bit of Boho embroidery for effect or an outlandish jewelry piece as a more definitive statement, your foundation garments must adhere to the classic language or, as Tory Burch described, a series of "easy pieces." Staples such as the sheath for evening, the fitted jacket or blazer, the silk day dress, the tailored shirt and the pencil skirt, the ballet flat and the classic pump, the trench coat and the fitted jean are all mandatory, and over time, the true Classicist accrues many variations of them.

Part of the Classicist legacy is the ability to wear these basics interchangeably and dress them up (with fine jewelry) or down (with costume jewelry) according to the occasion. A belted or buttoned front always appears neater than a drape, and hems should hit just below the knee, ankle, or foot, and nowhere in between. Tucks, mushroom pleats, and small ruffles are acceptable and even encouraged, as long as the effect is refined rather than precious. While there are rules about how to assemble the classic look, the most impactful styles exist in the spaces where these rules are bent; a décolleté neckline under a tailored blazer or an oversize brooch on a sheer gauze blouse conveys a timeless sense of chic, but more important, insinuates the personality of the woman wearing it.

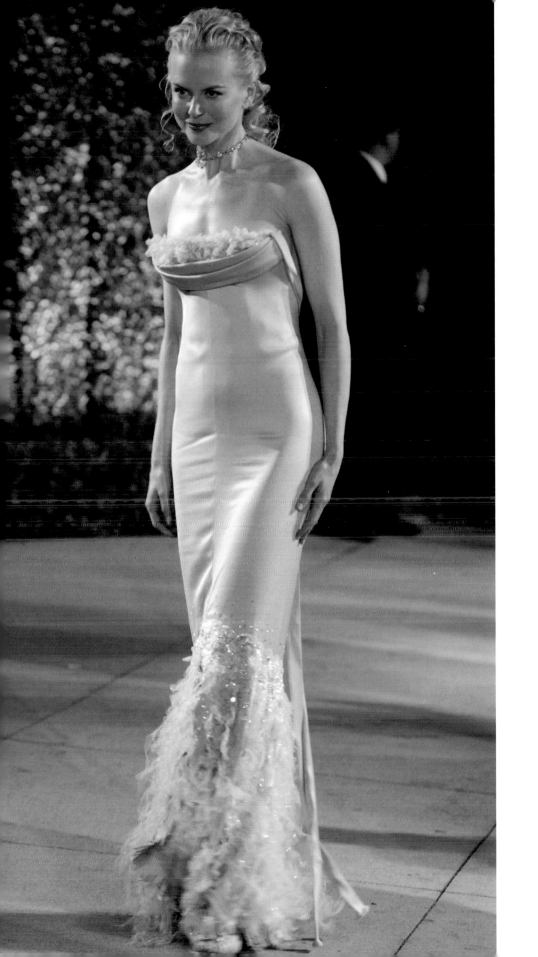

selected bibliography

Books

Beckham, Victoria. *That Extra Half Inch: Hair, Heels and Everything in Between.* New York: It! Books, 2007.

Bowles, Hamish, Rachel Lambert Mellon, and Arthur Schlesinger. *Jacqueline Kennedy: The White House Years.* New Haven, Conn.: Yale University Press and the Metropolitan Museum of Art, 2001.

Blum, Dilys. *Shocking! The Art and Fashion of Elsa Schiaparelli.* New Haven, Conn.: Yale University Press, 2003.

Buttolph, Angela. *Kate Moss: Style.* London: Random House, 2008.

Charles-Roux, Edmonde. *Chanel and Her Style.* Paris: Vendome Press, 2005.

David, Deborah. *Strapless.* New York: Tarcher, 2004.

Deneuve, Catherine. *Close Up and Personal.* London: Orion, 2006.

Doane, Mary Ann. *Femme Fatale: Feminism, Film Theory, and Psychoanalysis.* London: Routledge, 1991.

Dwight, Eleanor. *Diana Vreeland.* New York: William Morrow, 2002.

Goude, Jean-Paul. *So Far, So Goude.* Paris: Assouline, 2006.

Grafton, David. *The Sisters: Babe Mortimer Paley, Betsy Roosevelt Whitney, Minnie Astor Fosburgh: The Lives and Times of the Fabulous Cushing Sisters.* New York: Villard, 1992.

Grier, Pam, and Andrea Kagan. *Foxy: My Life in Three Acts.* New York: Springboard Press, 2010.

Harlech, Amanda, and Karl Lagerfeld. *Karl Lagerfeld & Amanda Harlech: Visions and a Decision.* London: Steidl, 2008.

Haugland, Kristina, Jenny Lister, and Samantha Erin Safer. *Grace Kelly Style: Fashion for Hollywood's Princess.* London: V & A Publishing, 2010.

Higham, Charles. *The Duchess of Windsor: The Secret Life.* Hoboken, N.J.: Wiley, 2004.

Jules-Rosette, Benetta. *Josephine Baker in Art and Life: The Icon and the Image.* Chicago: University of Illinois Press, 2007.

Keogh, Pamela Clarke. *Jackie Style.* New York: It! Books, 2001.

——. *Audrey Style.* New York: HarperCollins Publishers, 1999.

King, Greg. *The Duchess of Windsor: The Uncommon Life of Wallis Simpson.* New York: Citadel, 2003.

Kotur, Alexandra. *Carolina Herrera: Portrait of a Fashion Icon.* New York: Assouline, 2004.

Lasalle, Mick. *Complicated Women: Sex and Power in Pre-Code Hollywood.* New York: St. Martin's Griffin, 2001.

Lawson, Twiggy, and Penelope Dening. *Twiggy in Black and White: An Autobiography.* London: Pocket Books, 1998.

Mann, William J. *Kate: The Woman Who Was Hepburn.* London: Picador, 2007.

Olsen, Mary Kate, and Ashley Olsen. *Influence.* New York: Razorbill, 2008.

Picardie, Justine. *Coco Chanel: The Legend and the Life.* New York: It! Books, 2010.

Rink, Martina, and Philip Treacy. *Isabella Blow.* London: Thames & Hudson, 2010.

Ryersson, Scot D., Judith Thurman, Diane Von Furstenberg, and Michael Orlando Yaccarino. *The Marchesa Casati: Portraits of a Muse.* New York: Abrams, 2009.

Rogak, Lisa. *Michelle Obama in Her Own Words: The Views and Values of America's First Lady.* Jackson, Tenn.: Public Affairs, 2009.

Seymour, Stephanie. *Beauty Secrets for Dummies.* New York: John Wiley & Sons, Inc., 1998.

Sischy, Ingrid. *Donna Karan.* New York: Assouline, 2006.

Smith, Patti. *Just Kids.* New York: Ecco, 2010.

Spoto, Donald. *High Society: The Life of Grace Kelly.* New York: Three Rivers Press, 2010.

Steele, Valerie, and Patricia Mears. *Isabel Toledo: Fashion from the Inside Out.* New Haven, Conn.: Yale University Press, 2009.

Stenn, David. *Clara Bow: Runnin' Wild.* New York: Cooper Square Press, 2000.

Von Lehndorff, Vera. *Veruschka.* Paris: Assouline, 2008.

Von Teese, Dita. *Burlesque and the Art of the Teese.* New York: It! Books, 2006.

Vreeland, Diana. *D.V.* Cambridge, Mass.: Da Capo Press, 2003.

Weber, Caroline. *Queen of Fashion: What Marie Antoinette Wore to the Revolution.* London: Picador, 2007.

West, Naomi, and Dr. Catherine Wilson. *The Jackie Handbook.* New York: Mq Publications, 2005.

Williamson, Matthew, and Sienna Miller. *Matthew Williamson.* New York: Rizzoli, 2010.

Wilson, Elizabeth. *Bohemians: The Glamorous Outcasts.* New Brunswick, N.J.: Rutgers University Press, 2000.

Articles

Alexander, Ella. "Dita's Regime." *Vogue* (July 19, 2010). Accessed October 8, 2010. www.vogue.co.uk/news/daily/100719 -dita-von-teeses-style-tips-and-ico.aspx.

Alexander, Hilary. "Carla Bruni Is Diplomatic with the Stamp of Dior." *The Telegraph* (March 27, 2008).

——. "Death of a True Original." *The Telegraph* (May 7, 2007).

Armstrong, Lisa. "Daphne Guinness, Fashion's Invisible Muse." *Sunday Times* (May 22, 2010).

——. "Carine Roitfeld: The Ultimate Style-Setter." *Sunday Times* (August 26, 2009).

Ashman, Angela. "Fall Guide: Karen O's Style Guru Takes Us Shopping." *The Village Voice* (September 1, 2010).

Ballentine, Sandra. "White Star." *New York Times* (February 26, 2006).

Barber, Lynn. "The Interview: Anita Pallenberg Lady Rolling Stone." *The Observer* (February 24, 2008).

———. "My Brilliant Career." *The Observer* (August 19, 2007).

Barnard, Christopher. "Cher's One-of-a-Kind Fashion Legacy." *Vanity Fair* (November 2, 2010). Accessed November 12, 2010. www.vanityfair.com/hollywood/features/2010/12/cher -chutzpah-slide-show-201012#slide=1.

Blanchard, Tamsin. "Blow by Blow." *The Observer* (June 2002).

Blasberg, Derek. "Alison Mosshart." *Interview* (April 2009).

Blow, Detmar. "Hidden Torment of a Fashion Queen." *Sunday Times* (May 13, 2007).

Borrelli-Persson, Laird. "Grace Jones." *Style.com* (December 7, 2005). Accessed October 12, 2010. www.style.com/beauty/ icon/120705ICON.

Brant, Stephanie Seymour. "Azzedine Alaïa." *Interview* (March 2009).

Brinton, Jessica. "Downtown Darling: Leigh Lezark." *Times* (December 21, 2008).

Brown, Laura. "Victoria's Secrets." *Harper's Bazaar* (December 2008).

Bryan, Meredith. "Patti Smith." *Oprah.com* (January 22, 2010). Accessed October 14, 2010. www.oprah.com/style/5-Women -5-Paths-to-Amazing-Personal-Style_1/4.

Bullock, Maggie. "Fairest of Them All." *Elle* (March 2008).

Cannata, Teresa. "Portrait of a Lady." Italian *Vogue* (March 2010).

Carter, Lee. "Tilda Swinton" *Hint* (March 2010).

Carter, Nicole. "It's Official: Cher Turned Back Time." *New York Daily News* (September 13, 2010).

Carter-Morley, Jess. "Miller Sisters Use Celebrity Connection to Push Label. *The Guardian* (February 23, 2009).

———. "Fast and Louche." *The Guardian* (March 15, 2008).

———. "Beautiful and Damned." *The Guardian* (April 8, 2006).

Coleman, Claire. "Ooh La la! Designer Loulou de la Falaise's Parisian Home Oozes Bohemian Style." *Daily Mail* (March 31, 2008). Accessed July 16, 2010. www.dailymail.co.uk/ femail/article-1003862/Ooh-La-La-Designer-loulou-la-falaises -parisian-home-oozes-bohemian-style.html.

Cristobal, Sarah. "Fashion Secrets." *Harper's Bazaar* (September 2008).

Dargis, Manohla. "Godmother of Punk, Celebrator of Life." *New York Times* (August 6, 2008).

DiGaicomo, Frank. "Gatecrasher: In Midst of Reconciliation with Peter Brant, Nude Bust of Stephanie Seymour to Be Auctioned." *New York Daily News* (October 15, 2010).

D'Souza, Christa. "Heiress Apparent." *Sunday Times* (October 21, 2007).

Durrant, Sabine. "If Looks Could Kill." *The Telegraph* (November 13, 2005).

Dwight, Eleanor. "The Divine Mrs. V." *New York* (November 18, 2007).

Edwards, Alicia. "Padma Lakshmi: New Mother, Model, Actress and Jewelry Designer." *The Examiner* (May 24, 2010).

Foxley, David. "Editor Lauren Davis to Marry Andres Santo Domingo in Fantasy Wedding." *The Observer* (December 18, 2007).

Gabriel, Trip, ed. "Lou Doillon." *New York Times*, Pulse, Style Section (April 18, 2008).

Gallagher, Jenna Gabrial. "Peggy Guggenheim's Venice." *Harper's Bazaar* (August 2009).

Garvan, Sinead. "Karen O on Becoming a Style Icon." *BBC News* (July 17, 2009). Accessed October 8, 2010. http://news.bbc .co.uk/newsbeat/hi/music/ newsid_8149000/8149511.stm.

Gent, Helen. "Life Stories: Isabella Blow." *Marie Claire* (November 14, 2007).

Gilewicz, Samantha. "Skip to My Lou." *Nylon* (March 2008).

Givhan, Robin. "Michelle Obama's Fashion Diplomacy." *Washington Post* (November 8, 2010).

Grigoriadis, Vanessa. "Imagining Daphne." *New York* (August 15, 2010).

———. "Growing Up Gaga." *New York* (March 28, 2010).

Guinness, Daphne. "My Best Friend McQueen." *The Daily Beast* (February 11, 2010).

Haight, Sarah. "Tory Burch: Road Tripper." *W* (March 2010).

Hattenstone, Simon. "Grace Jones: 'God I'm Scary. I'm Scaring Myself.'" *The Guardian* (April 17, 2010).

——— "Her Relationship, Her Struggles, Her Freedom." *Elle* (December 18, 2006).

Heyman, Stephen. "Tag Team." *T* magazine (December 3, 2009).

Hollander, Anne. "The Queen's Closet: What Marie Antoinette Really Wore." *Slate* (November 3, 2006).

Horyn, Cathy. "Blow." *New York Times* (May 10, 2007).

———. "A Woman in the House: Isabel Toledo." *New York Times* (February 10, 2007).

Hume, Marion. "Isabella Blow, 'Fashion's Nutty Aunt,' Is Dead." *New York* (May 7, 2007).

———. "The Eminence Chic." *The Independent* (December 20, 1992).

Jones, Liz. "Grace Kelly A Legendary Fashion Icon." *Daily Mail* (August 13, 2007).

Jovovich, Milla. Interview with Lou Doillon. *Interview* (August 2009).

King, Joyann. "Lauren Santo Domingo Launching Runway Shopping Site." *Harper's Bazaar* (December 2, 2010).

Klappholz, Adam. "One Night, Two Tiaras." *Vanity Fair* (April 2008).

La Ferla, Ruth. "A Rare Spirit, A Rarer Eye." *New York Times* (March 19, 2010).

Larkworthy, Jane. "Charlotte Gainsbourg: Flower Girl." *W* (February 2010).

Larocca, Amy. "The Anti-Anna." *New York* (February 18, 2008).

———. "Attack of the Fashion Gremlins." *New York* (August 19, 2007).

———. "The Sad Hatter." *New York* (July 15, 2007).

Lee, Felicia R. "Pam Grier's Collection of Lessons Learned." *New York Times* (May 4, 2010).

Leon, Sarah. "Diane Pernet: Film Noir." *T* magazine (July 20, 2010).

Litchfield, Summer. "Wild Child." *Sunday Times* (April 8, 2007).

Louison, Cole. "Why Pam Grier Can Still Kick Your Ass." *GQ* (May 2010).

Long, April. "Women in Music: Karen O." *Elle* (June 2009).

Long, Carola. "My Life in Fashion: Daphne Guinness and Her Obsession with Armour." *Sunday Times* (August 22, 2007).

McLean, Craig. "I'm Like Every Other Woman. I Am Vain. I Have Issues." *The Guardian* (August 5, 2007).

Menkes, Suzy. "The Duchess of Windsor's Royal Style." *Harper's Bazaar* (October 15, 2010).

——. "A Life in a Dress." *New York Times* (February 16, 2010).

——. "Carolina Herrera: Days of Jasmine and Ponies." *New York Times* (April 23, 2007).

Miller, Korin. "Recession Proof? Mary-Kate and Ashley Olsen Hit It Big with Upscale Elizabeth and James Line." *New York Daily News* (April 2, 2009).

Moore, Booth. "On My Mind: Wallis Simpson's Style." *Los Angeles Times* (December 3, 2010).

——. "Style Notebook: Tory Burch Has Turned Her Line of Classics into a Must-Have Lifestyle Brand." *Los Angeles Times* (June 1, 2008).

Moore, Peter. "Interview with First Lady Obama." *Women's Health* (October 2009).

Morgan, Spencer. "Arden of Eden." *The Observer* (April 15, 2007).

Mulder, Sylvia. "Leigh Lezark—My London." *London Evening Standard* (November 20, 2009).

Murphy, Eileen. "Who's That Girl? Pondering Wallis Simpson, the Most Unlikely Trophy Wife." *Baltimore City Paper* (November 10, 1999).

Neel, Julia. "Style File: Michelle Obama." British *Vogue* (January 20, 2009). Accessed July 28, 2010. www.vogue.co.uk/celebrity -photos/081104-michelle-obama-style.aspx.

New York magazine staff. "Leigh Lezark's Fashion Favorites." *New York* (February 5, 2007). Accessed October 8, 2010. http:// nymag.com/daily/fashion/ 2007/02/leigh_lezarks_fashion _favorite.html.

——. "Madonna Dresses Her Age. Is That So Wrong?" *New York* (July 17, 2008).

Norwich, William. "Stephanie Seymour Has a Few Secrets to Tell You." *New York Observer* (January 24, 1999).

O'Connell, Vanessa. "Steering a Young Label in Lean Times." *Wall Street Journal* (September 8, 2009).

Odell, Amy. "Madonna Channels an 'Ordinary Woman' in the New Dolce & Gabbana Campaign." *New York* (July 12, 2010).

Orth, Maureen. "Paris Match." *Vanity Fair* (September 2008).

Osgood, Charles, anchor. "Sophia Loren: I Was No Sex Bomb." *CBS News* (December 18, 2009). Accessed October 20, 2010. www.cbsnews.com/stories/2009/12/18/sunday/main5995948.shtml.

Ouyang, Brittany. "Tilda Swinton Makes Us Swoon in Our Exclusive I Am Love Interview." *Refinery29.com* (June 2010). Accessed August 14, 2010. www.refinery29.com/tilda-time-swinton -makes-us-swoon-in-i-am-love.php.

Patner, Josh. "Widow's Peak." *New York Times* (August 28, 2005).

——. "Don't Call Her a Socialite." *New York Times* (October 3, 2004).

Paxton, Anne. "Two Fashion Icons: Katharine Hepburn and Jackie Kennedy Onassis." *Suite101.com* (November 16, 2001). Accessed July 22, 2010. www.suite101.com/article.cfm/ womens_fashion/85044.

Peden, Lauren David. "Toledo's FIT Fete." British *Vogue* (September 4, 2008). Accessed on August 1, 2010. www.vogue.co.uk/news/daily/080904-isabel-toledo -honoured-by-fit.aspx.

Pfeiffer, Alice. "Diane Pernet on Tavi, Fashion Film, and the Future of Catwalks." *Fashionista.com* (August 12, 2010). Accessed August 12, 2010. http://fashionista.com/2010/08/diane-pernet-on-tavi -fashion-film-and-the-future-of-catwalks/.

Picardie, Justine. "Amanda Harlech: A Charmed Life." *The Telegraph* (December 2, 2007).

Puente, Maria. "In the Style of Josephine Baker." *USA Today* (June 15, 2006).

Quart, Alissa. "Daughter of the Revolutionary." *New York* (April 15, 2007).

Roberts, Glenys. "Isabella Blow: Eccentric to the End." *Daily Mail* (May 9, 2007).

Rosenblum, Emma. "The Gown Designer." *New York*, Weddings Issue (Summer 2009).

Rovzar, Chris. "Looking for the Next Mrs. Astor." *New York* (September 26, 2010).

Salisbury, Mark. "Danger Woman." *The Observer* (October 23, 2005).

Sheffield, Rob. "Yeah Yeah Yeahs: Goth, Nerd, Slut." *Rolling Stone* (April 7, 2006).

Singer, Maya. "Stephanie Seymour's Lingerie Tips." *Style.com* (April 21, 2008). Accessed August 20, 2010. www.style.com/ stylefile/2008/04/stephanie-seymours-lingerie-tips/.

Singh, Anita. "Michelle Obama in Vogue: First Lady of American Fashion." *The Telegraph* (February 11, 2009).

Style.com staff. "Lady Gaga on Nicola Formichetti's Appointment at Thierry Mugler." *Style.com* (September 16, 2010). Accessed September 18, 2010. www.style.com/stylefile/2010/09/lady -gaga-on-nicola-formichettis-appointment-at-thierry-mugler/.

Sullivan, Chris. "Audrey Tautou—Style with Substance." *The Independent* (July 24, 2009).

——. "The Beyoncé Experience." *Cosmopolitan* (April 2008).

Trebay, Guy. "U.S. Fashion's One-Woman Bailout?" *New York Times* (January 7, 2009).

——. "She Dresses to Win." *New York Times* (June 8, 2008).

Weiss, Shari. "Oh, Baby!" *New York Daily News* (October 28, 2010).

Weller, Sheila. "Once in Love with Ali." *Vanity Fair* (March 2010).

Williams, Ben. "In Conversation: Debbie Harry and Santogold." *New York* (September 28, 2008).

Willis, Paul. "Queen Rania of Jordan: A Beautiful Paradox." CNN (July 11, 2008). Accessed on July 20, 2010. http://articles.cnn .com/2008-0711/world/queen.rania _1_queen-rania-king -abdullah-ii-honor-killings?_s=PM:WORLD.

Wilson, Eric. "Who's That Girl?" *New York Times* (July 17, 2008).

Wood, Gaby. "Tilda Opens Up." *The Guardian* (October 9, 2005).

Woods, Vicki. "Cate Modern." *Vogue* (July 2000).

Women's Wear Daily staff. "Loulou de la Falaise's Midsummer Night's Reverie." *Women's Wear Daily* (July 8, 2010).

——. "Grace Jones Sings at Viktor & Rolf Party." *Women's Wear Daily* (March 5, 2010).

Yuan, Jada. "Chloë Sevigny Designs the Clothes of Her Dreams." *New York*, "The Cut" (September 12, 2007). Accessed on August 2, 2010. http://nymag.com/daily/fashion/2007/09/ chloe_sevigny_designs_the_clot_1.html.

Yvette, Mar. "Isabel Toledo Interview." *Clear* magazine (Summer 2007).

PHOTOGRAPHY CREDITS

Chapter 1: Icons
Page 12: James Devaney/Getty Images. 14: Dimitrios Kambouris/Getty Images. 15: Ron Galella/Getty Images. 17 (left): Courtesy of the Hesse Princely Collection, Archiv der Hessischen Hausstiftung. 17 (right): Imagno/Getty Images. 19: Keystone/Getty Images. 20: © Frank Trapper/Sygma/Corbis. 21: Felix Lammers/Figarophoto/Getty Images. 22 (clockwise from top left): © MCV; courtesy of CHANEL; courtesy of Marc Jacobs; courtesy of Manolo Blahnik; courtesy of CHANEL. 24: David Cameron/Getty Images. 25: Daisy Fellowes by Cecil Beaton, bromide print, 1941 © National Portrait Gallery, London. 26: © Condé Nast Archive/CORBIS. 28: Courtesy of Art Partner/ Mert Alas and Marcus Piggott. 29: Mel Bouzad/Getty Images. 30: Lipnitzki/Getty Images. 32 and 33: Courtesy of Trunk Archive/© Hedi Slimane. 34: François Durand/Getty Images. 35 (left): Ron Galella/Getty Images. 35 (right): David Cairns/Getty Images. 37: Rob Loud/Getty Images.

Chapter 2: Mavericks
Page 41: *Portrait of the Marchesa Luisa Casati with a Greyhound, 1908* (oil on canvas) by Giovanni Boldini (1842–1931) private collection/Photo © Christie's Images/The Bridgeman Art Library. 42: Courtesy of Karl Lagerfeld. 43: © Paolo Roversi /Art + Commerce. 44: © Craig McDean/Art + Commerce. 46: © Tim Walker/Art + Commerce. 47: Donald McPherson/Getty Images. 48: Dave M. Benett/Getty Images. 49: Matt Cardy/Getty Images. 50: Claude Huston/Getty Images. 51 (clockwise from top): © MCV; courtesy of Dior Fine Jewelry; courtesy of Stephen Jones and the Dorchester Collection. 53: © Condé Nast Archive/CORBIS. 54: © Richard Phibbs. 57: Courtesy of Jonathan Becker Studio. 58: © Miguel Villalobos; 59: courtesy of Karl Lagerfeld.

Chapter 3: Sirens
Page 64: Carl De Souza/Getty Images. 65: Kevork Djansezian/Getty Images. 67: Lee Lockwood/Getty Images. 69: Eric Ryan/Getty Images. 70: Hulton Archive/Getty Images. 71: Kevin Mazur/Getty Images. 72: Fabrizio Ferri/Getty Images. 73: Alfred Eisenstaedt/Getty Images. 74: Donald McPherson/Getty Images. 75: Amelia Troubridge/Getty Images. 76 (clockwise from top left): © MCV; courtesy of Cynthia Rowley; courtesy of MAC; © MCV. 78: Eugene Robert Richee/Getty Images. 79: Hulton Archive/Getty Images. 80: Fred Duval/Getty Images. 83: Pascal Le Segretain/Getty Images. 84: Scott Gries/Getty Images. 85: Mark Mainz/Getty Images.

Chapter 4: Gamines
Page 89: Michael Ochs Archives/Getty Images. 91: ALLIED ARTISTS / THE KOBAL COLLECTION. 92: Keystone/Getty Images. 93: Courtesy of Art Partner/© Alasdair McLellan. 94: Courtesy of Art Partner/© Mert Alas and Marcus Piggott. 95: Alfred Eisenstaedt/Getty Images. 96: Courtesy of Open Space Paris/© Jan Welters. 97: Otto Dyar/Getty Images. 98: © Underwood & Underwood/Corbis. 99: Hulton Archive/Getty Images. 100: MJ Kim/Getty Images. 102: Deborah Turbeville/Getty Images. 103: Kate Barry/Getty Images. 104 (clockwise from top left): © MCV; © MCV; courtesy of Petite Bateau; courtesy of Marc by Marc Jacobs.

Chapter 5: Bohemians
Page 109: © Condé Nast Archive/Corbis. 111: Dove/Getty Images. 112: Pictorial Parade/Getty Images. 114: Brad Barket/Getty Images. 115: Julian Broad/Getty Images. 116: Harry Dempster/Getty Images. 117: © Roberto D'Este/Corbis Outline. 118: Courtesy of Jonathan Becker Studio. 119: Dante Gabriel Rossetti/Getty Images. 120: © Condé Nast Archive/Corbis. 123: J. Vespa/Getty Images. 124 (clockwise from top left): © MCV; courtesy of Charm & Chain; courtesy of Charm & Chain; courtesy of House of Harlow 1960; courtesy of Bottega Veneta.

Chapter 6: Minimalists
Page 129: Courtesy of Trunk Archive/© Norman Jean Roy. 131: Joe Corrigan/Getty Images. 132: © Brigitte Lacombe. 134: PATRICK KOVARIK/Getty Images. 135: Eric Ryan/Getty Images. 137: Chris Weeks/Getty Images. 138: Courtesy of Trunk Archive/© Inez Van Lamsweerde and Vinoodh Matadin. 139: © Craig McDean/Art + Commerce. 140: Julien Hekimian/Getty Images. 142 (left) Tony Barson/Getty Images. 142 (right): Trago/Getty Images. 143: Eric Charbonneau/Getty Images. 144 (clockwise from top left): © MCV; courtesy of James Perse; courtesy of Marni; courtesy of Louis Vuitton; © MCV. 146: © Craig McDean/Art + Commerce.

Chapter 7: Rockers
Page 151: CBS Photo Archive/Getty Images. 153: Andy Sheppard/Getty Images. 154: Mick Gold/Getty Images. 155 (clockwise from top): © MCV; © MCV; Courtesy of Cynthia Rowley. 156: FilmMagic Inc./Getty Images. Page 157: Michael Caulfield/AMA2009/Getty Images. 159: Roberta Bayley/Getty Images. 160: Kevin Mazur/Getty Images. 161: Bob King/Getty Images. 162 (left): Francois G. Durand/Getty Images. 162 (right): John Parra/Getty Images. 163: Eric Ryan/Getty Images. 165: Dimitrios Kambouris/Getty Images. 166: © Dusan Reljin. 167: Frank Micelotta/Getty Images.

Chapter 8: Classicists
Page 171: Popperfoto/Getty Images. 172: SHAUN CURRY/Getty Images. 174: © Stephane Cardinale/People Avenue/Corbis. 175: Slim Aarons/Getty Images. 176: © Maher Attar/Sygma/Corbis. 177: AFP/Getty Images. 178: Dan Kitwood/Getty Images. 181: Thos Robinson/Getty Images. 182: Randy Brooke/Getty Images. 183 (clockwise from top): © MCV; courtesy of Calvin Klein Collection; © MCV. 185: © Tony Kent/Sygma/Corbis. 186: Frazer Harrison/Getty Images; 187: Mark Mainz/Getty Images.

Acknowledgments

The Style Mentors is a volume drawn from the sartorial expressions of several centuries' worth of fashion icons, yet its content would not have been realized without the enthusiasm, support, and encouragement of my editor, Elizabeth Viscott Sullivan; the creative art direction of Iris Shih; and the beautiful graphic design work of Christine Heslin. I would also like to extend a heartfelt thanks to those who assisted in the research and gathering of the book's imagery, including but not limited to: Katie Walker, AnnMarie Araujo, and Butch Vincenzio, Getty Images; Norman Currie, Corbis; Mikaela Gross, Art & Commerce; Justin Rose, Trunk Archive; Gregory Spencer, Art Partner; Julie Tran Le, the Metropolitan Museum of Art; and Jamie Vuignier, the Kobal Collection. Finally, I must thank my family, Eyal and Boaz, for putting up with my obsession with fashion and accompanying me always in the pursuits it yields.